GLORY

Magical Visions of
Black Beauty

Kahran and Regis
Bethencourt

St. Martin's Press
New York

First published in the United States by St. Martin's Press, an imprint of St. Martin's Publishing Group

www.stmartins.com

The Library of Congress Cataloging-in-Publication Data is available upon request.

ISBN 978-1-250-20456-1 (hardcover)
ISBN 978-1-250-20457-8 (ebook)

Our books may be purchased in bulk for promotional, educational, or business use. Please contact your local bookseller or the Macmillan Corporate and Premium Sales Department at 1-800-221-7945, extension 5442, or by email at MacmillanSpecialMarkets@macmillan.com.

First Edition: 2020

10 9 8 7 6 5 4 3 2 1

To our parents and
everyone who has ever supported
our movement: this is our thanks to you.

TABLE OF CONTENTS

FOREWORD
by Amanda Seales

In the late 60s, newspaper headlines and magazines chronicled America bursting into flames as black folks watched great leaders of our community be taken down by oppressive forces. Out of those ashes came the Black Arts Movement and the black pride movement. Dashikis and Afros, mud cloth and black power fist picks, red-black-and-green wristbands and Africa pendants flooded the landscape as black folks reconnected with the inner and outer beauty that they had been taught for so long to despise. Entire communities began to actively teach not only the truth about the African diaspora, but the importance of black hair, its uniqueness, its strength, and its power. A generation finally saw their blackness represented without restraint.

I was fortunate to grow up in the 90s. Hip-hop was becoming a global phenomenon giving identity to all of us with something to say, and styles upon styles to wear; it was pre-TSA and you could see your folks off at the gate at the airport, and most awesomely, as a young black girl I was surrounded by representations of black girl magic. In music, athletics, and television, the 90s saw all different shades and shapes of black women stepping into the light and owning it.

They had all types of hairstyles, fashion flavas, professions, accents, attitudes, and unique attributes. I'd watch them and could see myself in them. I'd hear them, and find my funny in their comedic genius. I'd study their demeanor, their walk, the way they held their champagne glasses, and my young and influential spirit would take it in, process it through my maturing mind's mainframe and pieces of each of them would take their place on the strands of my ever-forming identity's DNA. That time of development was incredibly integral to my becoming the black woman I always wanted to be. Outside of my own familial circles, parents, and peer groups, seeing those images of black beauty represented in front of me informed me, from the dawn of my development, that I was worthy, I was valuable, and I could be anything!

For the current generation, TV has been replaced with social media. At its best, social media serves as a place to share and learn new information, find humor, and watch an incredible animal rescue. As a comedian and actress, it has been a great resource for sharing my comedy, like the countdown to the release of my HBO stand-up special, *I Be Knowin'*, behind-the-scenes photos as the character Tiffany DuBois on HBO's *Insecure*, connecting folks to my black culture comedy game show, *Smart Funny & Black*, and giving insight on social issues, relationships, and *Game of Thrones*. Most important, it has been a source point for connecting with various voices that regularly resonate a message of love and empowerment to the black community.

Though there are a number of pages that consistently amplify the glory—from the kitchen to baby hairs—of the natural black crown, when I first came across the AfroArt series on Instagram, I was mesmerized. The photos were more than just cute captures of adorable kids cheesing beneath meticulously oiled scalps. In their unique and elevated vision, the AfroArt creators had deftly found the natural regal spirit of these beautiful brown children and, with the lens, given it space to illuminate and radiate.

Behind a pointed gaze, with each kink and curl in place, the subjects connect with the viewer. The creativity in their settings and costumes was exceeded only by how both were seamlessly interwoven with the bold hairstyles that framed each magnificent and innocent face. The varied combination of pastoral, couture, jewels, and more continuously expand the possibilities of how we see ourselves as black bodies.

To be young and black in this world can be a dangerous burden of the pressures of having to pursue perfection and duel with discrimination, but in the work of the AfroArt series, we see the embodiment of self-love displayed in portraits of pride and power that lift not only our spirits, but our community, reminding us of our boundless possibilities.

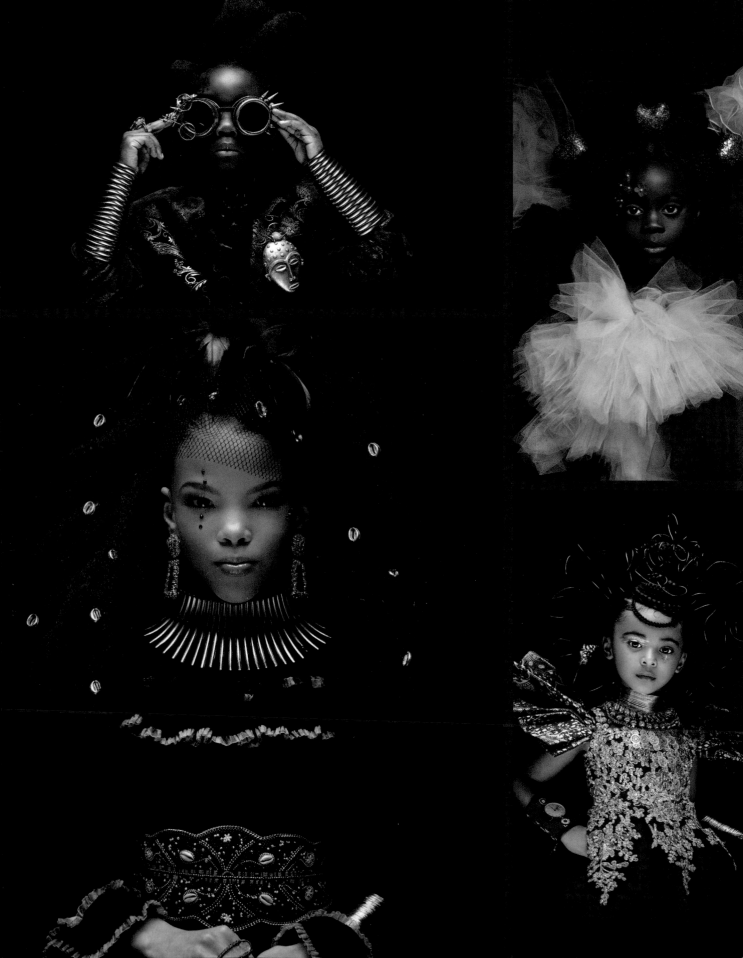

INTRODUCTION

As photographers, we are blessed with the opportunity to capture the stories we want to tell through images. We are literally looking through a lens at our people, and what we see in everyday folks is the beauty of black culture. It is an extraordinary beauty that is rarely represented in its full glory. Often symbolized by our hair, that glory is a halo that radiates up to the heavens and confirms the exquisite grace of its natural state.

We think of ourselves as cultural storytellers, documenting not only the world as we see it, but also imagining the world we want to see. For generations, black culture, black identity, and black hair has often been under-celebrated in the western world. In the past, black kids were often taught that their natural hair was too kinky or "nappy," not long enough, not straight enough. Battles on the schoolhouse playground about whether your skin was too dark or too light were a typical occurrence for many, and sadly still are today.

Growing up, Reg and I had vastly different experiences with black culture and black hair. For me, as a black kid in the South it was understood that at a certain age, when my soft and curly baby hair had grown out, it was time to either get a kiddie perm or straighten my hair to manage its "kinky" texture.

At the age of six, I was introduced to the world of relaxers, which would become my norm for the next twenty-two years. As an adult I began a long journey of not only learning about it, but loving and accepting my hair in its natural state.

The child of a Filipino mother and a black father, Reg grew up with very different experiences. In school, black kids (specifically girls and women) always commented on his "good hair." Boys would often make fun of it and chide him for not really being black. Reg often wore hats or had short haircuts to hide his natural curls. Rather than dealing with the confusion surrounding his identity as a mixed-race child, hats and short hair allowed him to blend in.

Today, we are able to channel those experiences into our work. We often imagine our future kids living in a world where their identity is celebrated rather than derided, misunderstood, and misappropriated.

Our journey as photographers began with a love of visual storytelling. We started by documenting our families' stories and evolved into the kids' fashion industry where we quickly noticed a lack of diversity. At photo shoots, parents often felt the need to straighten their kids' natural hair in an attempt to have them fit in.

For decades, images of our children's "subdued" selves have traveled out into the world, reaffirming the sense that acceptable black beauty was not our natural beauty. We knew this had to change.

We didn't just want to question traditional beauty standards—we wanted to shatter them. We wanted to create images that flew in the face of the established spectrum of acceptable standards of beauty. With our pictures we wanted to tell a story of a people who for centuries were artists and artisans, strategists and intellectuals, warlords and warriors, kings and queens. At their heart, our photos are a recognition and celebration of the beauty and versatility of black beauty and its innate glory.

In *GLORY*, our photos of young innovators illustrate our royal past, celebrate the glory of the here and now, and even dare to forecast the future. We showcase not only their inherent natural beauty, but also what makes them special. In "The Past: Once and Future Kings and Queens" we highlight young men and women who have made a difference, often by choosing to be strong in the face of at times, overwhelming adversity. Many have endured poverty, colorism, bullying, or a life-threatening illness. Instead of being defined or diminished by it they were empowered by it. In "The Present" we celebrate our Regal Renaissance with the young revolutionaries making it happen. The freedom fighters, activists, scientists, aspiring astronauts, STEM/STEAM boys and girls, and teen CEOs who are in full control of their power and are using it to make positive changes in their community and in the world. In "Our Unbound Glory" we look to the future trailblazers who are paving the way in aviation, neuroscience, the arts, design, sports, and activism.

These change-makers—some as young as three years old—are changing policy while redefining standards and ideals along the way. Their stories are inspirational.

3

Their diverse beauty shows that what makes us different is what makes us special. Within these pages you'll find skin of every hue, kinky hair and curly hair, and everything in between—the distinct features that represent every aspect of our rich and storied heritage.

We are proud to have had the opportunity to showcase the talent, drive, determination, and ingenuity in our youth across the diaspora. We wanted to show a variety of young people with an even wider range of interests and achievements so that black children around the world would see themselves represented in all their glorious, natural, transcendent beauty. Seeing the look on a child's face when they see a version of themselves they never knew existed, or was even possible, is a priceless gift. We hope it will be our legacy for years to come.

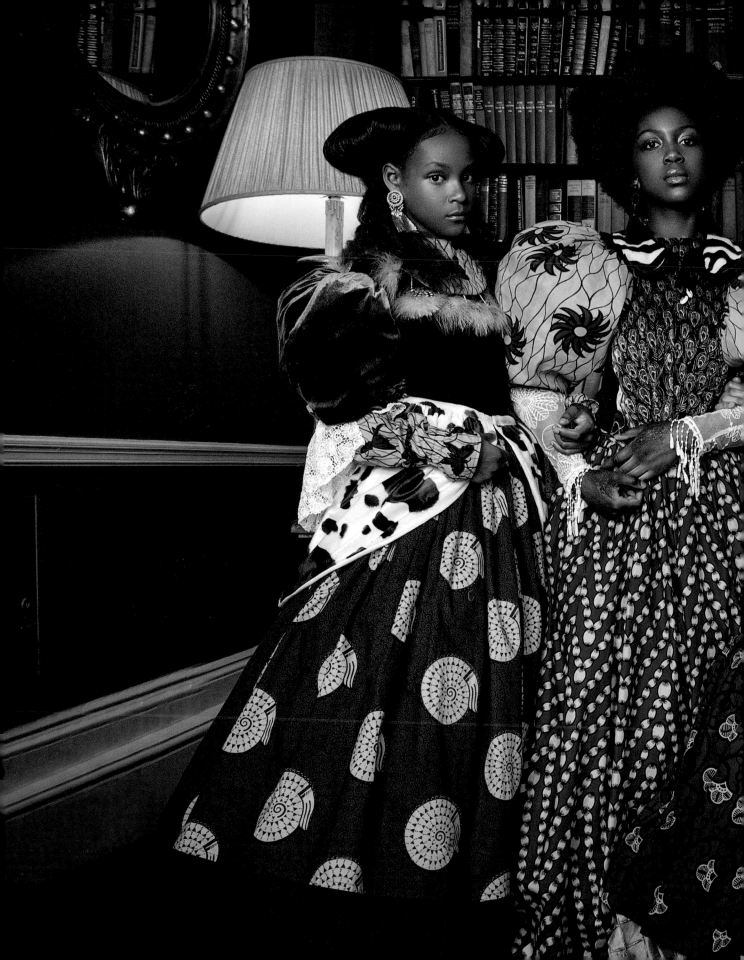

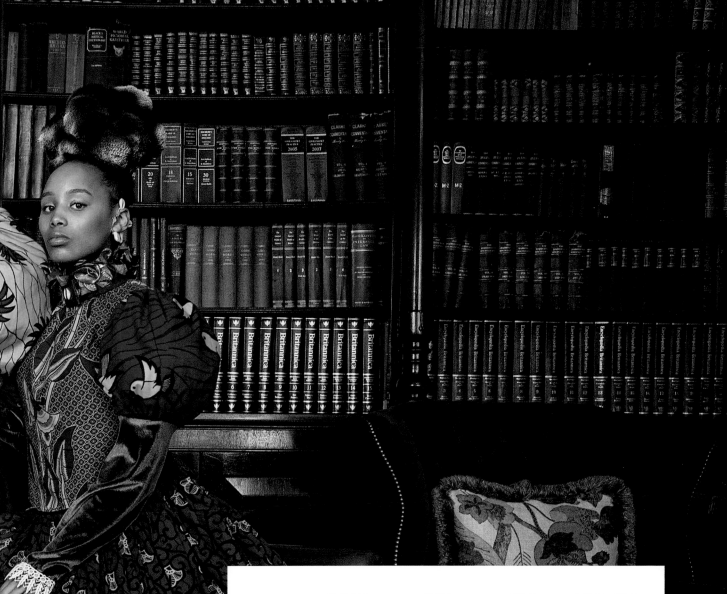

PAST

ONCE AND FUTURE KINGS AND QUEENS

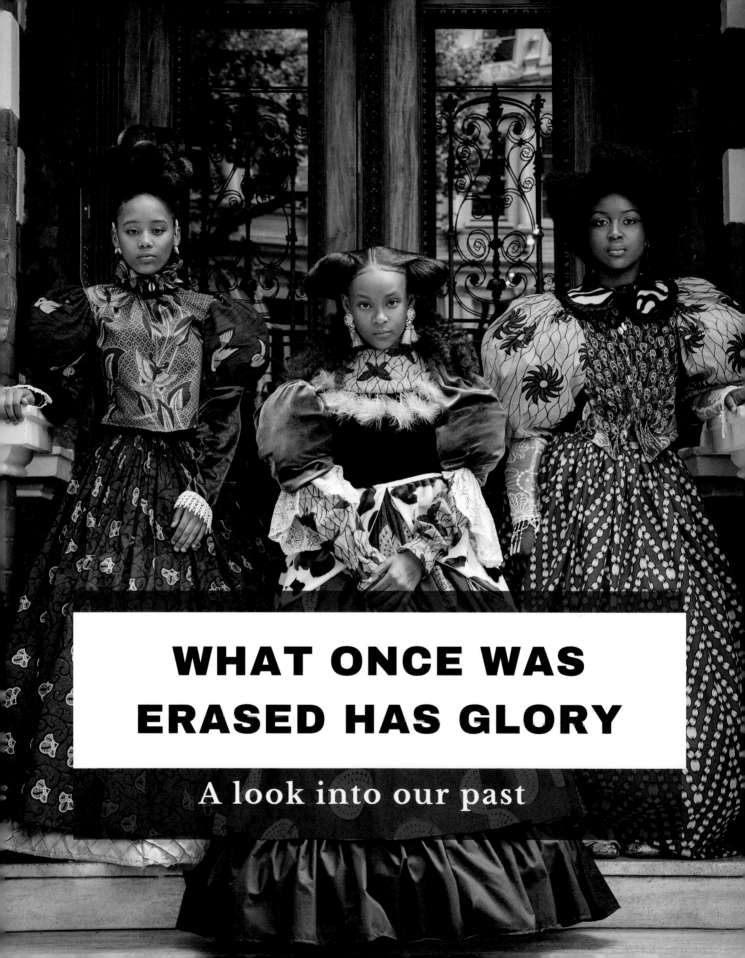

WHAT ONCE WAS ERASED HAS GLORY

A look into our past

We are once and future kings and queens, royalty from the shores of Senegal to the urban streets. Regal, aristocratic. Our past is not prologue, footnote, endnote; we claim it now, for the magnificence and the magnitude of the beauty that so astounded—even unadorned —that it had to be tamped down, stamped out, bound. But in our glory we now rise and ascend to thrones almost forgotten.

After 400 years of our story being told by others we reclaim that right. Egypt was the first of many great African civilizations. It lasted thousands of years, innovating science, mathematics, medicine, technology, and the arts. Egyptian civilization was already more than 2000 years old when Rome was built. In the west of Africa, the kingdom of Ghana was a vast Empire that spread across an area the size of Western Europe. Its wealth was akin to a medieval European empire, its army of 200,000 men undefeated. The past is with us as we live out the physical legacies of the north, west, east, and south of Africa.

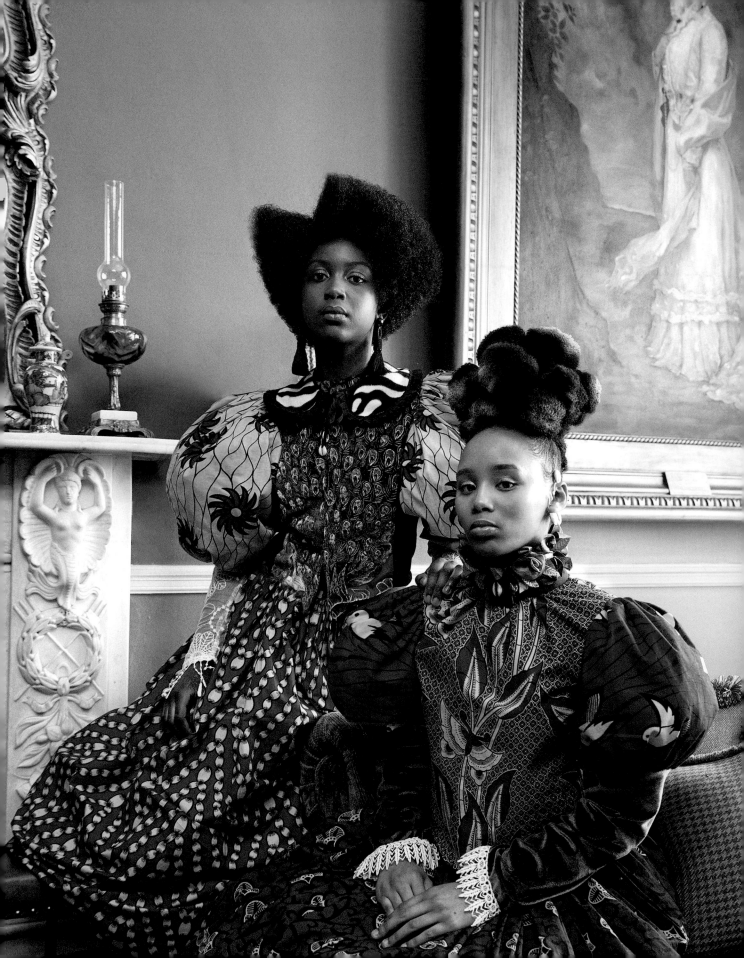

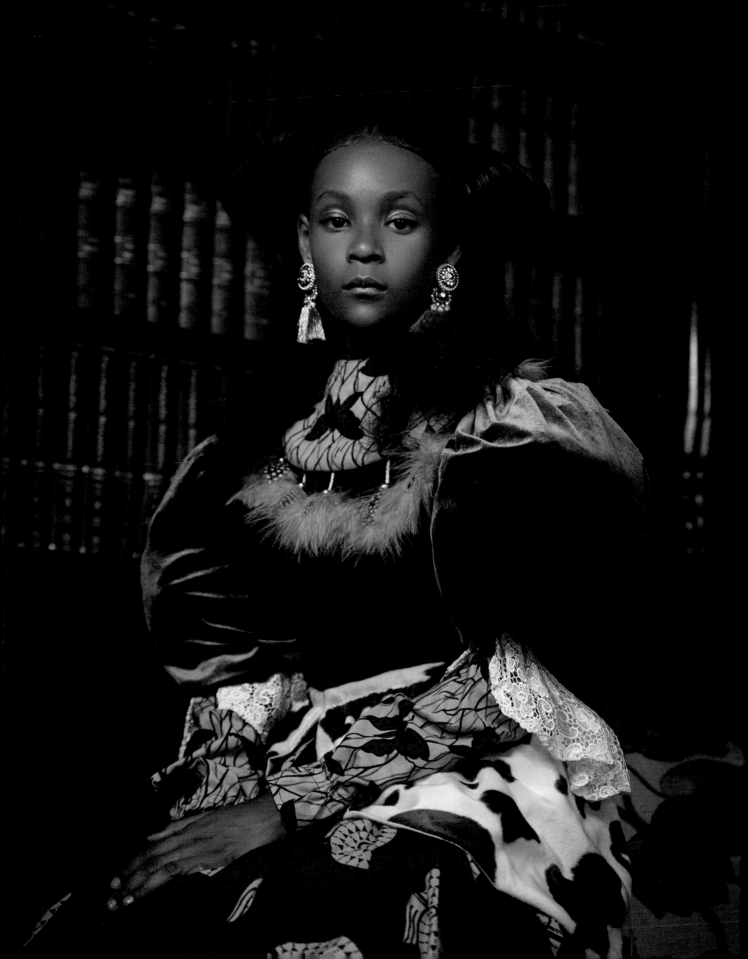

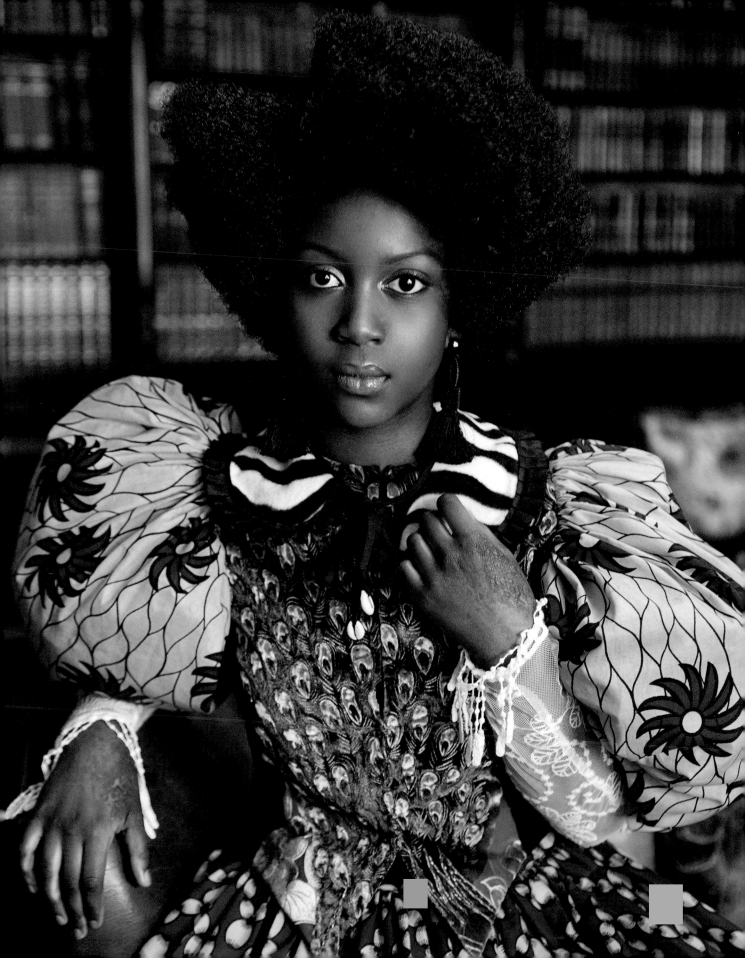

Though only thirteen years old, Nia Gelly is an independent and determined young woman who does not follow the crowd, but instead follows her heart. She is quietly confident without being arrogant, a result of having severe eczema, which led to complete hair loss and scars on her skin. Along with the discomfort and various treatments, she's also had to endure stares and hurtful comments. Even during her lowest days she would make her family smile and they always instilled in her that she was brave, strong, and beautiful.

Nia's hair has grown back full and thick and the insensitive comments have lessened. In spite of it all she is composed and self-possessed beyond her years. Nia recently won a public speaking competition for students under thirteen. She spoke about the importance of education for girls wherever they might be in the world. Nia is inspired by her mother and grandmother, and believes that what makes her special is her inner strength and determination. She also stands up for the underdog and steps in where she sees injustice. "To inspire others, I would say be true to yourself, work hard, and follow your dreams."

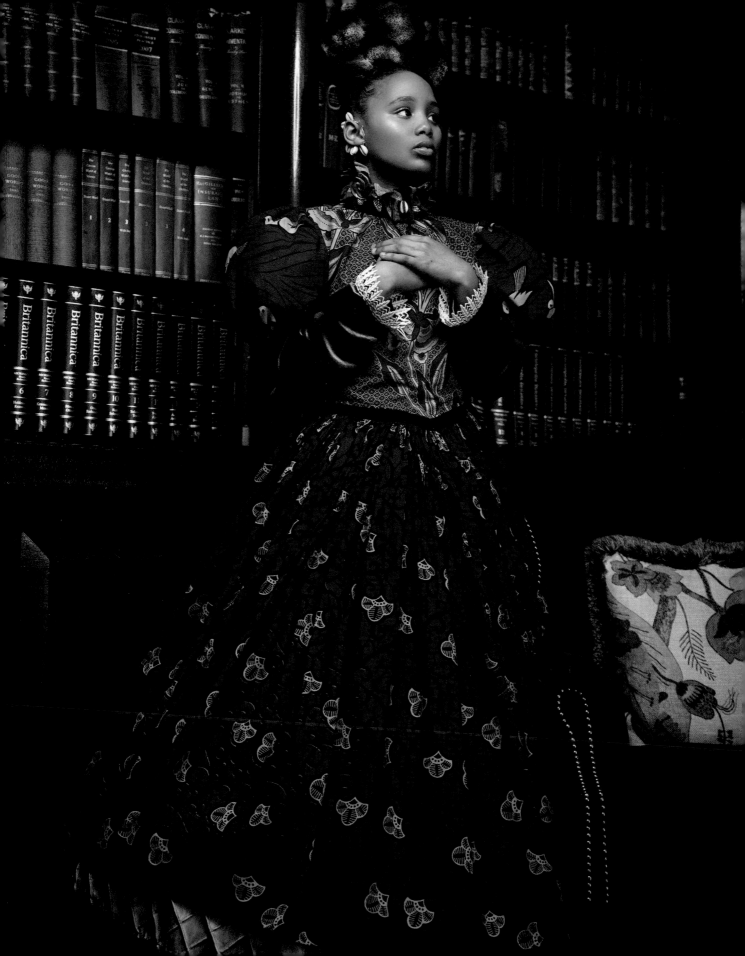

WAMI

Step into Your Power

Leigh Wami Tucker was born in Johannesburg, South Africa, in 2004. When her family moved to England in 2006 she quickly realized that she was different from the girls with whom she went to nursery. She went home one day and told her mother that she believed the other children didn't want to play with her because of her kinky Afro hair and that she wanted long blond hair. As a child, Wami had a very outgoing personality, but moving to the U.K. changed her. She didn't see many children or people who looked like her, and the once-vivacious youngster became withdrawn. She was an outsider among her school friends, and she felt it was because she had brown skin and "woolly" hair.

Wami faced many challenges, but the biggest one was accepting herself and embracing who she was. Moving away from South Africa and not being surrounded by her family's cultural heritage had a massive effect on her not truly knowing who she was. Wami's mom only wears her hair in an Afro and wanted her daughter to see that she was beautiful just the way she was. She told Wami that her gorgeous gravity-defying hair was her crown and made her unique. She embraced it fully after that conversation and now, at fifteen, loves the way she looks. Her message to other young black girls is, "Be yourself, embrace yourself, and love yourself unconditionally, because there is nothing more powerful that being authentically you."

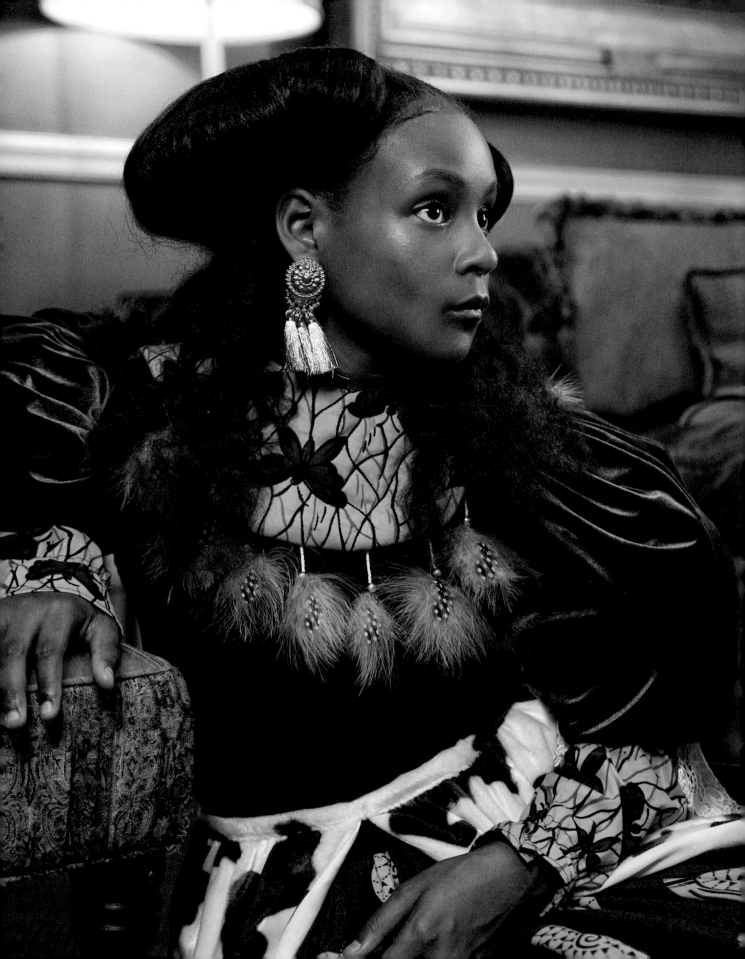

T'AMIA

The Silent Warrior

Years of feeling not good enough in the eyes of a controlling parent greatly affected T'amia Weight's confidence. Her mother made the difficult decision to take T'amia and her sister and leave their abusive environment. Her mother struggled immensely with the guilt, but it wasn't until she saw T'amia begin to blossom that she truly understood how trapped they had been.

It has been a long journey, but a year and a half later they are all stronger, happier, and more self-assured. Although still a little shy, T'amia, now twelve, loves animals, children, and spending time with her family and friends. To other young people, she says, "Be positive. Always believe you can do something and then you will be able to do it."

T'amia now knows who she is and who she wants to be. Her past has not affected her knowing her culture or her roots. She loves the skin she is in, her natural hair, her everything.

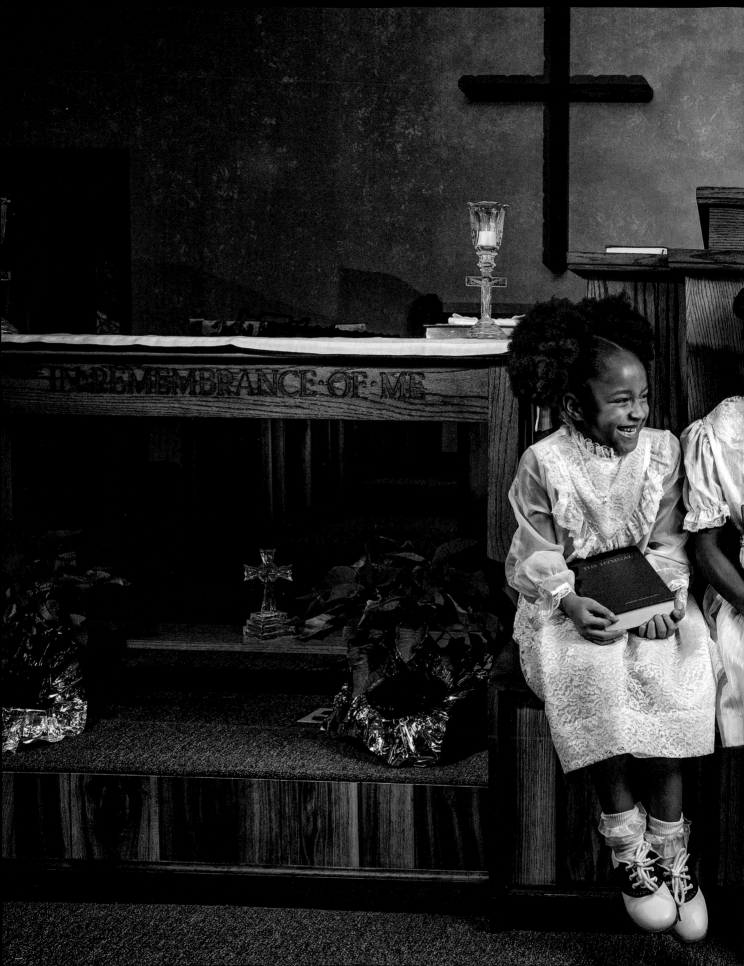

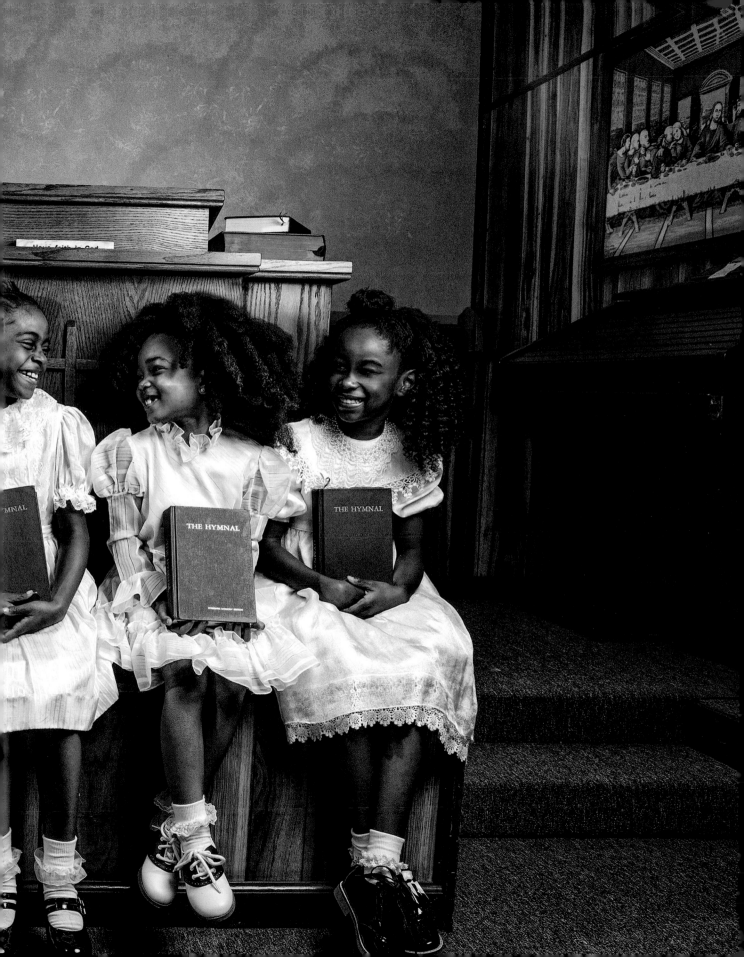

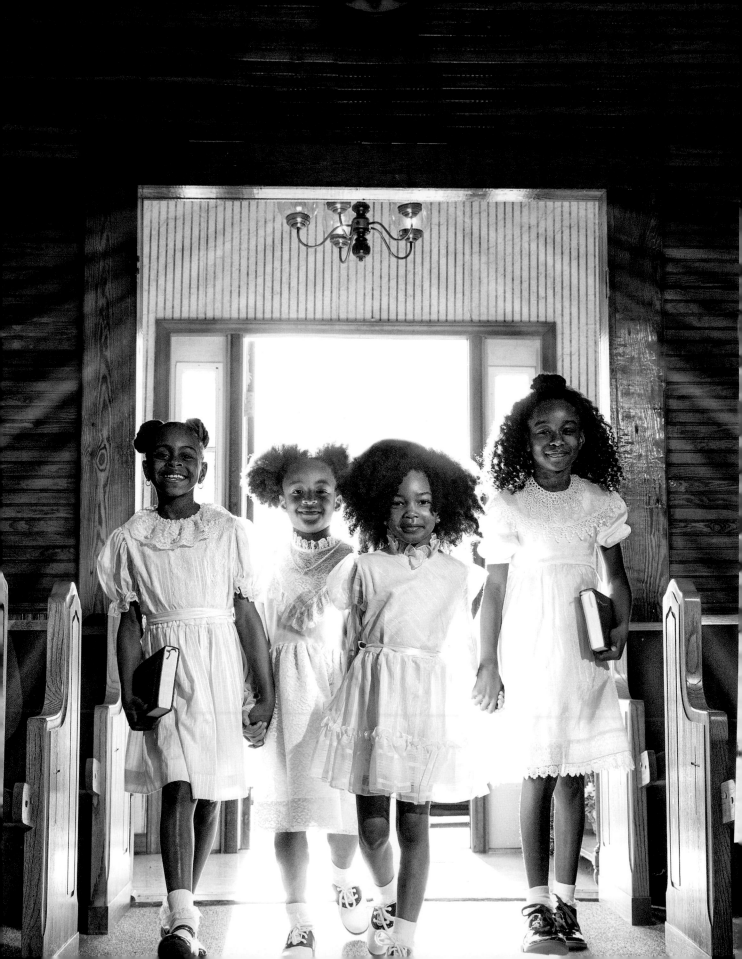

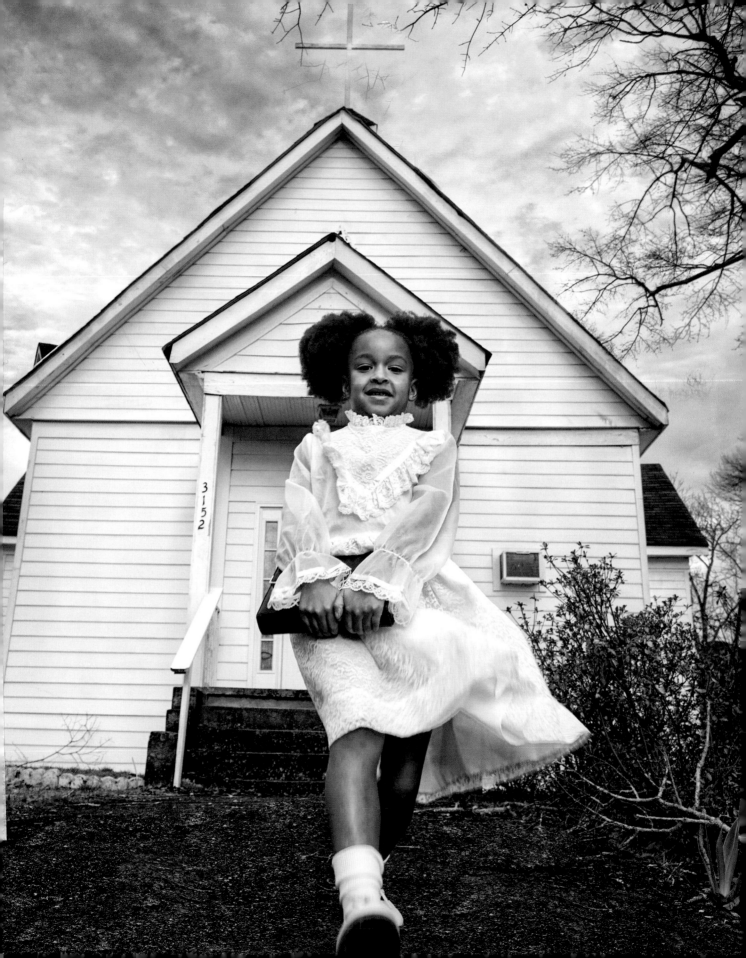

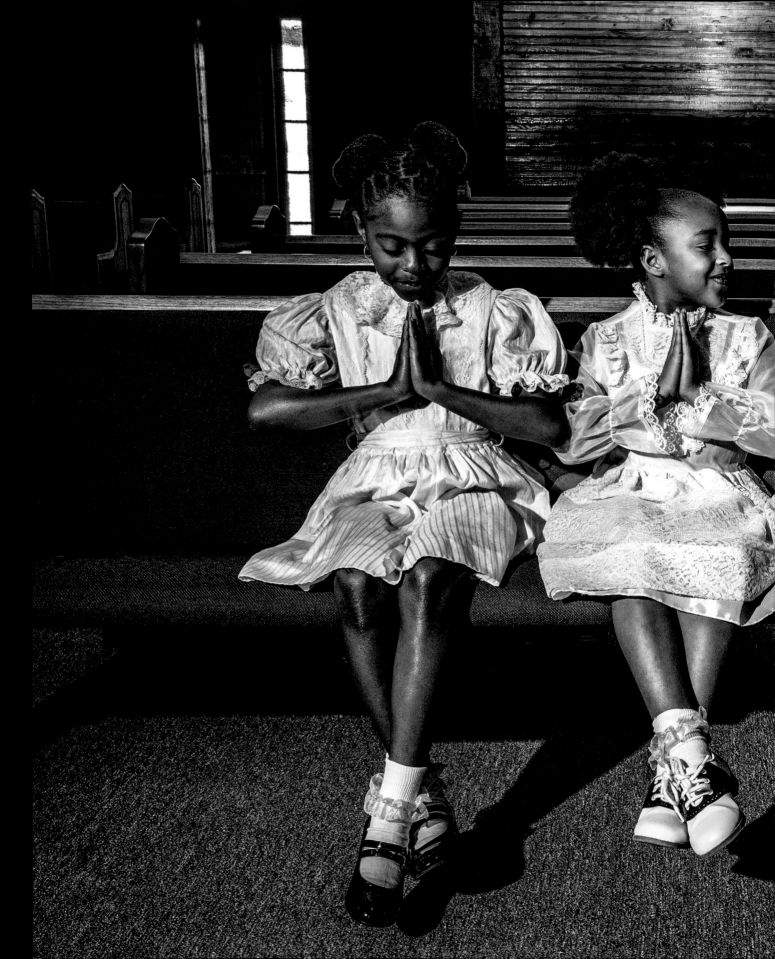

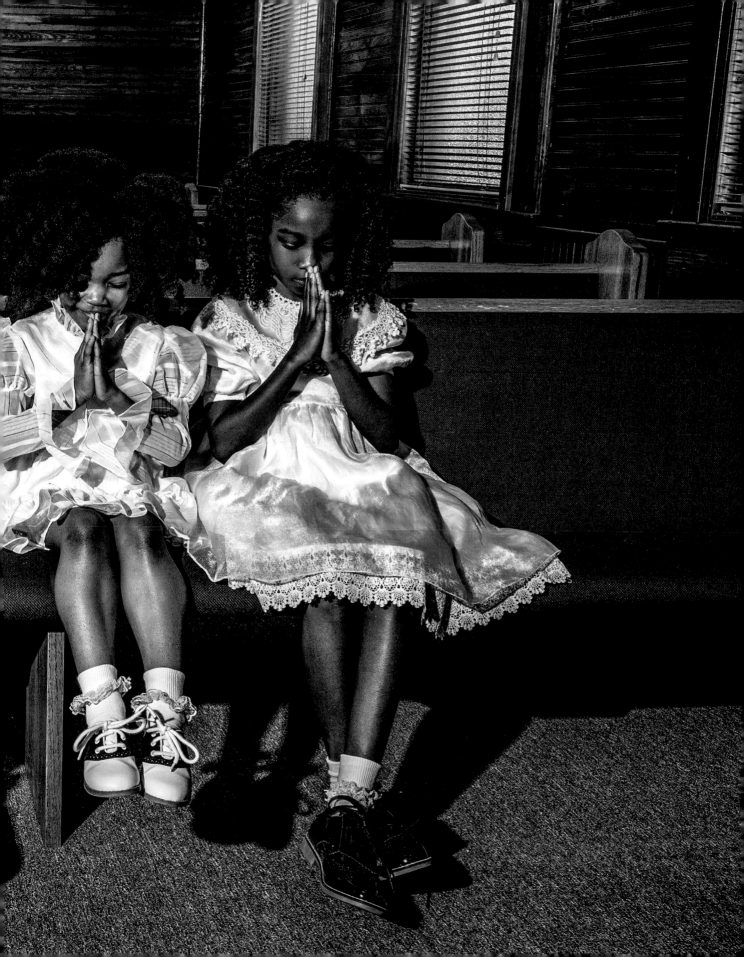

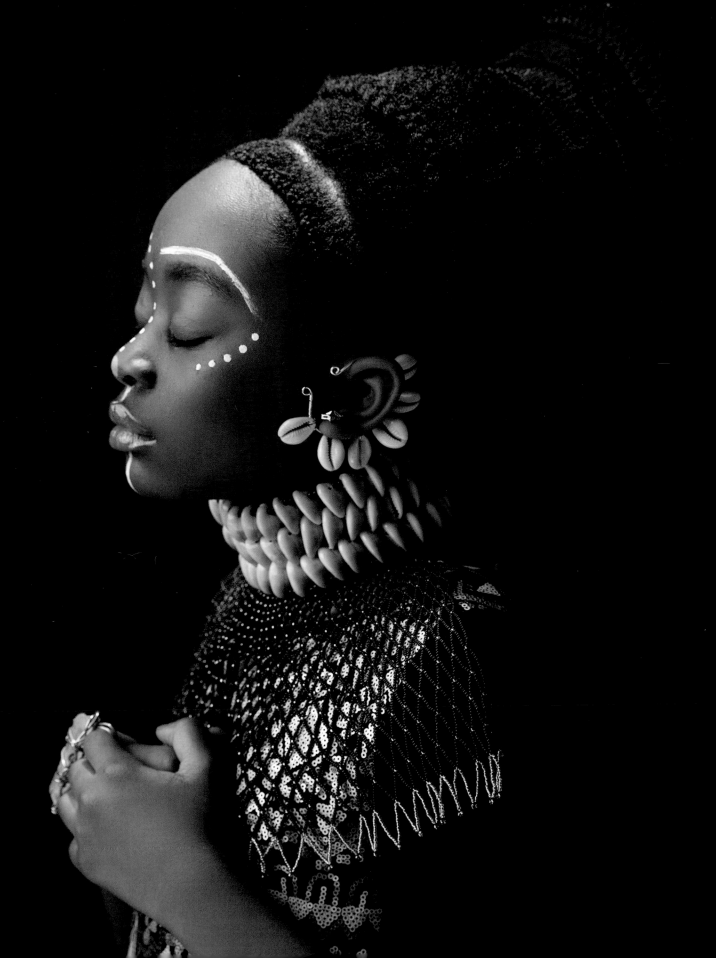

FOR I AM MY MOTHER'S DAUGHTER, AND THE DRUMS OF AFRICA STILL BEAT IN MY HEART.

—*Mary McLeod Bethune*

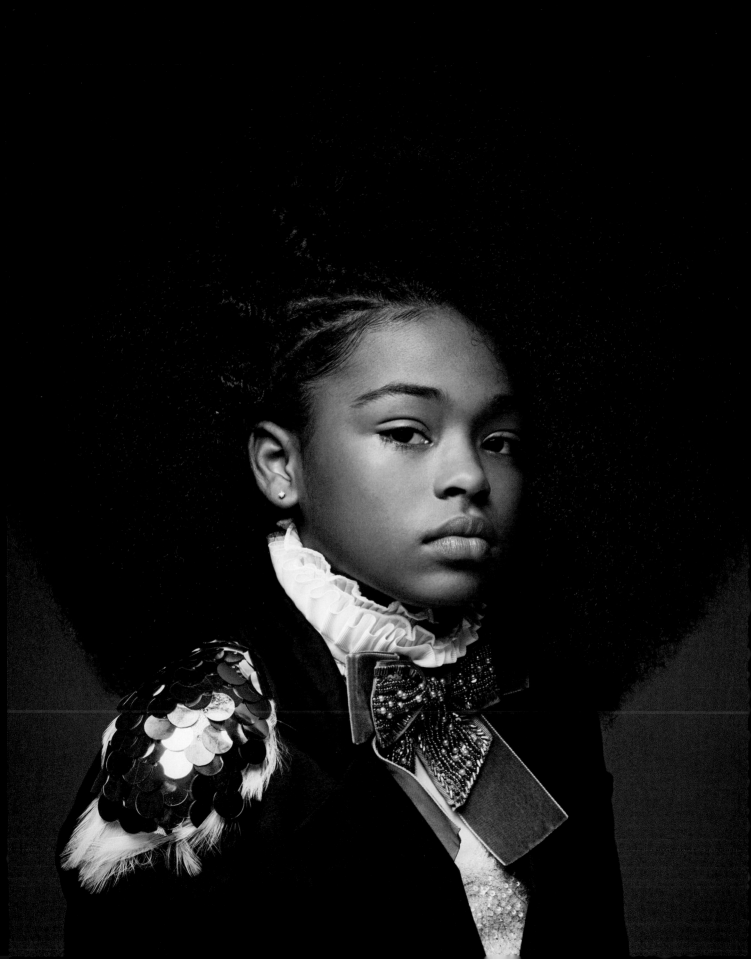

ZOI

The Baroque Princess

Stunning Zoi Polley Flowers is already breathtakingly lovely, and her hair is known as "The Afro Seen Around the World." The baroque-style image we took of her immediately went viral and has been shared by millions of people internationally. Through it all, this bubbly twelve-year-old lives her life like a regular tween who doesn't seem too fazed by it all.

A working model and gymnast in Dallas, her mother decided she needed to show her daughter's already regal looks in a standout and empowering way. When Zoi faced the camera for the first time, with her natural hair unbound and resplendent, she held her head higher and saw the uniqueness of her transcendent beauty.

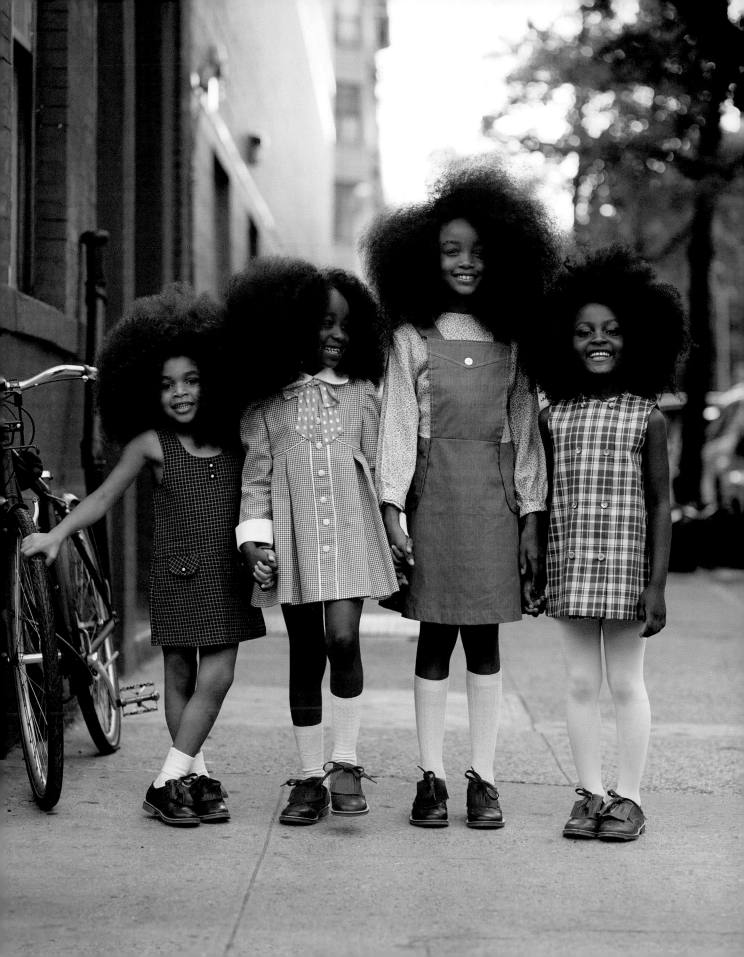

UNITY IS STRENGTH, DIVISION IS WEAKNESS.

—*Swahili Proverb*

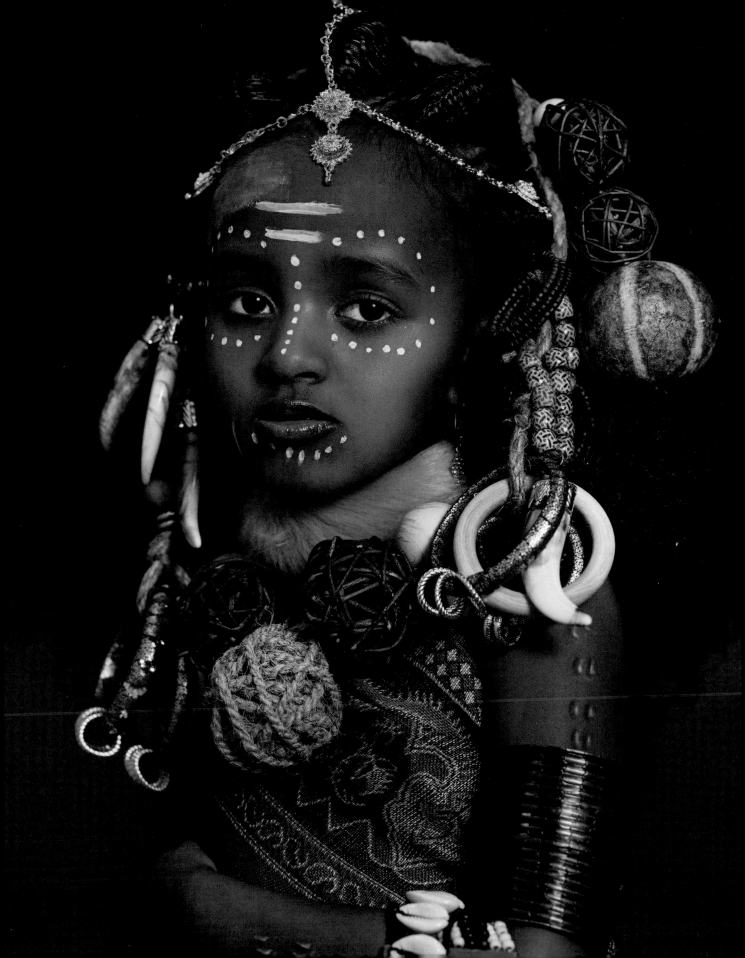

NARIAH

Cultural Ties

Nariah Cham is a spunky five-year-old girl with an abundance of personality and a colorful cultural background that ties back to Eritrea, Ethiopia, and the Republic of Gambia. Her diverse cultural beauty is evident in her soulful eyes and gorgeous hair. Nariah loves dancing, swimming, and spending time with her family. At such a young age, Nariah has already cultivated a taste for good food. She is somewhat of a cheese connoisseur and never hesitates to try a new dish or food that is unfamiliar to her. Inquisitive and full of life, Nariah hopes one day to be a singer, to share knowledge about reading, spelling, and about God. The sky is truly the limit for this confident little girl who isn't afraid to use her voice and be heard.

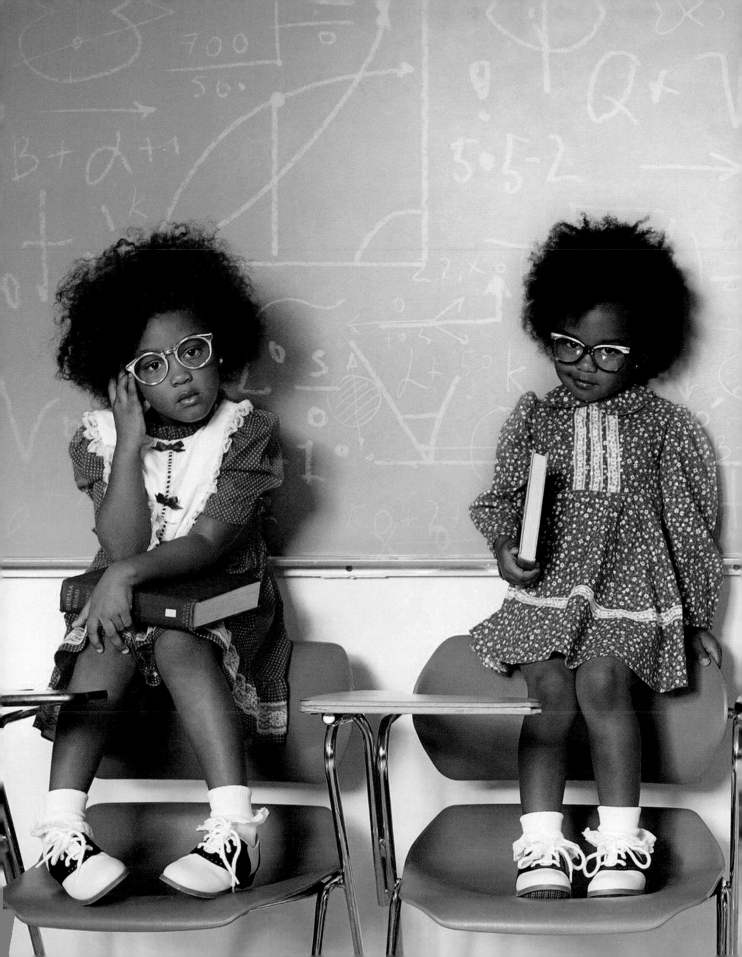

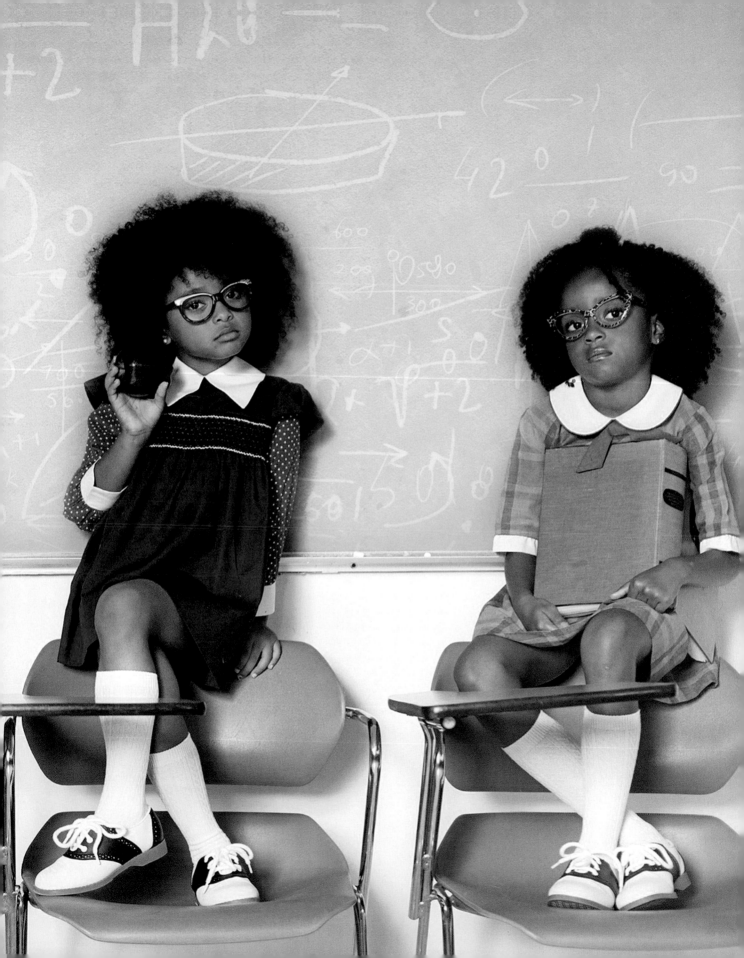

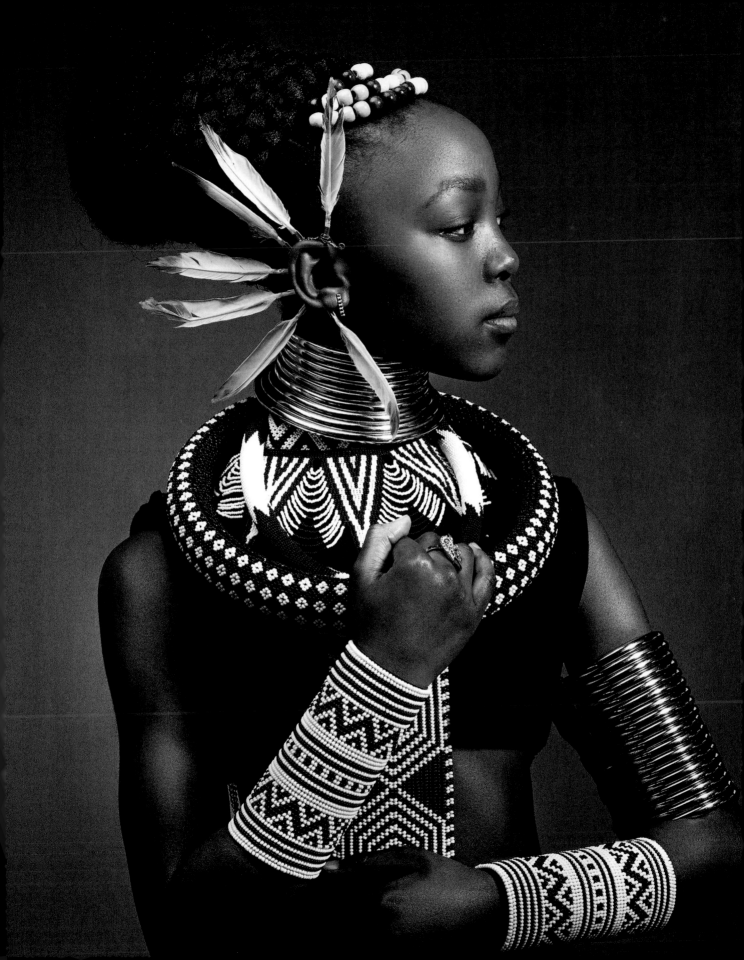

MBALI

SOUTH AFRICA

Tribal Roots

When Mbali Msimang's mother found out that she was carrying a girl, her brothers named her Mbaliyethu, which means "our flower." She is the perfect mixture of various tribes in South Africa—her mother is from the Xhosa and her father is from the Zulu tribe. She also grew up around her grandmother, who is Ndebele and taught her the Ndebele language.

Mbali is beloved in South Africa and many girls look up to her because of her bubbly personality. Her parents enrolled her in a modeling school, but they didn't know if she would be a good fit because she was very shy when meeting new people. To their surprise she placed second in her first pageant competition. Regal and naturally elegant, eleven-year-old Mbali has since won 106 titles. She also loves sports and is a sprinter with many school trophies and medals.

Mbali has thick natural hair, which she loves. In South Africa girls like her go to pageants with long straight hair but she always prefers her Afro because she says it makes her feel pretty. She also wants to show that girls can be beautiful just as they are.

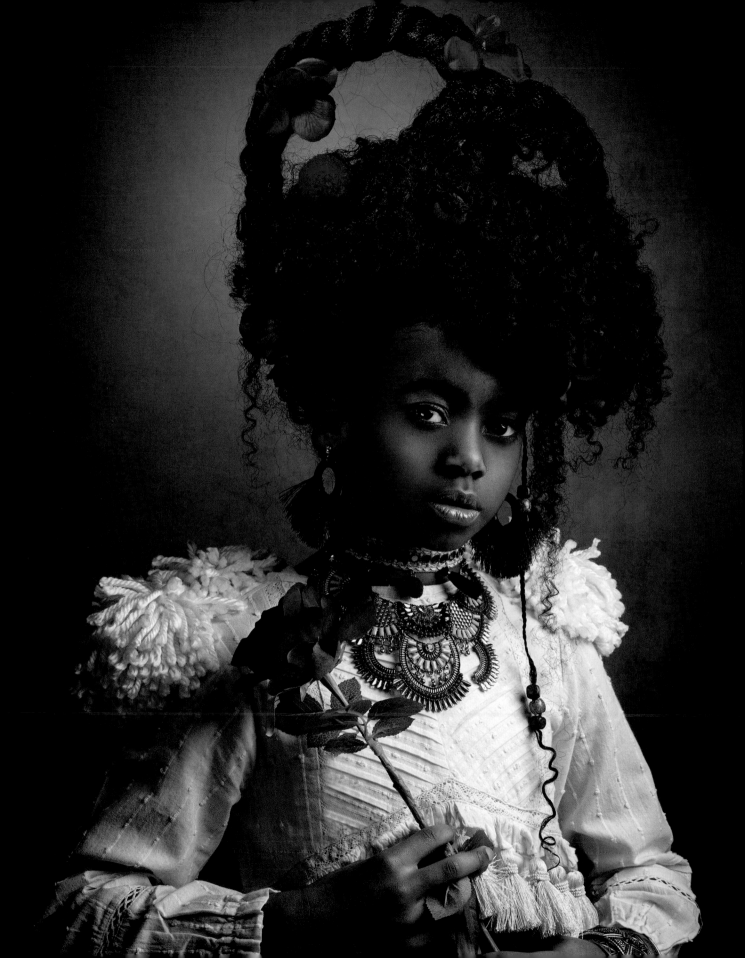

LALA

TENNESSEE

Standing on the Shoulders of Greatness

LaLa Maldonado is of both African-American and Puerto Rican descent. Born Alana Faith Maldonado in Senatobia, Mississippi, her roots from both cultures are evident in her family dynamics. Her Hispanic roots allow her to share a beautiful bond with her father. Her mother's African roots compel her to never give up, reminding her that she is standing on the shoulders of greatness.

LaLa calls herself "a country girl with a city vibe." The nine-year-old wanted to be a star since she was three, when she started participating in beauty pageants. She now holds several titles, and has won many sashes, crowns, and trophies. LaLa says, "My dad says it's what makes me different. Being of both races makes me special. I would tell kids what my parents often tell me, which is always be yourself no matter what anyone thinks of you. I have really big hair and I didn't like it at first. I attend a private school, where you don't see many kids that look like me. I told my mom I wanted my hair straightened and I wanted it to be yellow. But she taught me to love my hair and to love myself because God made us all unique and different. My hair makes me unique. So now I love it. I believe that what you hate about yourself is what draws people to you."

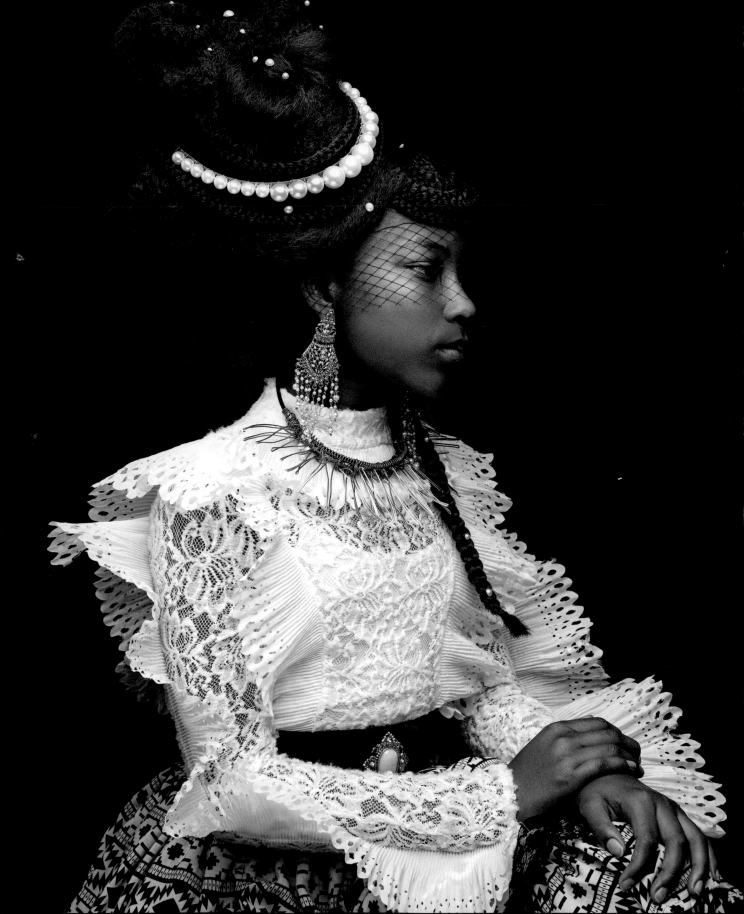

SIT DOWN. BE HUMBLE.

—Kendrick Lamar

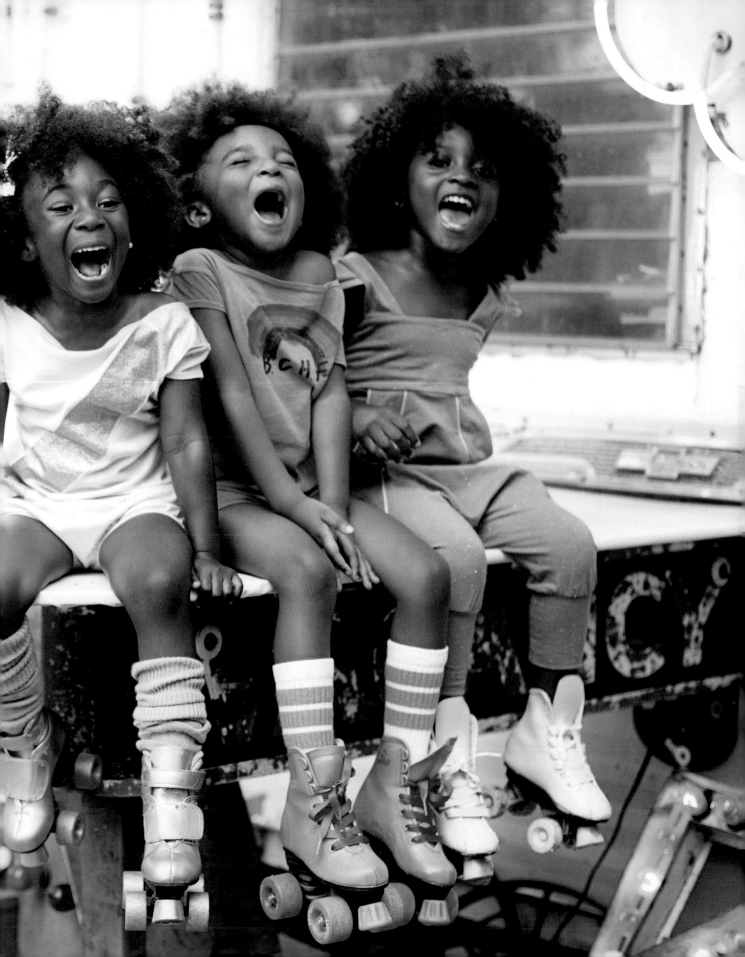

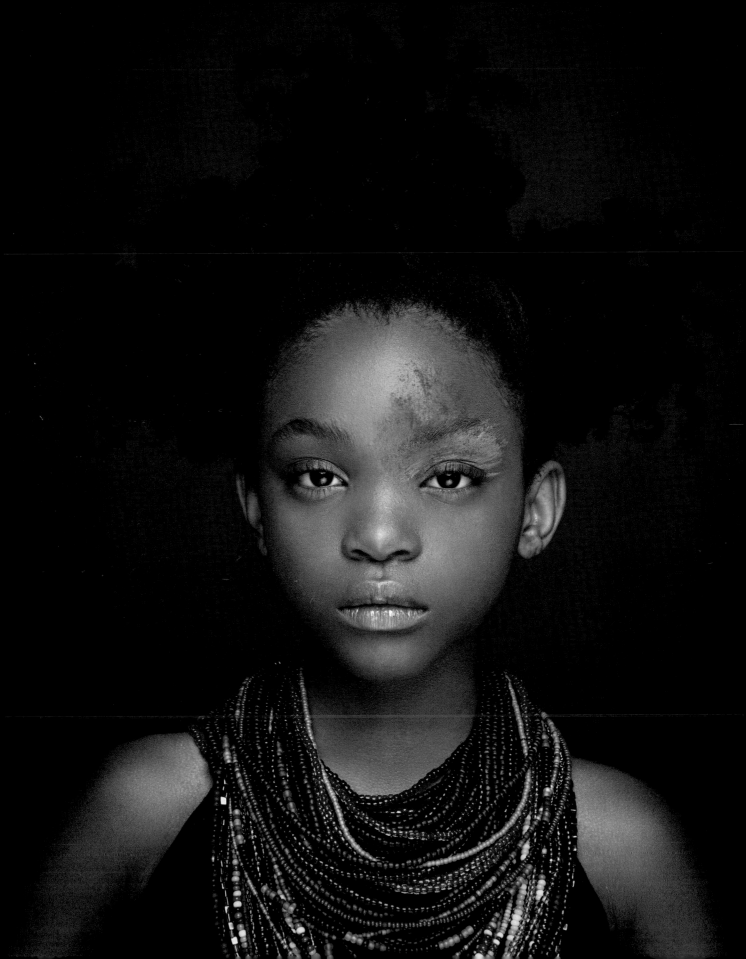

CELAI

CALIFORNIA

Walk in Your Purpose

Celai West is a quirky ten-year-old girl who recently became the youngest professional runway model to walk in an all-adult lineup in New York Fashion Week. Celai is determined to change the "standard of beauty" while teaching little brown girls how gorgeous their skin tones and big hair are on a global scale. This STEM girl is proving that school is cool, and you are never too young (or old) to find your purpose.

"I'm the youngest professional runway model. It feels pretty good to know that you can change industry standards with hard work and prayer. I want to inspire and encourage little girls who look like me to love their natural hair. I'm proud of my family for standing with me and always supporting me. They help me to encourage others to walk in their purpose."

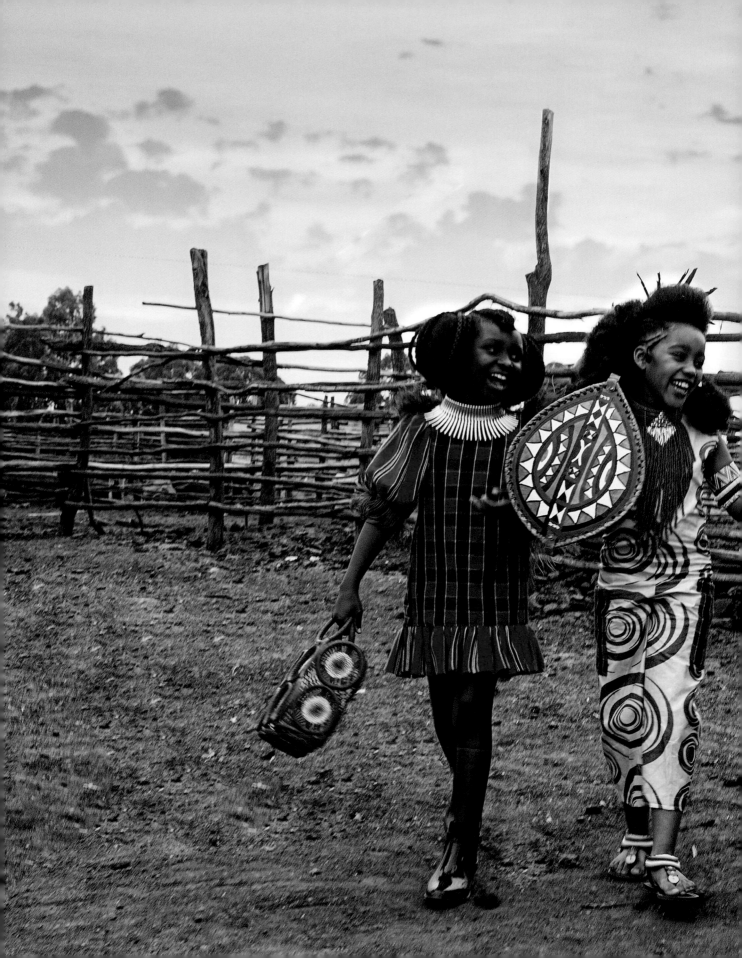

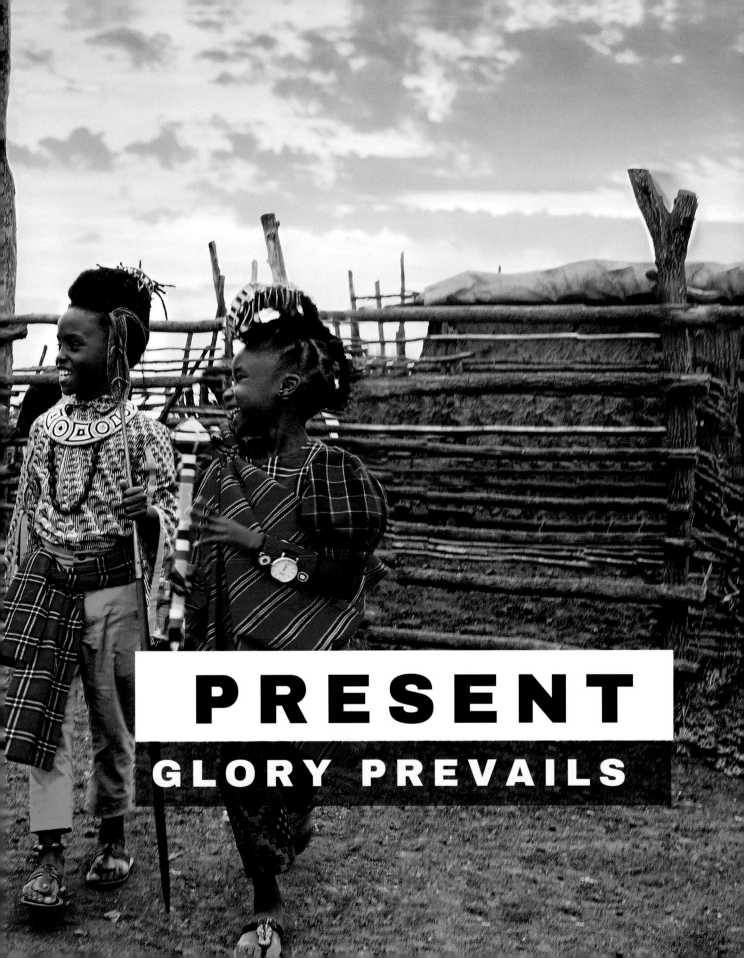

PRESENT
GLORY PREVAILS

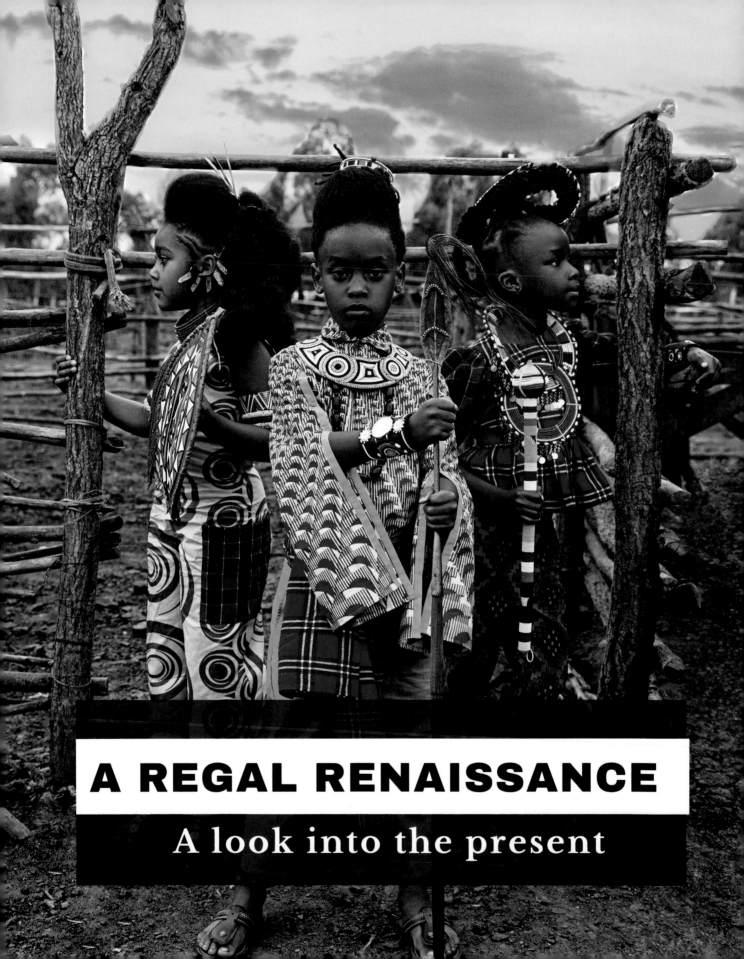

A REGAL RENAISSANCE

A look into the present

We have come out of a long waiting, buds held tight in the earth against drought, and now we bloom. Our hair is blooming, our beauty is blooming. We are in the full flower of black beauty. We, who were brought here, now bring music, dance, food, innovation, inspiration, culture, and style to the world. We travel beyond boundaries that were once set and we find our brown beauty all over the world again. What we came with, what we made, what we have, we celebrate and share. Our beauty is now our source of communion, our resurgence.

See us, know us, this is who we are. Now, in this moment, this present we rise, like a phoenix from the ashes of our past. We move with a blazing beauty and blinding light. An armament of glorious magnitude surrounds us and defines us. No longer bound, no longer restrained. We are regal in our renaissance and royal in our own image. We stand and face the world free to choose our own definition of beauty, free to be our own standard we leave wonder and amazement in our wake.

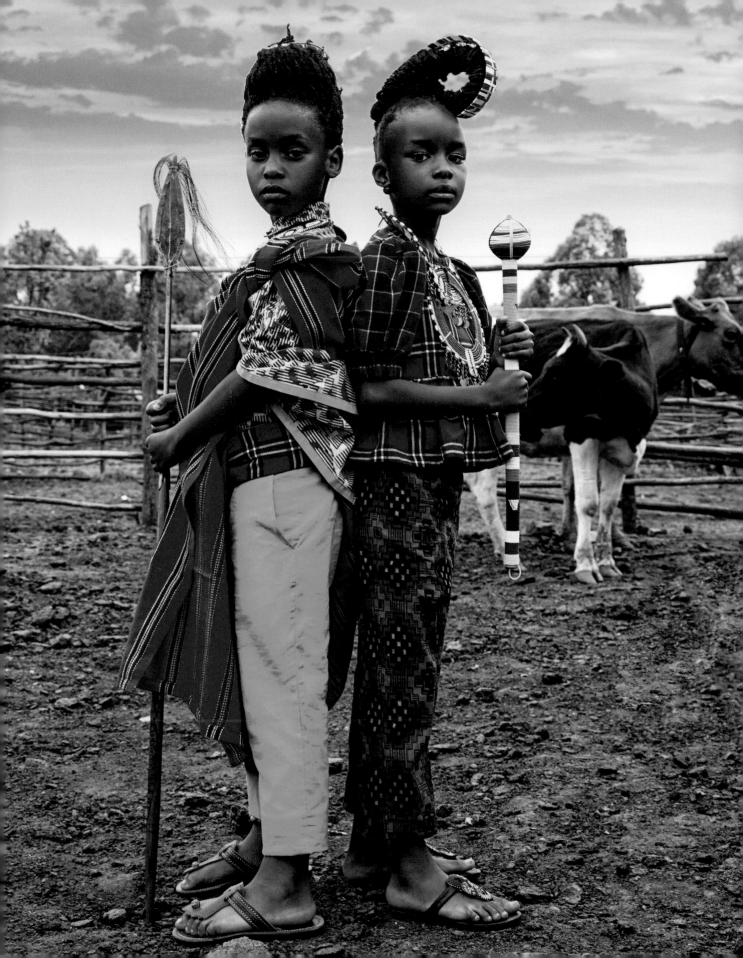

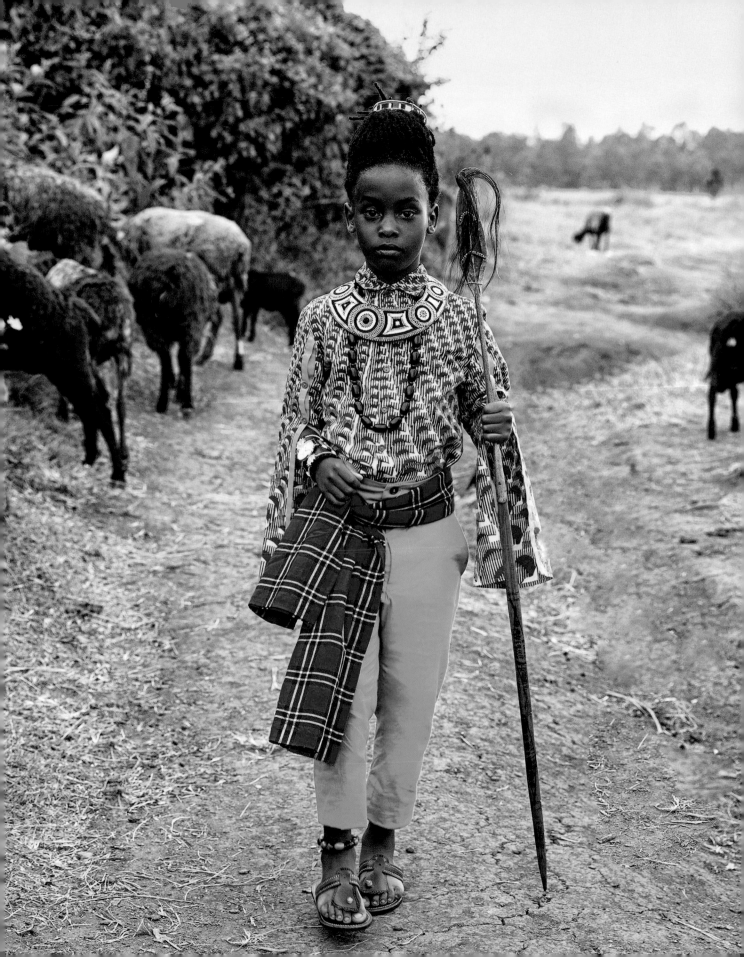

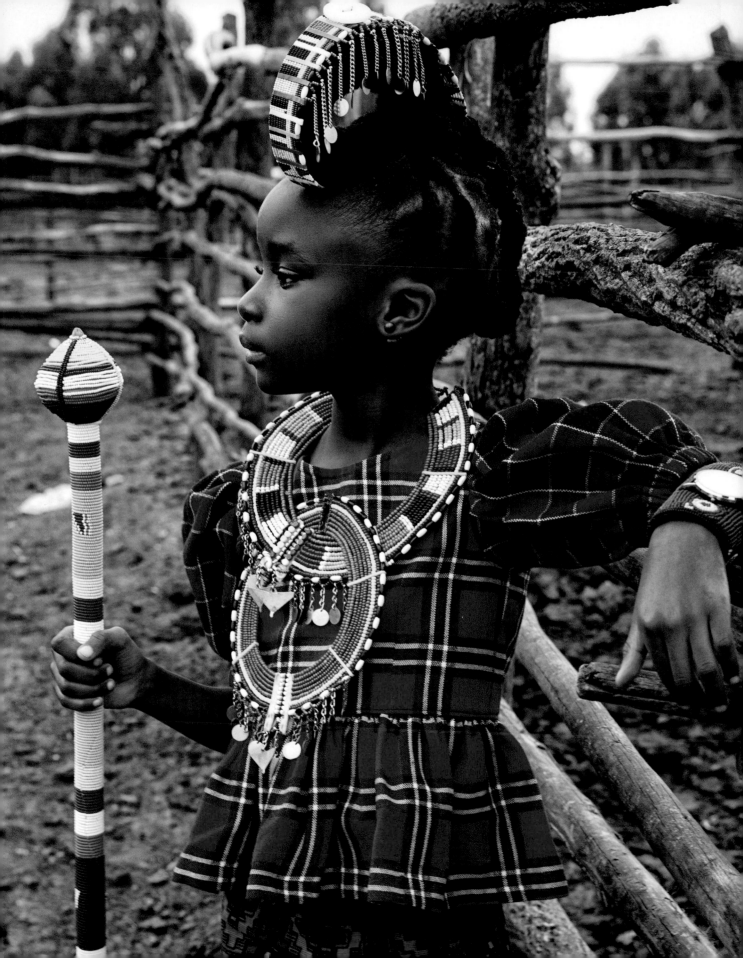

MAYA

KENYA

Regal and Royal

With her locks upswept in a crown, little Maya Kimanthi is the epitome of royalty. Yet in Kenya, where nine-year-old Maya lives, one of the top schools in the country and all public schools do not allow students with dreadlocks to attend because of age-old British colonial policies. This is the norm in Kenya and in many African countries.

Regardless, Maya proudly wears her long hair in dreadlocks. She believes that "everybody is unique and who we are is not determined by our hair, but by how much love we can share with others." Already shattering the status quo, she wants other African girls her age to know and appreciate their distinct looks and personal appeal. "I don't believe that the mean things people say about our hair should determine what we think of ourselves. What matters is how patient, kind, loving, gentle, and peaceful we are. Africans are glorious and what people say about them and their hair not being beautiful is not true."

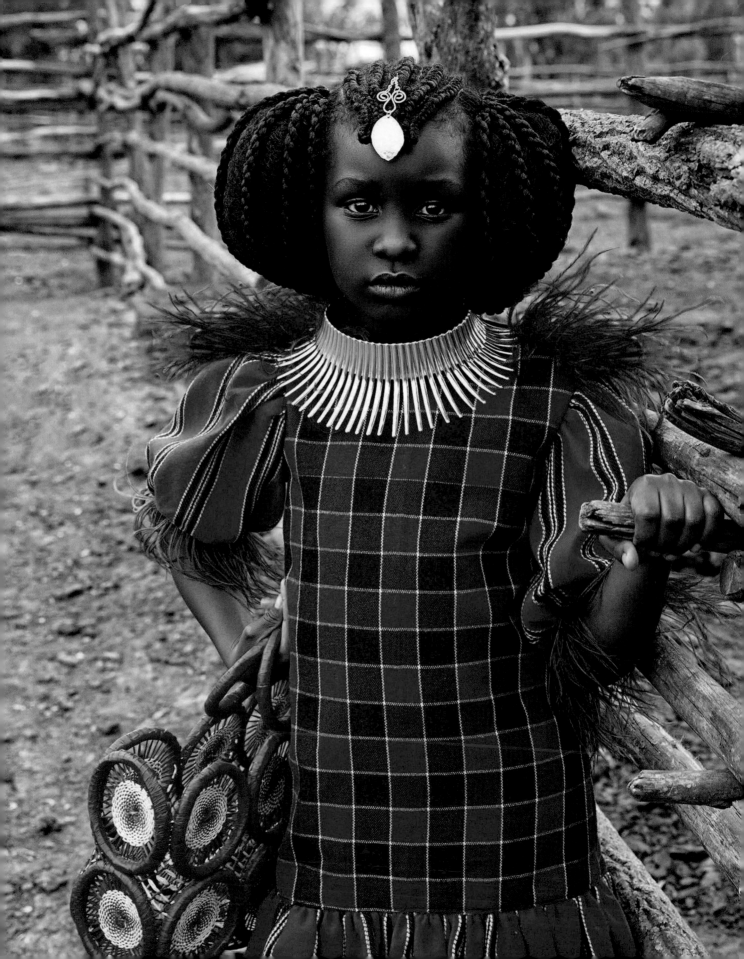

IMAAN

My Black is Beautiful

Imaan Kasule, a sweet and sensitive nine-year-old, enjoys art, music, and dancing. She also loves traveling and learning new cultures. Imaan is blessed with a gorgeous complexion and thick natural hair, which at times elicits mixed comments. "At school sometimes, other children say mean things to me because I am short and I have dark skin. And sometimes they say nice things to me because I have really long hair. My parents have taught me to believe I am clever and pretty no matter what anyone says, and I tell them that."

People often tell Imaan she does not look like her parents, who have a lighter skin color. Her family has taught her that black is beautiful, no matter the complexion. Her parents would like children her age to affirm her and let her know that there are many other girls who look like her and are lovely and full of confidence like she is.

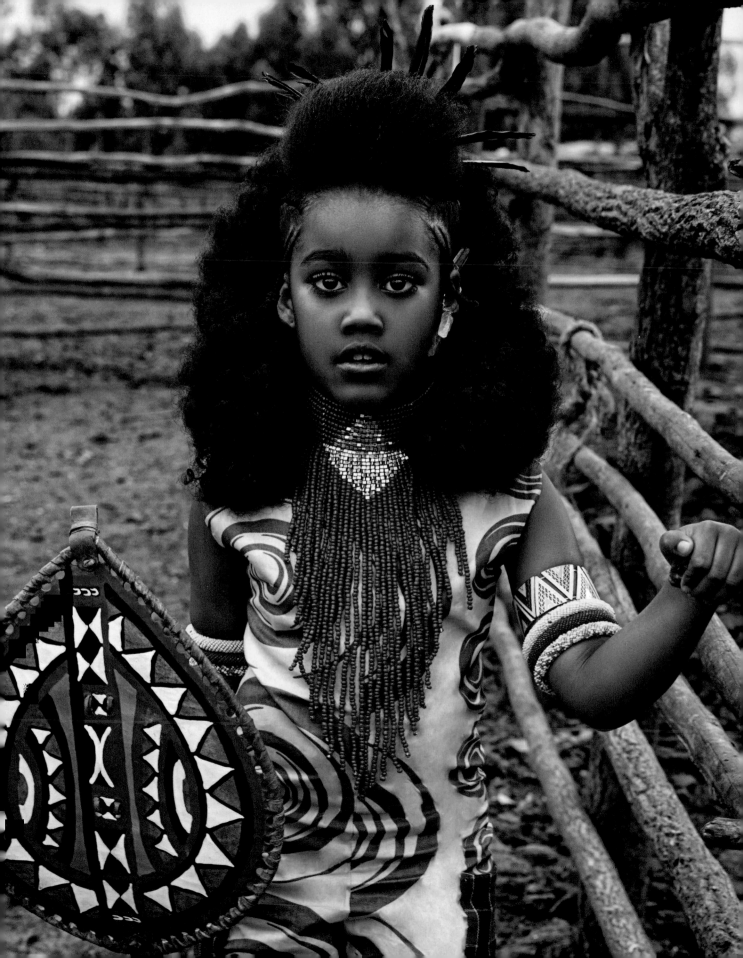

HAZEL

KENYA

A Diverse Beauty

Hazel Hussein was born in Nairobi, Kenya, a country of diverse cultures. Her father is from the coastal region and her mother from the central region of Kenya. Because of this she is exposed to many customs and is an open-minded and inquisitive girl.

Hazel gives her all to everything she does, from school work to extracurricular activities. She loves to sing and perform. The stage is her home and definitely her first love. At six years old she got the lead role in her school play and was recognized for a great performance for both her singing and acting. In December 2018, she was part of a Christmas concert that aired on television. This eight-year-old loves glamour and all things pink and girly and dreams to one day make it on an even bigger stage.

Hazel is most proud of being herself and being a part of a country that is unique. Her message to other young people is "When you do something new, be confident and brave and work toward achieving your dream."

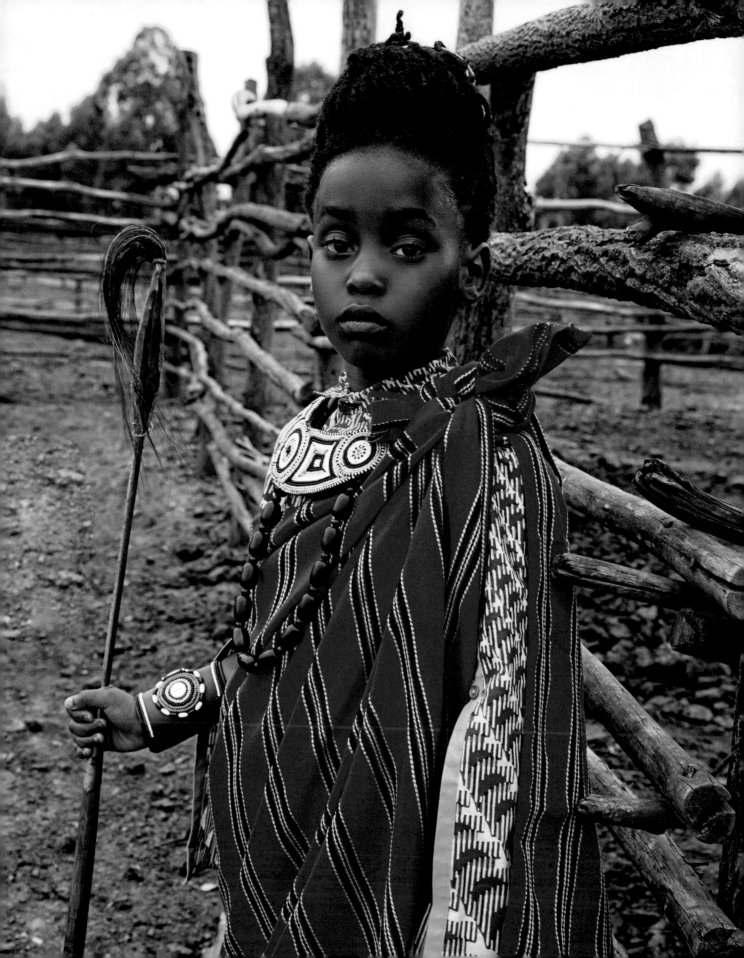

DARRYL

Little Mr. Kenya

Nine-year-old Darryl Mwangi has an infectious smile and a charming personality. An only child, he loves reading books, playing video games, swimming, and traveling. One of his dreams is to fly in a plane. He hopes to be a pilot one day and works toward this dream by putting in extra work at school.

In Kenya, having dreadlocks is frowned upon. Finding a school in Nairobi that allows students with dreadlocks is very difficult. Darryl's parents have always taught him to be proud of who he is because they knew the kind of environment he would grow up in as a young boy with locks. Sometimes people stare or say negative things to Darryl, but he doesn't let it bother him, although he wishes that one day, people with dreadlocks would not be discriminated against.

Darryl has already achieved so much in his young life. He was even crowned Little Mr. Kenya. His parents did not wait for him to become an adult to follow his dreams instead they allowed him to live his dreams while growing up. He in turn, has shown his appreciation by being the best that he can be.

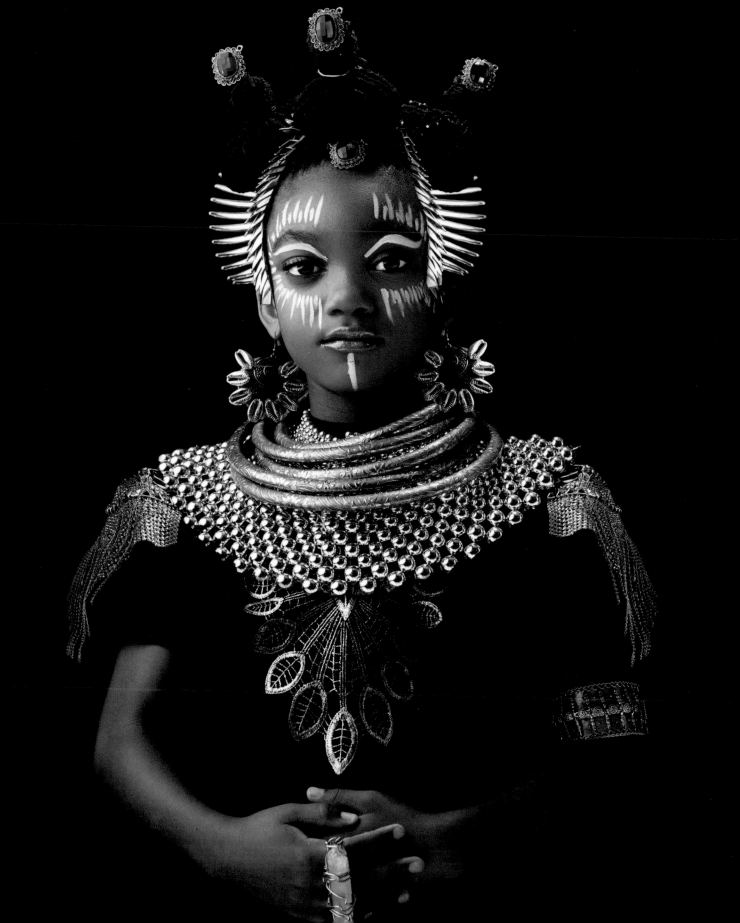

EVERY DAY MEN AND WOMEN BECOME LEGENDS.

—Common

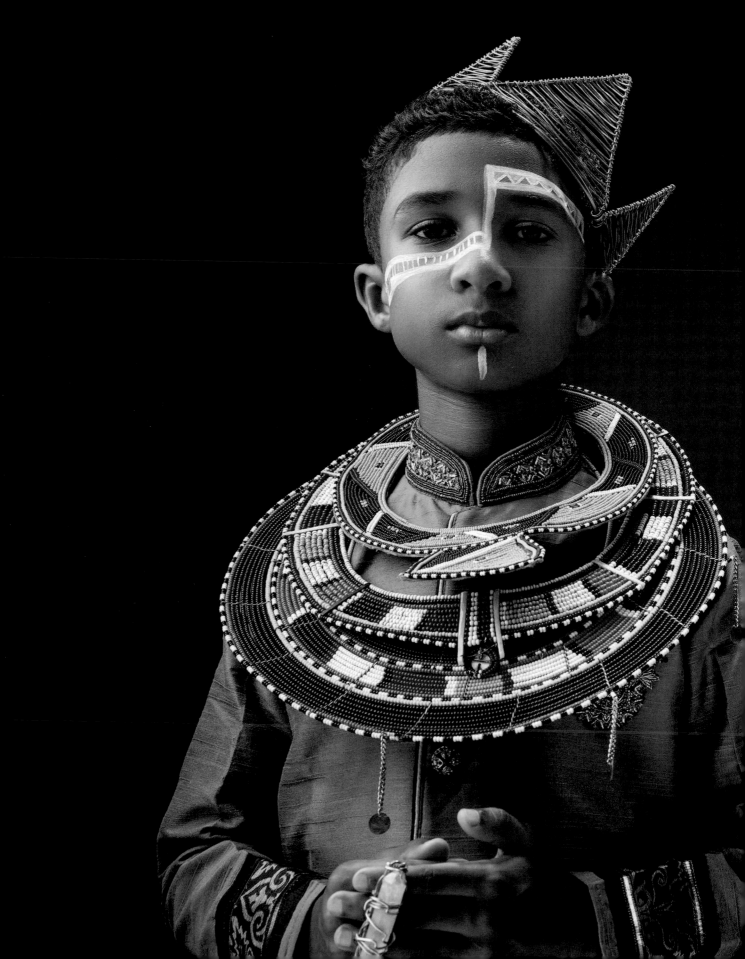

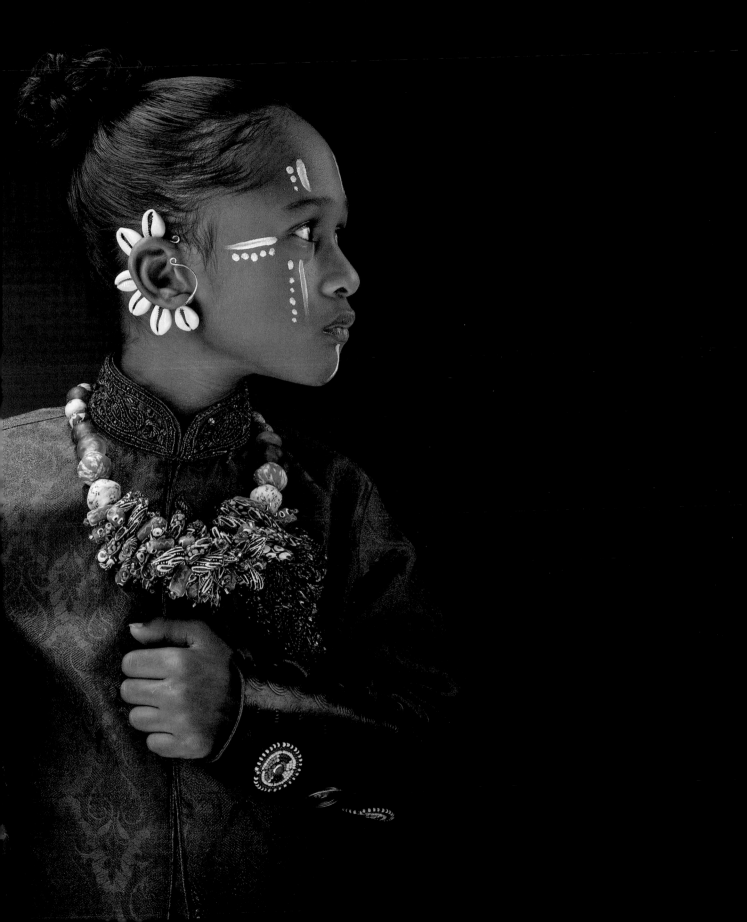

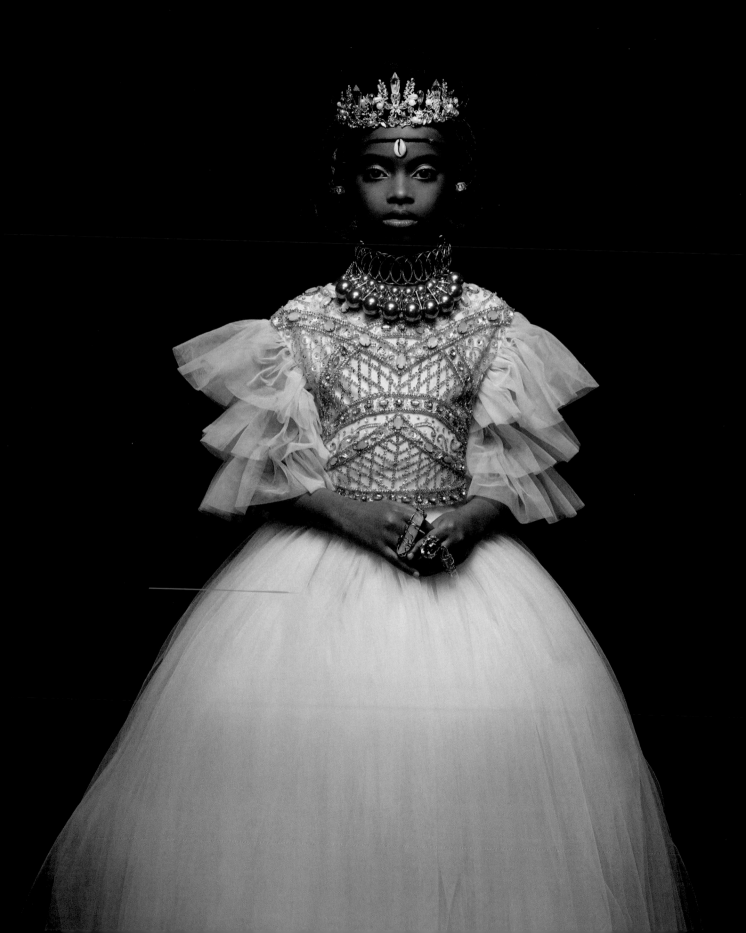

A QUEEN IS NOT AFRAID OF FAILURE. FAILURE IS ANOTHER STEPPING-STONE TO GREATNESS.

—*Oprah Winfrey*

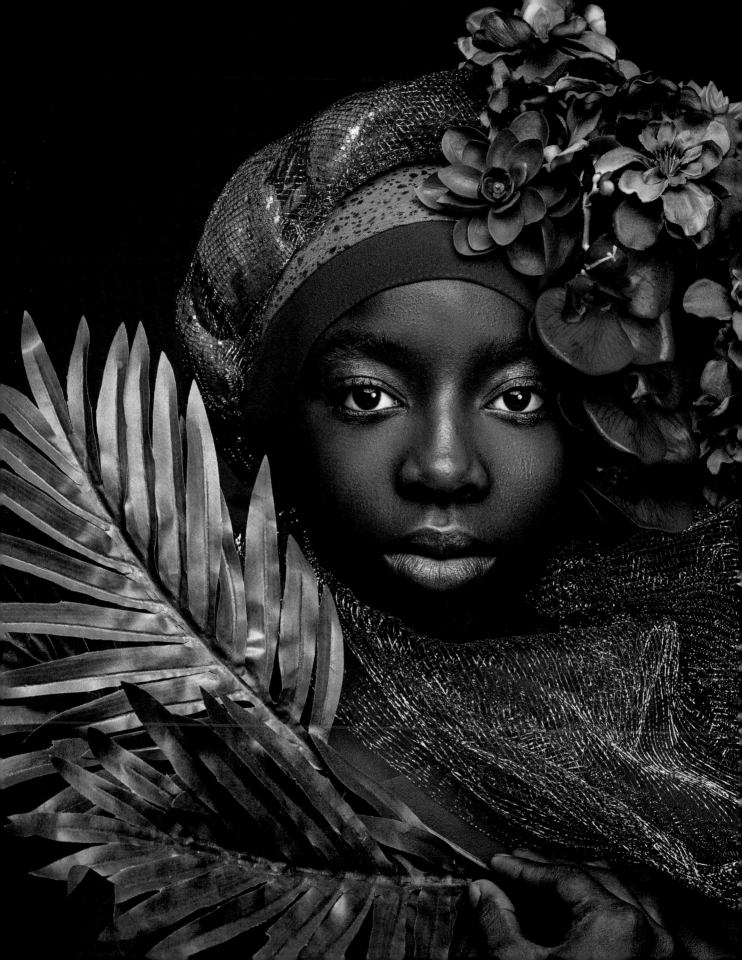

I NEVER LOSE. I EITHER WIN OR LEARN.

—Nelson Mandela

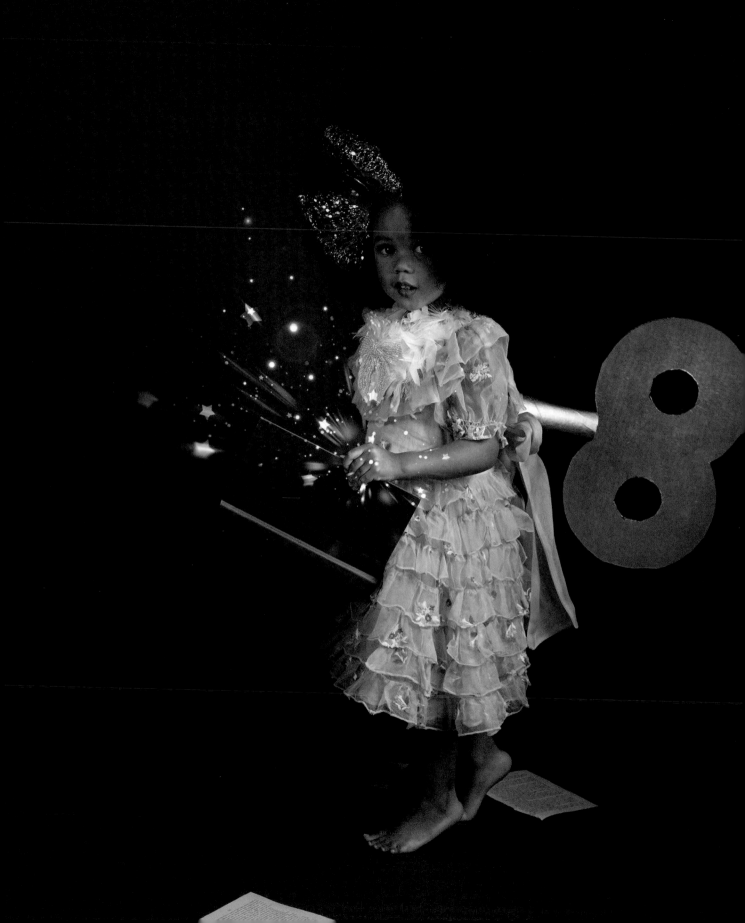

NAILAH

The Reading Toddler

Three-year-old Nailah Stallworth was just a little over a year old when she started reading. She was not able to speak in full sentences. Instead she would use the words that she knew and sounds or motions to tell her family what she was reading on the cards. A few weeks later she was sight-reading words in Spanish. By the age of fifteen months Nailah could read close to 100 words and knew numbers up to twenty. Nailah's family wanted to share her gifts. They posted a video on social media and before they knew it more than one million people had viewed and fallen in love with Nailah and her charm, intellect, and unexpectedly, her thick head of natural hair.

People from all over the world have now shared their delight with Nailah, especially the fact that her family raised Nai to love every part of herself, including her hair. They use her social media platform to share her growth and the bond she has with her family, especially her big brother, Illyjah. They make sure that Nai shares messages of heightened self-love and acceptance. They recognize the importance of sharing positive images with others because they are "contagious" and create what they call the "Happy Effect."

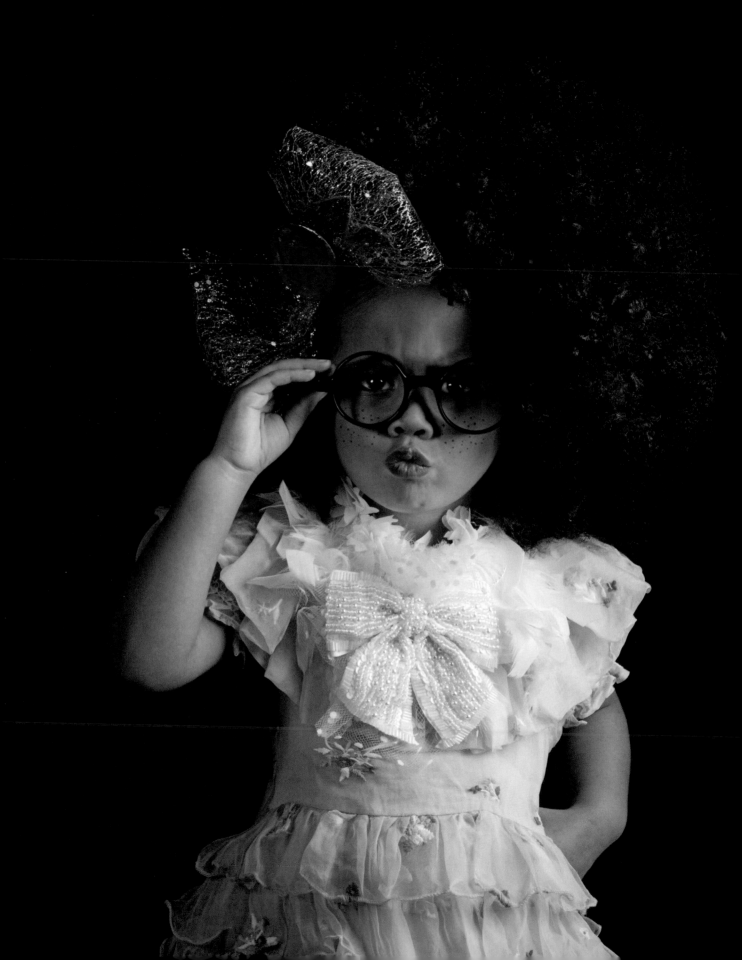

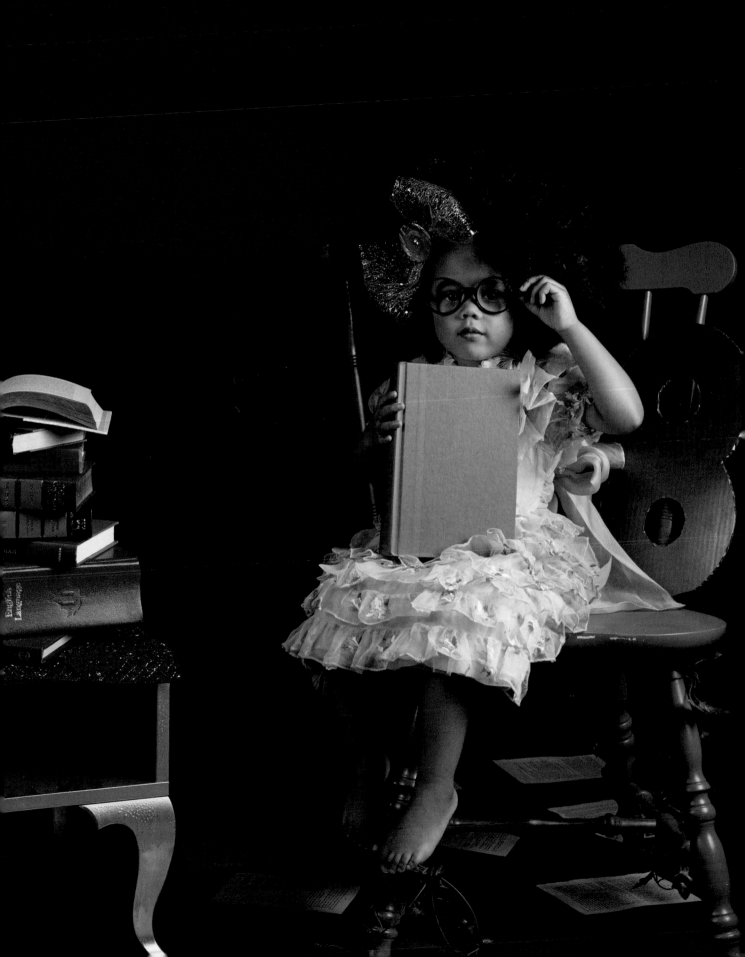

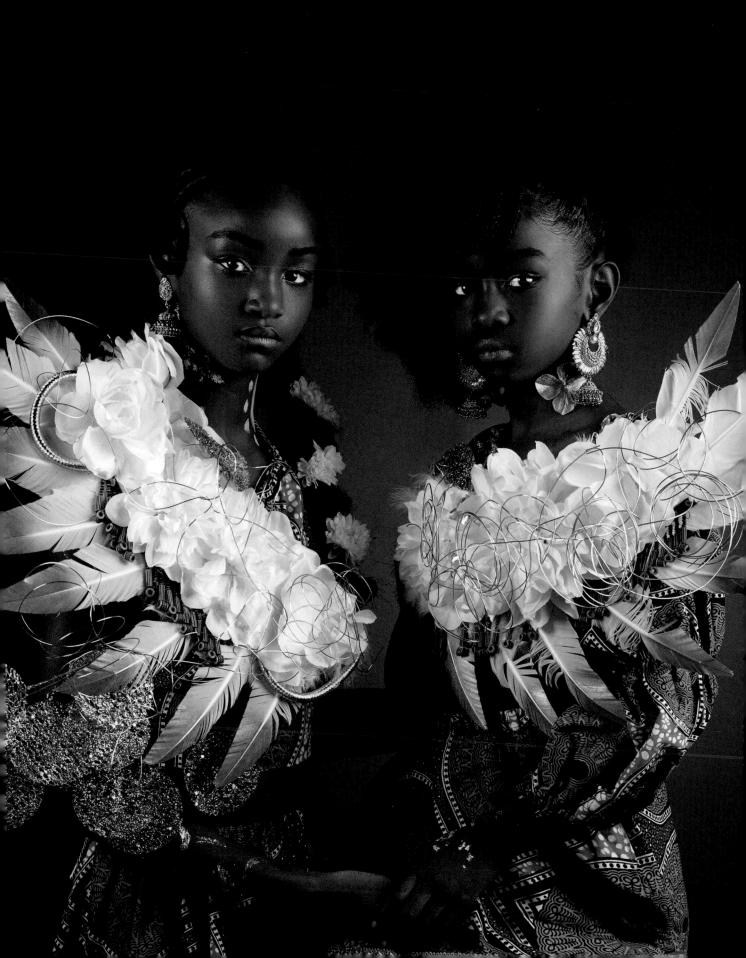

IF YOU WANT TO GO FAST, GO ALONE. IF YOU WANT TO GO FAR, GO TOGETHER.

—African Proverb

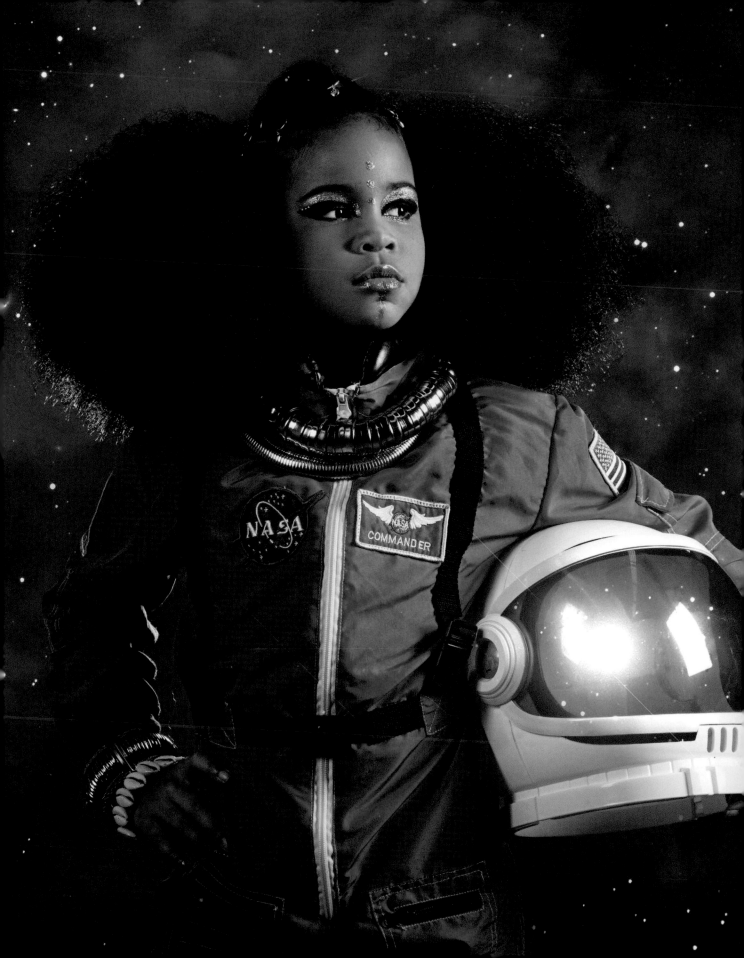

HAVANA

Reach for the Stars

Havana Chapman's parents are US diplomats. At eight years old she has lived in six different countries. She loves to travel to new places and meet amazing people from all over the world.

"I love learning about the planets and I want to see them all in person. When I read about Dr. Mae Jamison, I learned she was the first African-American astronaut, but she also loves to dance and speaks a lot of languages just like me. I thought being an artist/astronaut would be a perfect job for me."

Havana has attended Space Camp USA and visited NASA Jet Propulsion Laboratory (JPL). She also wears her astronaut suit to events and speaking engagements to show her friends—and the world—that little black girls have big dreams and they deserve the same chance to achieve their goals as everyone else.

Havana has fundraised more than $25,000 to donate black girl magic books to girls around the world. "I know that a girl with a book is a girl who is unstoppable. I read a study that said black kids have thirty-seven less books than white kids at home, so I wanted to give the extra thirty-seven books to each of the kids in my choir. I wanted them to see kids who look like them and know that they can grow up to conquer their big giant dreams too. Just like my hair, my dreams defy gravity."

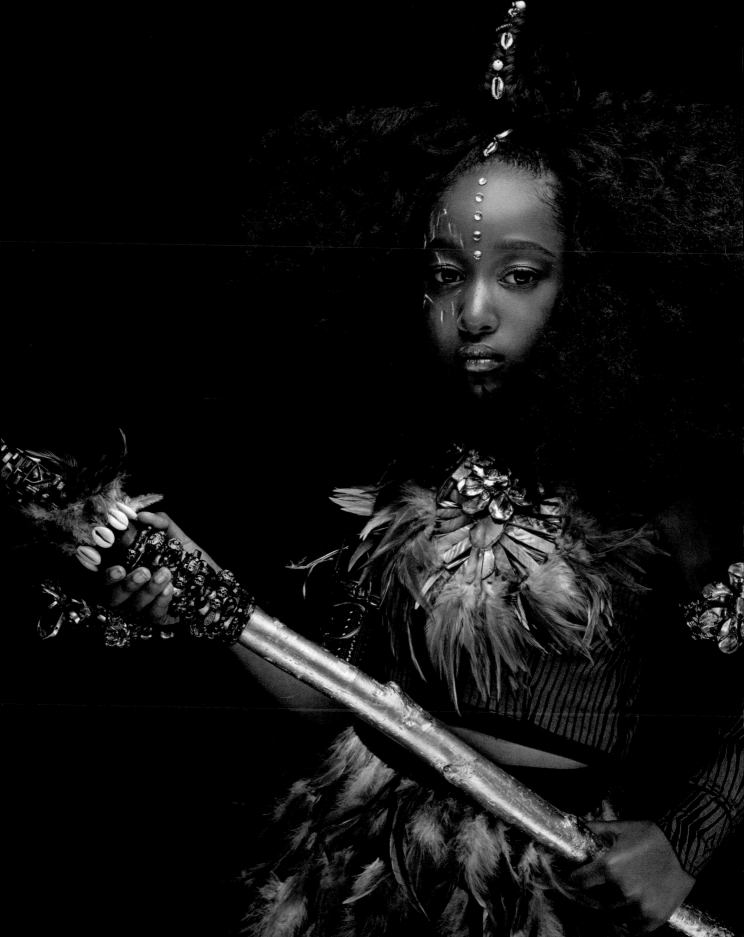

FREEDOM IS NEVER GIVEN, IT IS WON.

—*A. Philip Randolph*

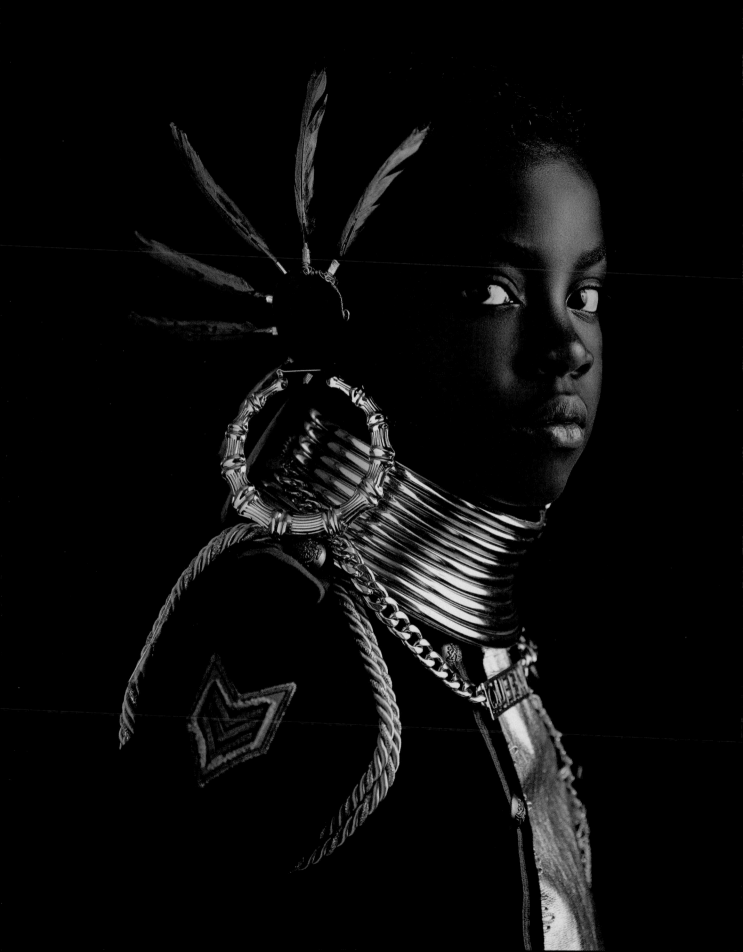

ERICA (DJ SWITCH)

GHANA

The Mix Master

Ten-year-old Erica Armah Bra-Bulu Tandoh, also known as DJ Switch, has been spinning since age nine, and is the subject of a video released on BBC News Africa, which went viral. Even before the BBC video, she's had her share of fame. In June 2018, Erica became the youngest person to win Ghana's annual DJ award. In September 2018, she opened the Bill and Melinda Gates Foundation's annual Goalkeepers event in New York as the warm-up act to French President Emmanuel Macron.

In addition to her DJ chops, she raps, dances, and plays trumpet and keyboards. She also loves school; when she grows up she would like to be a gynecologist and help reduce the infant mortality rate. "I want to be a doctor DJ because I want to make delivery easier by playing music that comforts a woman in pain. I've also started the DJ Switch Foundation aimed at quality education, good health and well-being, and gender equality in my country."

Erica is accomplished and a visionary beyond her years, and her message to other young people, especially girls, is, "Don't allow yourself to be intimidated because you are a girl. Keep pushing until you are there. No matter your age, encourage yourself because you're never too young or old to achieve your dreams."

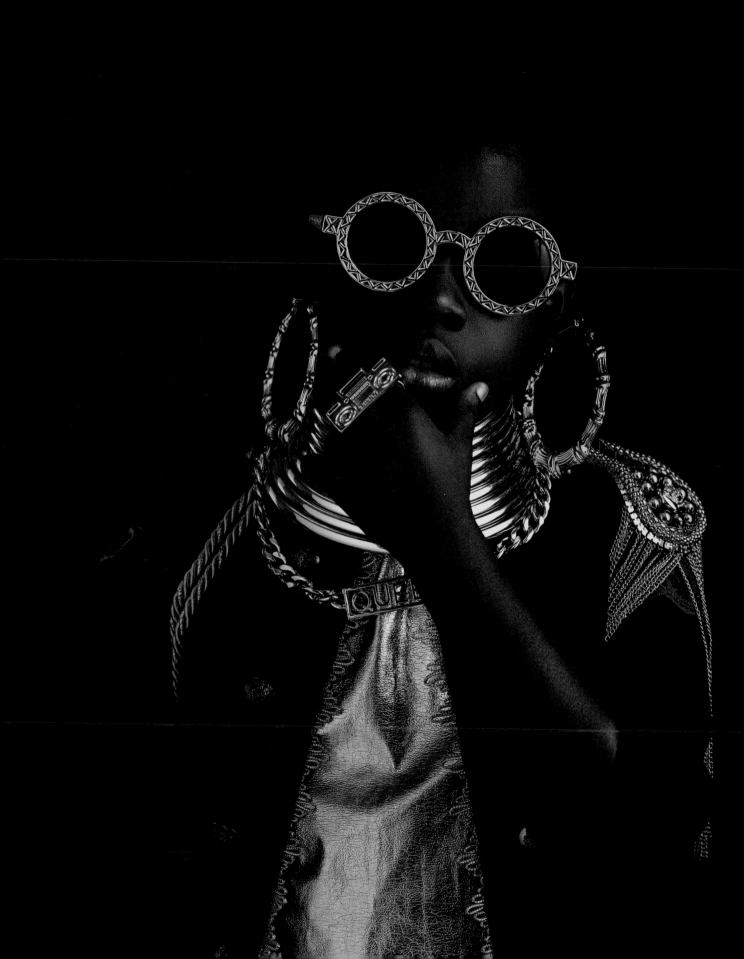

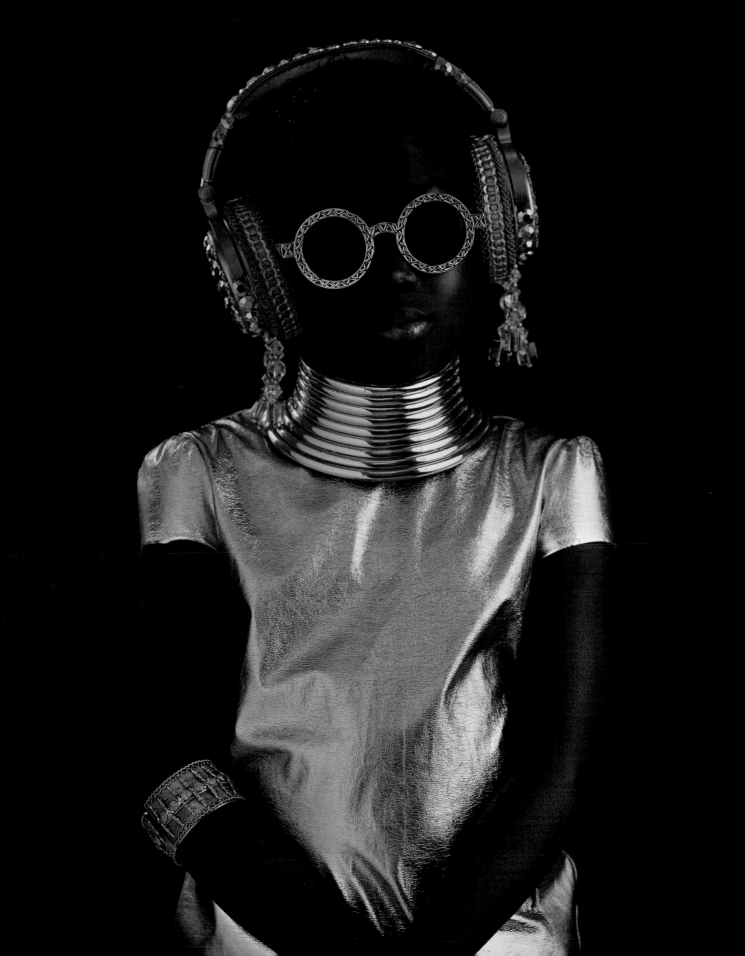

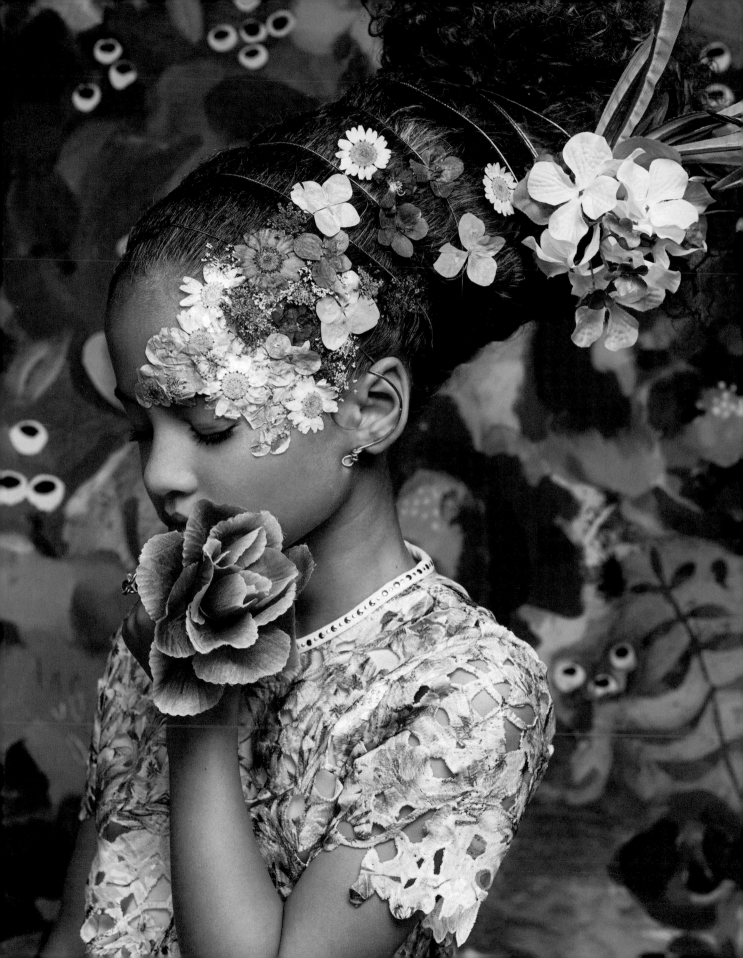

WHAT YOU GIVE YOU GET, TEN TIMES OVER.

—*Yoruba proverb*

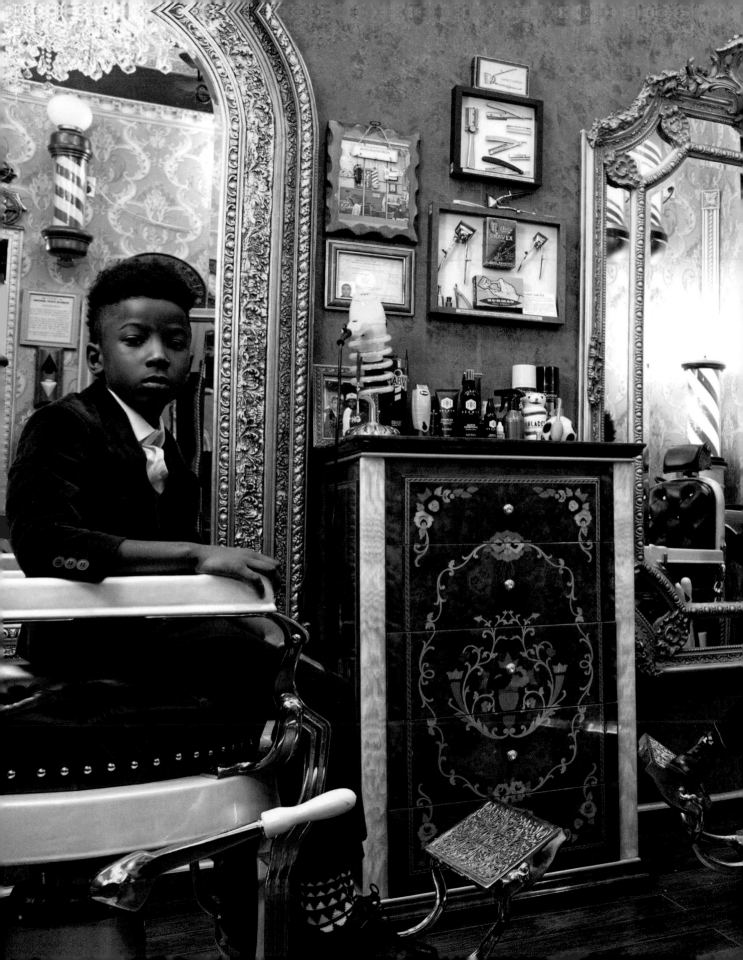

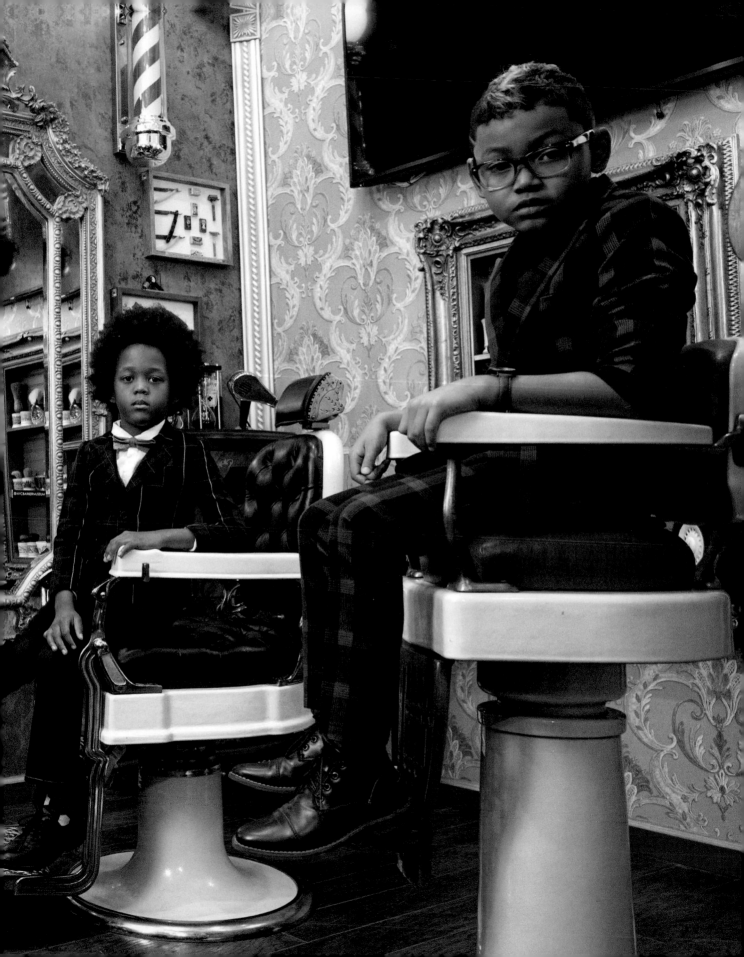

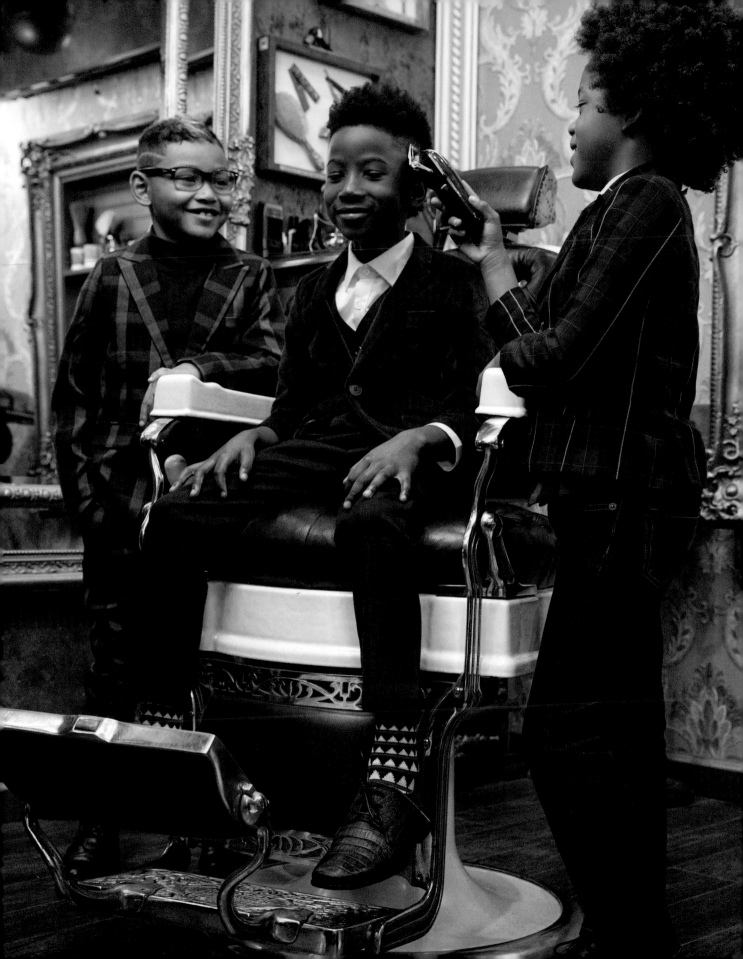

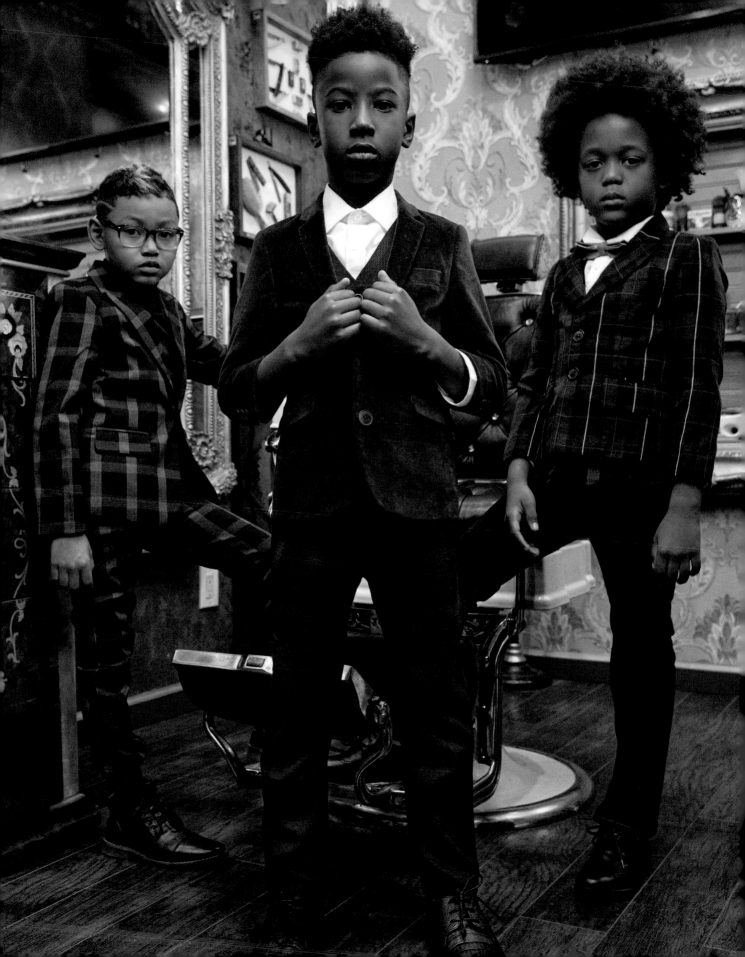

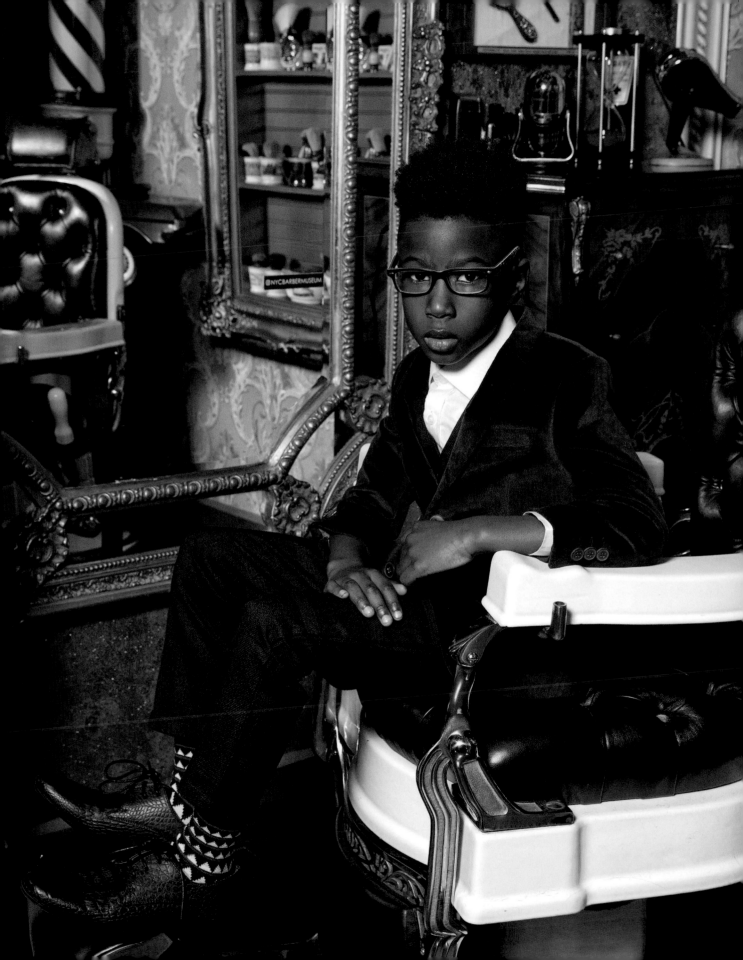

KYBREN

A League of His Own

Born to a Senegalese father and an African-American mother, seven-year-old Kybren Kabir Niane, known as "Prince Kybren," loves getting dressed up and singing in the choir at Calvary Revival Church in Virginia. From a very young age, Kybren used his hair as a form of creative expression. Innovative and artistic, he is known for his artfully colored hair and cool mohawk cuts. This creative young man is already in a league of his own and looks forward to seeing what the future will bring.

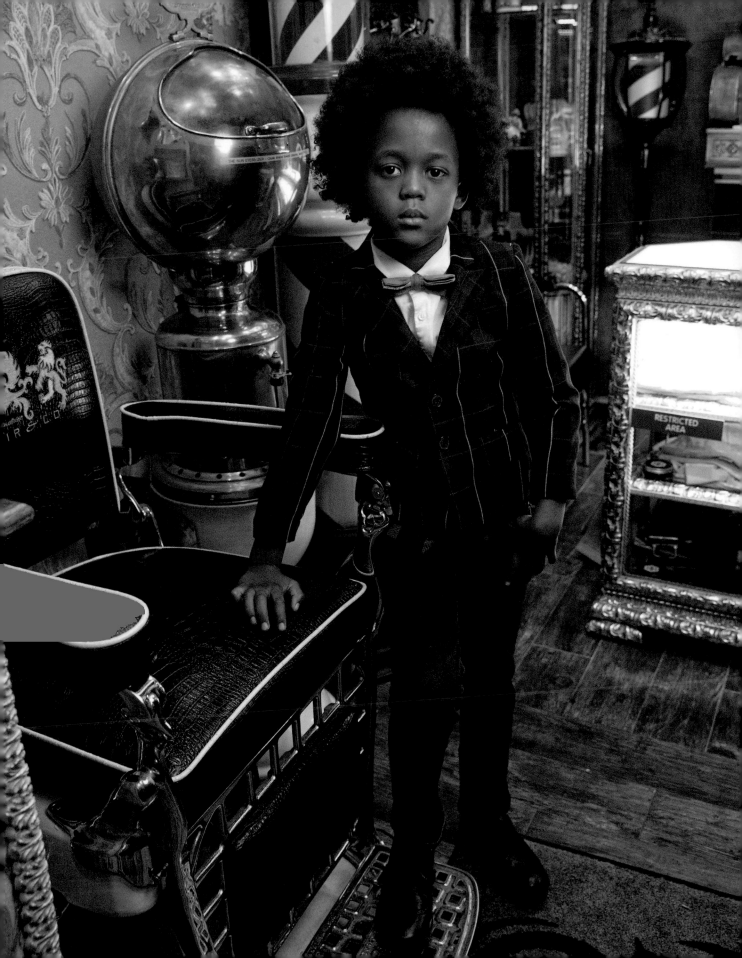

LIAM

The Cool Kid

Seven-year-old Brooklyn native Liam Evan Pyram is anything but typical. Always composed and stylish, he is considered a "cool kid" in school. His friendly and helpful nature also makes him a natural leader.

After participating in a modeling showcase at the age of four, Liam signed with an agency. Some of his most notable accomplishments include modeling for major campaigns such as Ralph Lauren, Brooks Brothers, Target, J. Crew and more. In addition to modeling, Liam enjoys being creative, reading, outdoor activities like skating, bicycle riding, swimming, and other sports. Liam aspires to one day become an architect and own a construction business. A trailblazing young man, Liam doesn't let anything or anyone define him.

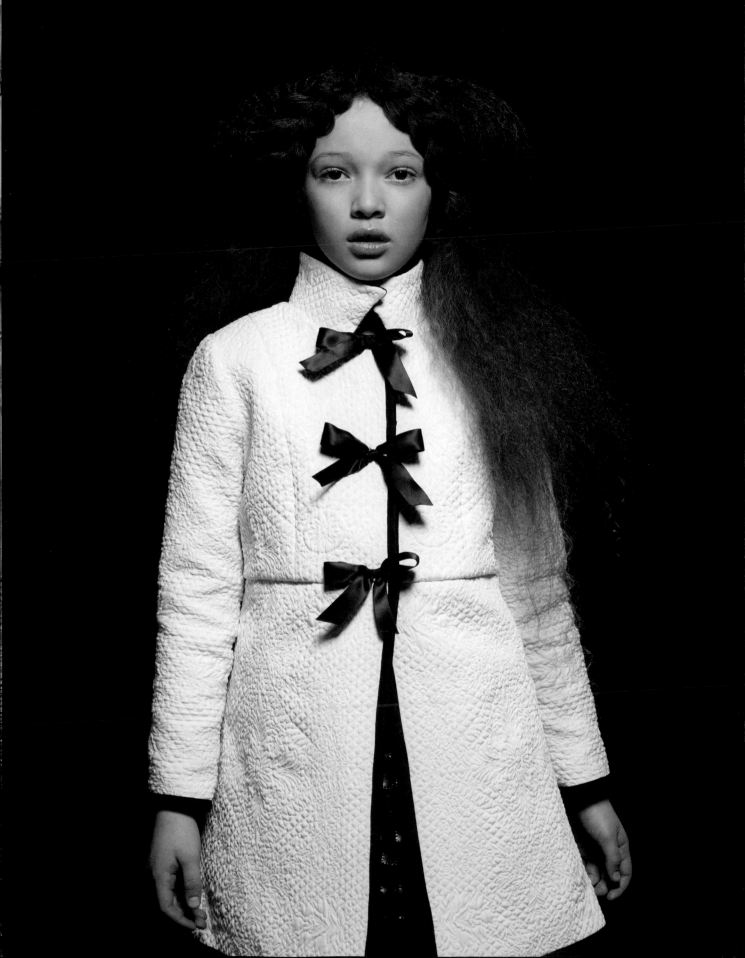

WISDOM DOES NOT COME OVERNIGHT.

—Somali proverb

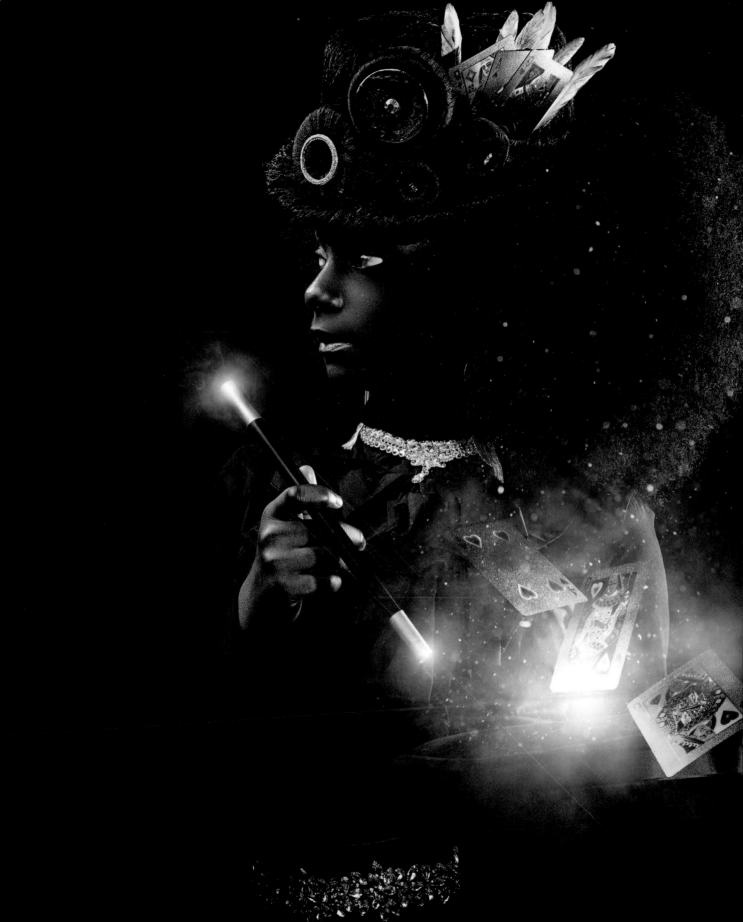

KHERIS

CALIFIORNIA

Flexin' in My Complexion

Kheris Rogers is widely known for founding the Flexin' In My Complexion clothing line to combat racism and colorism. She was inspired after being bullied in school for her "dark complexion." The thirteen-year-old CEO is now an ardent spokesperson against colorism, and has partnered with Nike and Lebron James to help promote change.

When she struggled to feel confident in her skin, instead of letting adversity defeat her, it spurred her on to amazing things. "I would tell other young people who are dealing with low self-esteem that it doesn't matter what other people think of you; only what you think of yourself. You are smart, creative, special, and perfect just the way you are."

Kheris now fully embraces her glorious ebony shades from the coils of her jet black hair to the glowing sable of her skin.

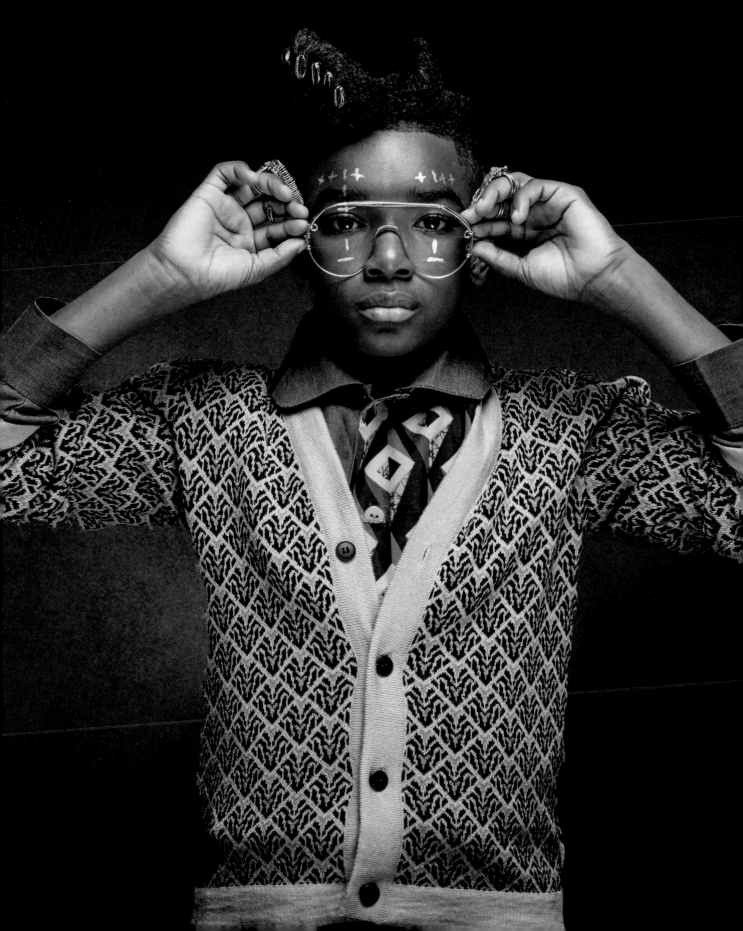

IF MY MIND CAN CONCEIVE IT AND MY HEART CAN BELIEVE IT — THEN I CAN ACHIEVE IT.

—Muhammad Ali

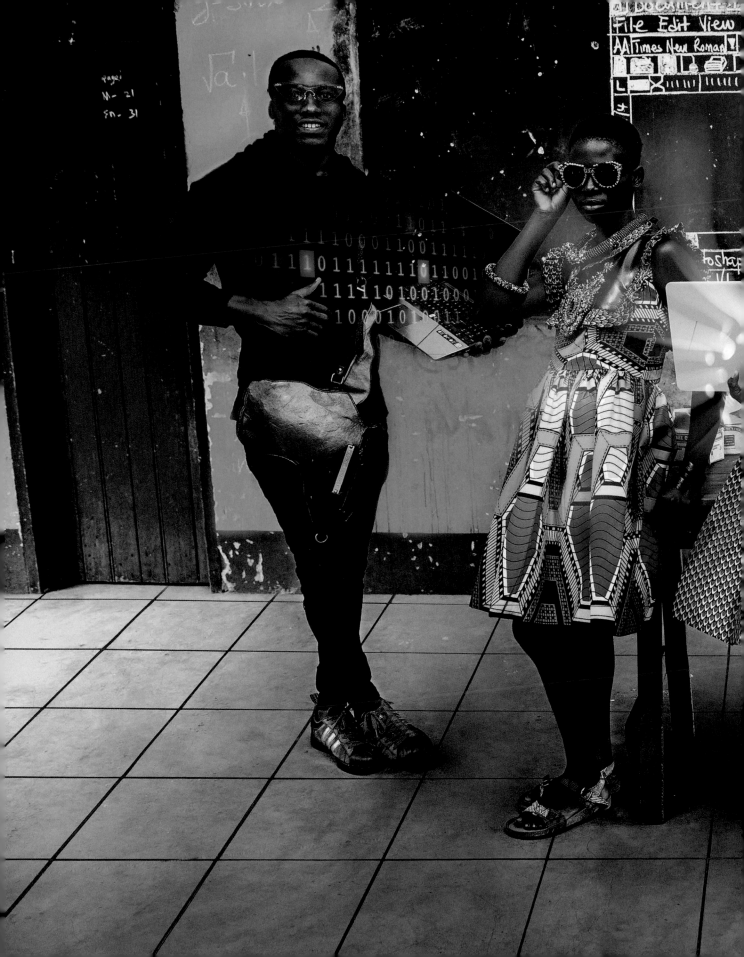

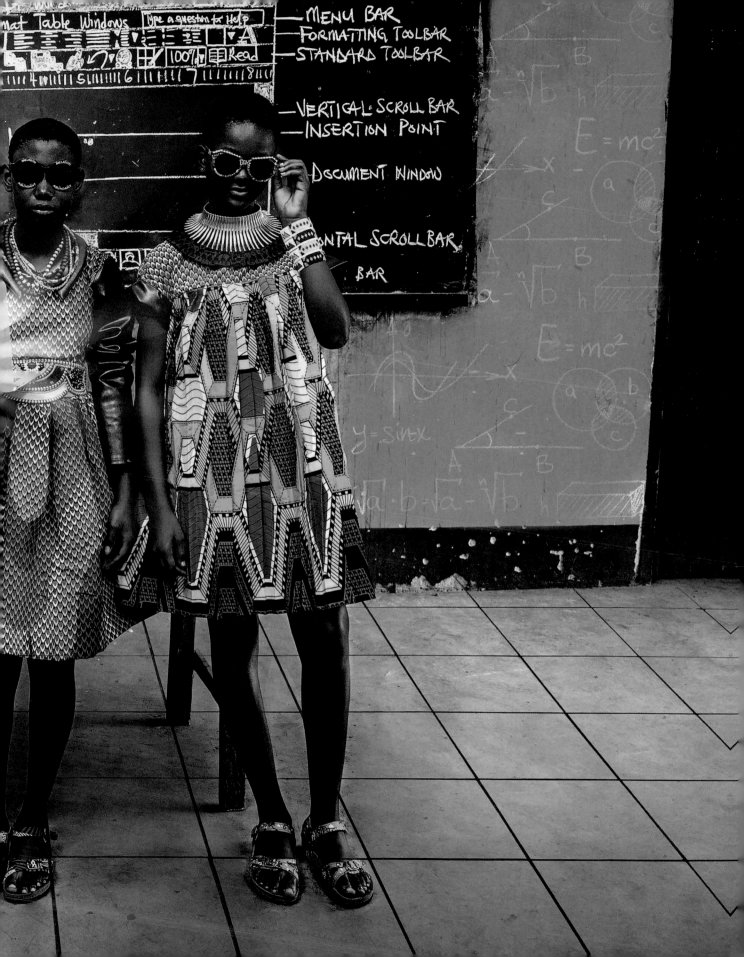

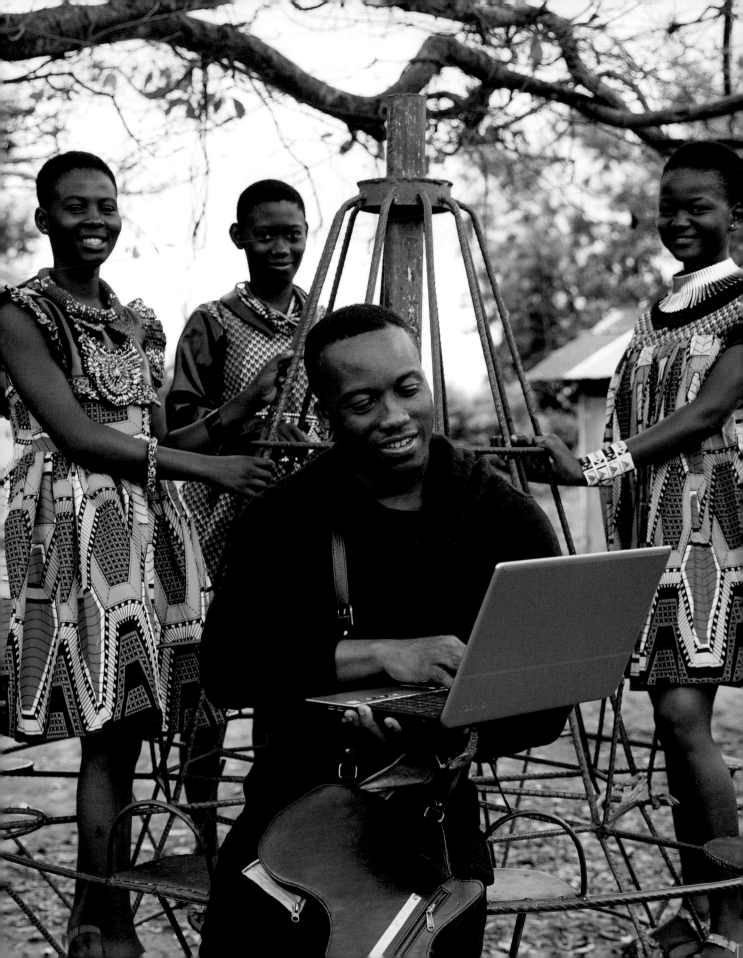

BETANESE M/A
JUNIOR HIGH

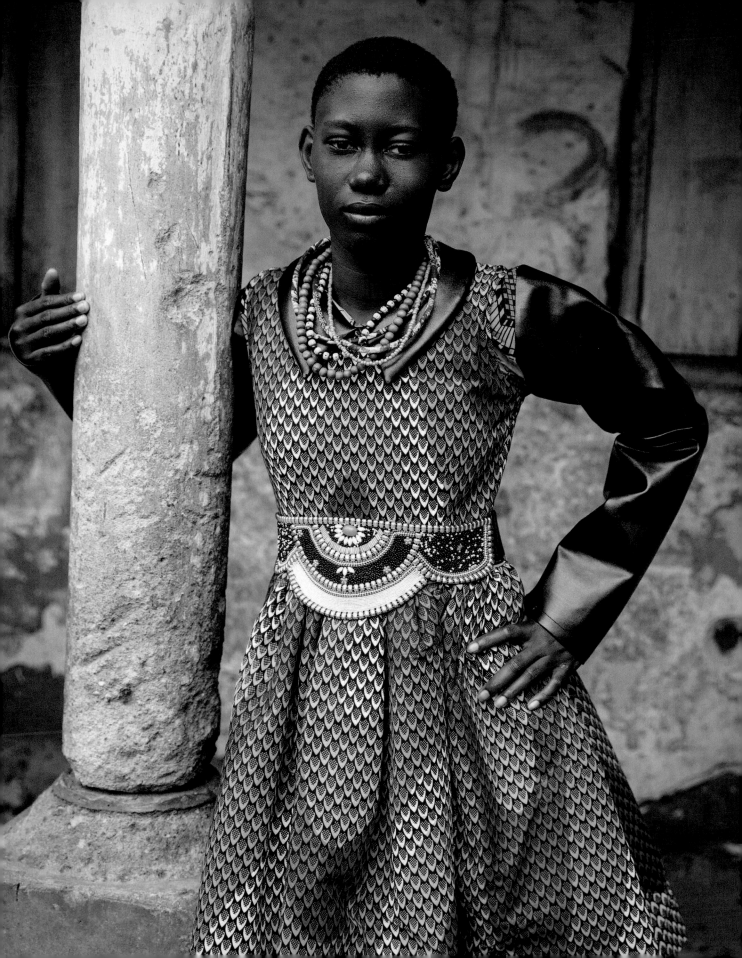

NAOMI

GHANA

Staying focused

At sixteen, Naomi Asaamah, a native of Sekyedumase, in the Ashanti Region, is in her final year at Betenase M/A Junior High School. She is the second born in her family and works on the farm with her parents during the weekends. A self-starter who strives to be positive and upbeat, she hopes to be a nurse so she can better serve her community.

Blessed with an indomitable spirit, Naomi is a fierce athlete who plays for the school's women football (soccer) team. She knows it is important to stay focused on her goals. The rate of teenage pregnancy in her village is very high, so she would advise other young girls to focus on their education. Naomi is proud to be a part of her family, and proud that she is able to help support them.

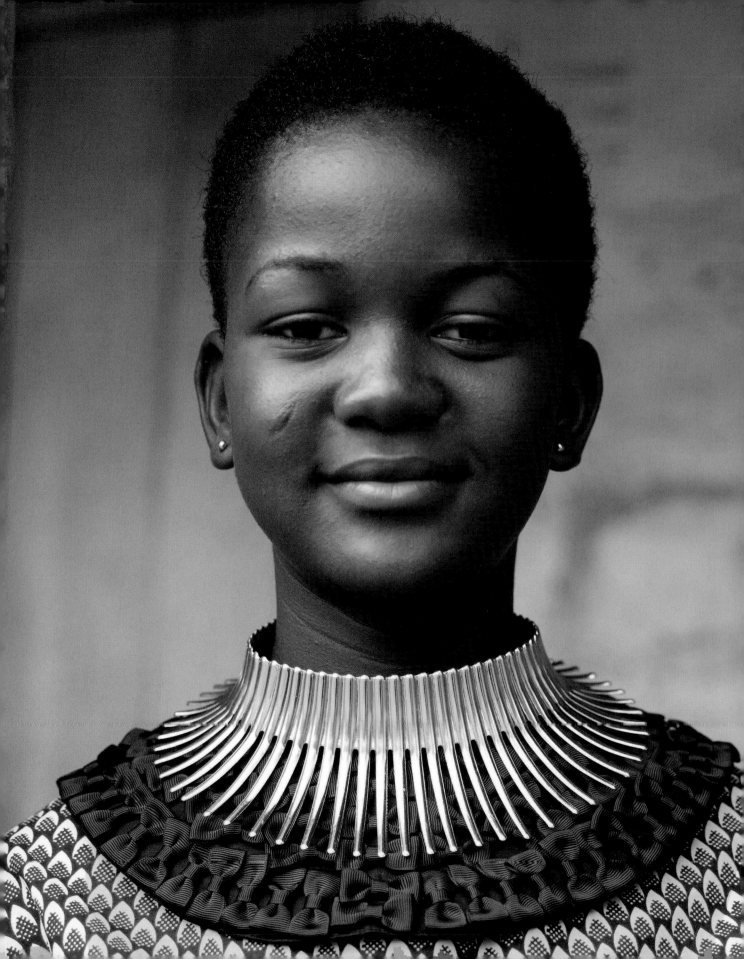

POKUAA

GHANA

Hope for the Future

Pokuaa Nchor is sixteen years old and also attends Betenase M/A
JHS. An excellent student, she often represents Betenase JHS during
inter-school quizzes. As much as she loves school, Pokuaa isn't
always able to go every day. Like many other children in her
community, she works to help support her family. Blessed with a
sweet smile and comforting presence, Pokuua wants to be a nurse so
she can take care of future generations.

Her family is from the northern part of the country and she is the
last born of five girls. She enjoys spending time with her sisters and
listening to their advice. She loves the freedom and peace in Ghana
and her hope is to see the country develop so it can take care of its
people.

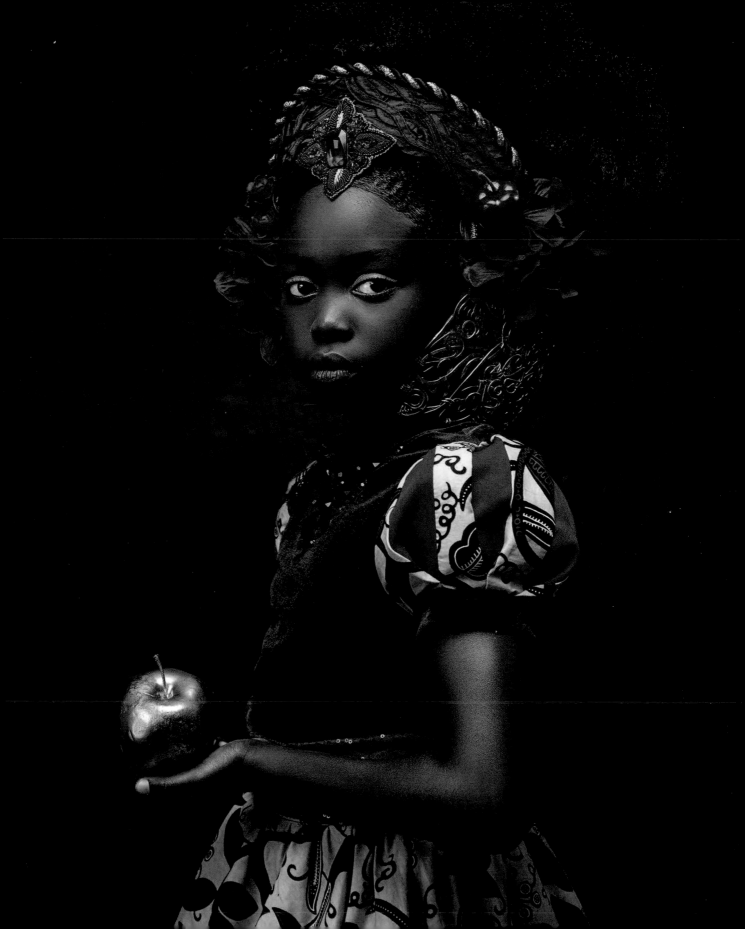

YOU GET IN LIFE WHAT YOU HAVE THE COURAGE TO ASK FOR.

—*Oprah Winfrey*

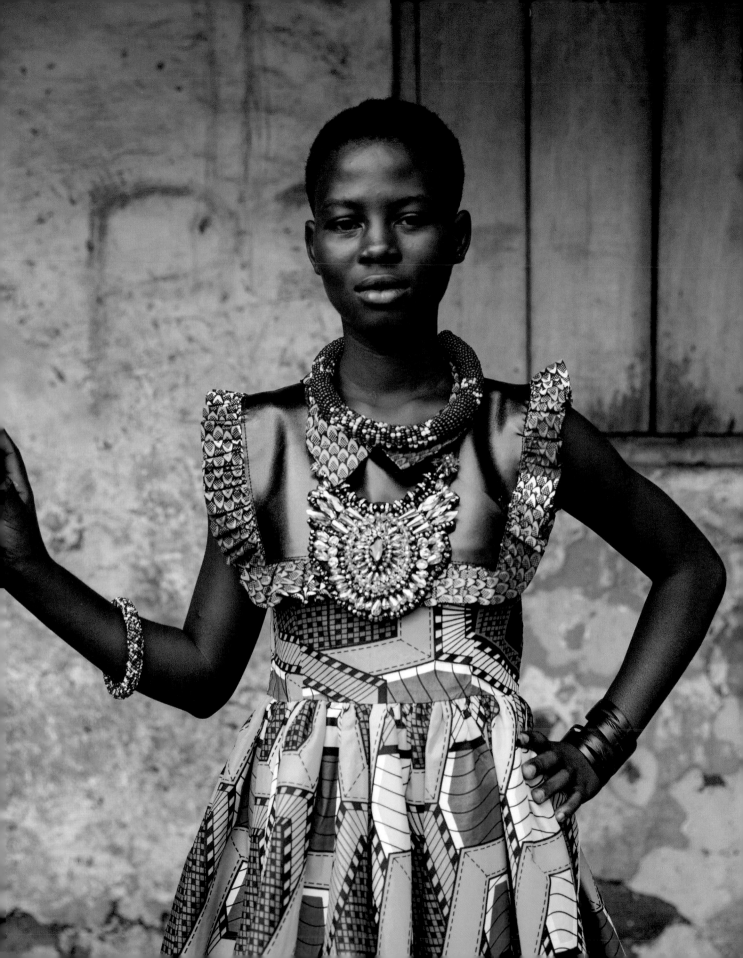

SARAH

Proud and Resilient

Sarah Amaoko is fifteen years old and in her final year at Betenase M/A JHS. She is an Akan and the last born in her family, who hails from the Sekyedumase community. Like her friends Pokuaa and Naomi, she also helps her family farm to harvest food to sell to meet their needs. Sarah wants to be a teacher to help impart knowledge in her community.

A gifted athlete, she also plays for the school's women's football (soccer) team. Proud and resilient, Sarah loves her family for their strong bond, and her country for its peace and tranquility.

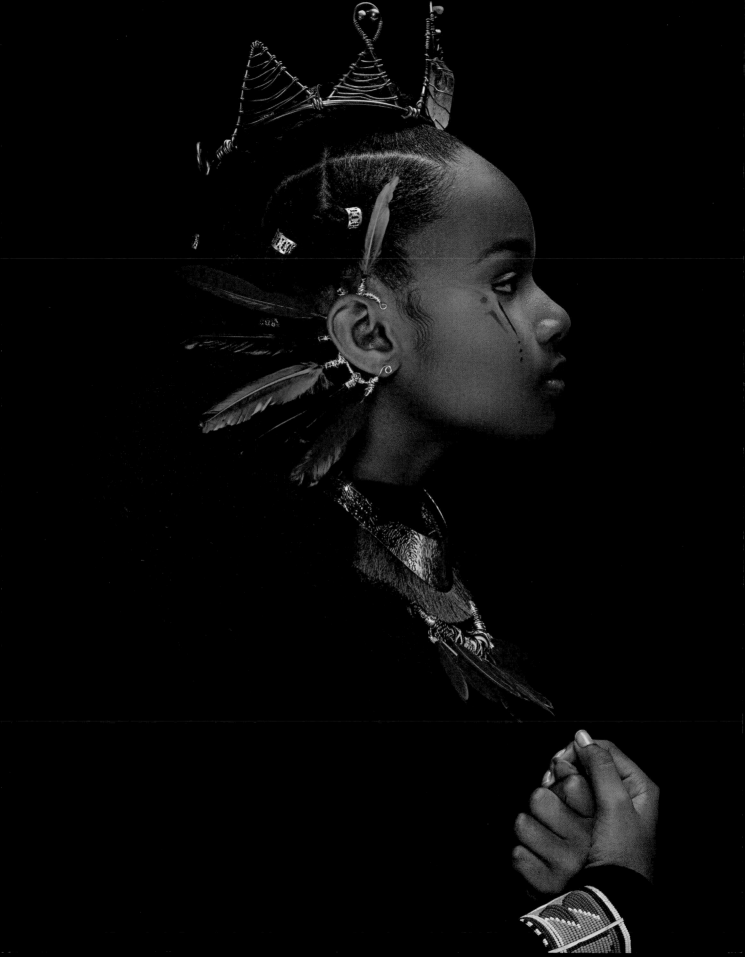

EVERY GREAT DREAM BEGINS WITH A DREAMER.

—Harriet Tubman

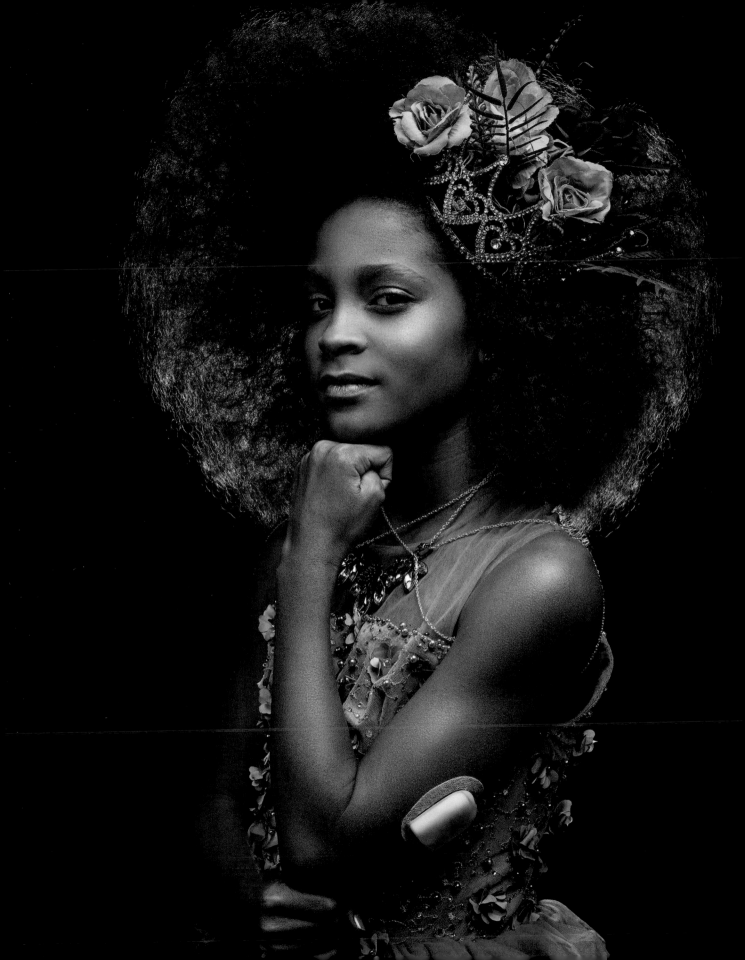

LAYLA

The Fighter

At the age of eight, Layla Lerus was diagnosed with type 1 diabetes, an autoimmune disease where the insulin making cells in her pancreas attack themselves. Layla can eat whatever she wants, but everything that she does eat has to be covered by insulin. Until there is a cure, she will be insulin dependent. Now thirteen, she wears an insulin pump (that you see on her arm) and this allows her to get the insulin she needs minus the needles after every meal.

Layla is a fighter. She never lets her illness get in the way of living her life to the fullest. Despite these challenges Layla has a great sense of humor and loves making people laugh. She hopes to become an Olympian in track and field. She is a sprinter and comes from an athletic family. "We are all very close. I love my sense of humor and making people laugh." She also loves that she comes from a bilingual family that speaks French and English.

Layla hopes to show other young children with type 1 diabetes that there is no need to be ashamed. "Never be afraid to be yourself, even if you have a little something that makes you different from everyone else. That is what will make you stand out."

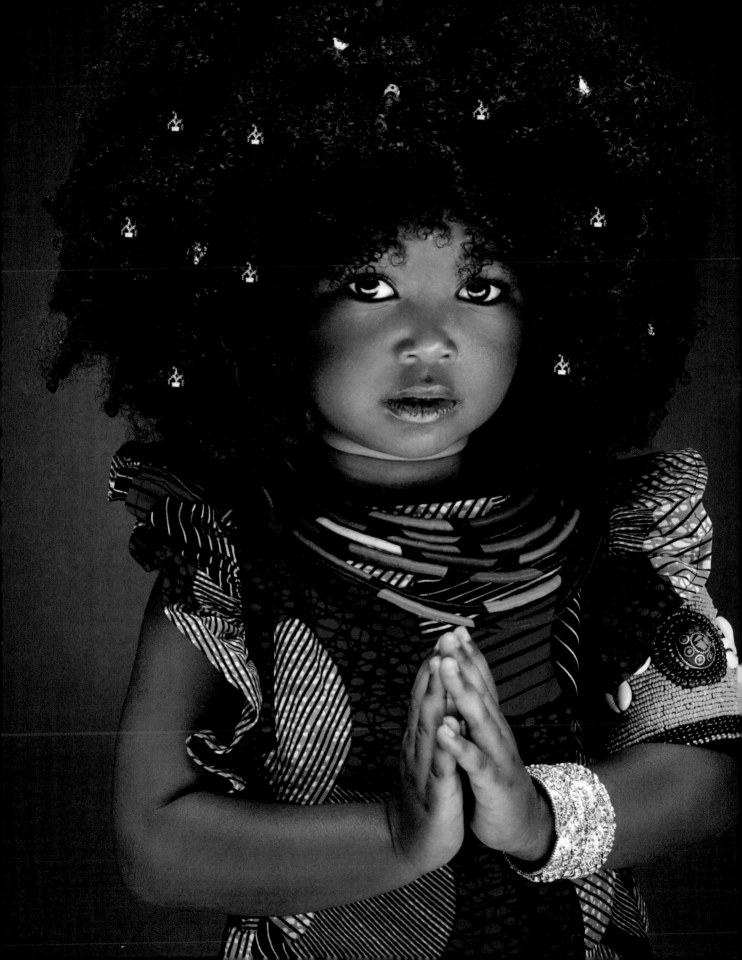

IF YOU ARE FILLED WITH PRIDE, THEN YOU WILL HAVE NO ROOM FOR WISDOM.

—African proverb

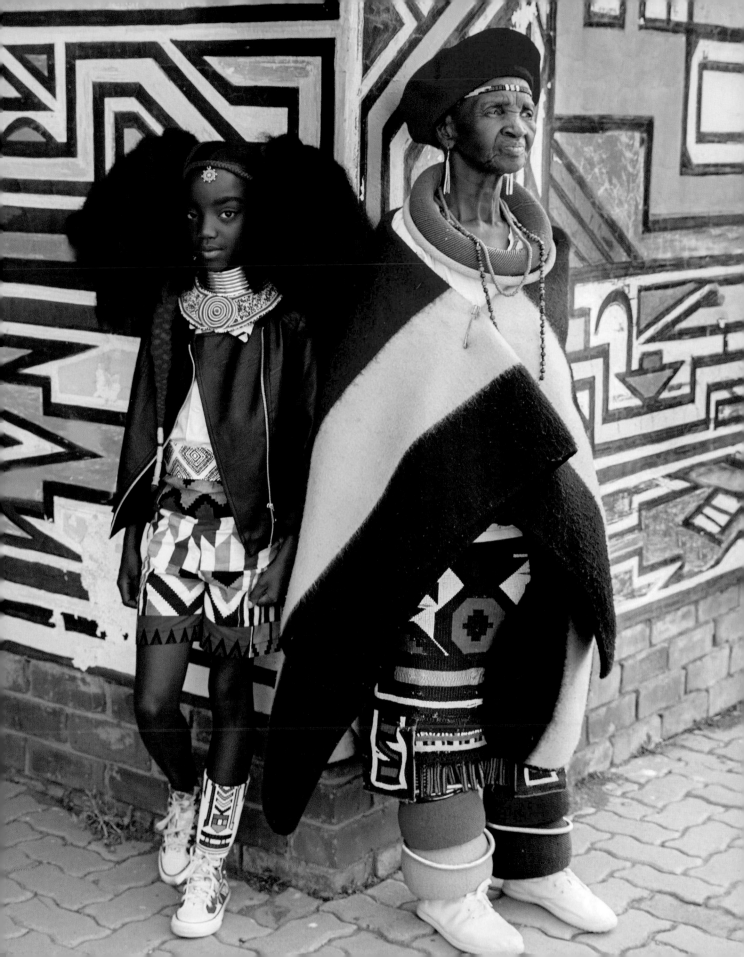

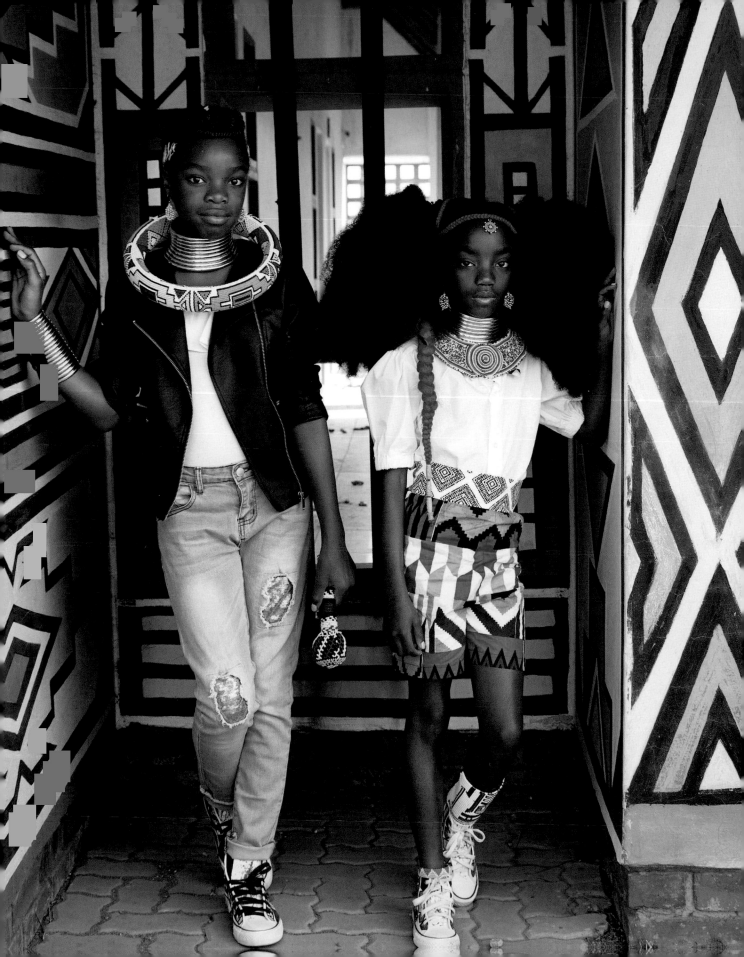

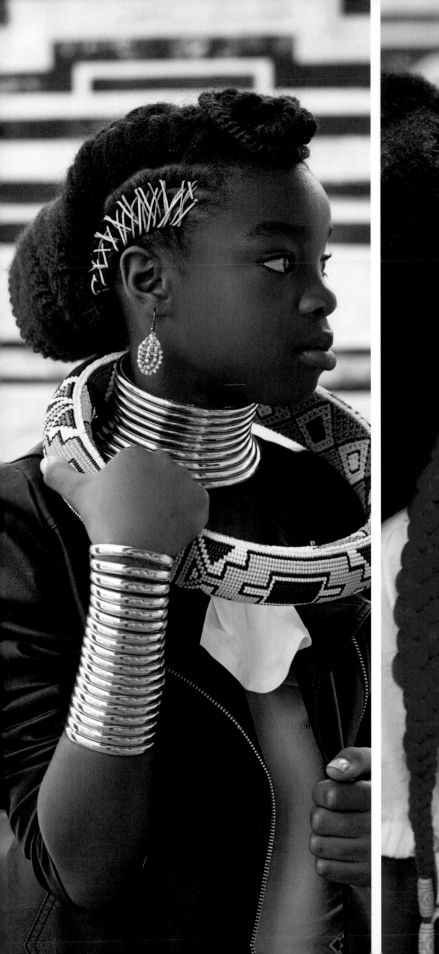
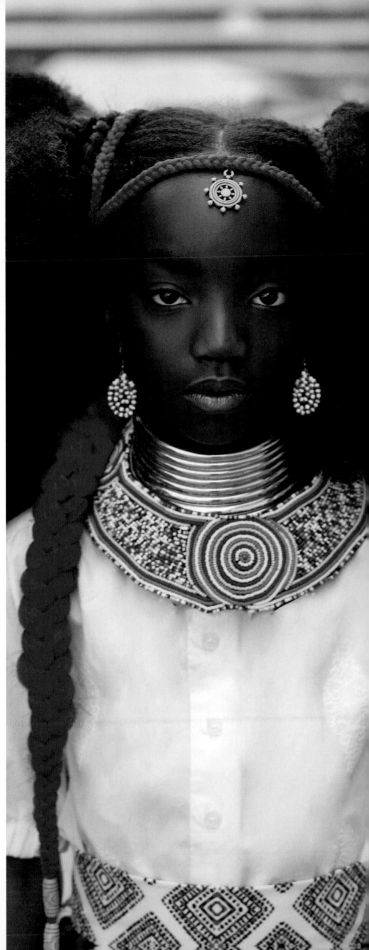

ACEHI &
AMPOMAAH
SOUTH AFRICA
Uniquely Inspiring

Cousins and best friends Acehi Jaswa, twelve, and Ampomaah Frimpong, ten, have created an online community where they share their thoughts on books, fashion, natural hair care, and travel. They inspire girls around the world by just being themselves and through the special bond they share with each other. Although they live in South Africa, they have Ugandan, Nigerian, and Ghanaian roots.

"When we were much younger, wherever Pomie and I went, whether it was a market or even a public bathroom, we were always asked about our hair or fashion or people just complimented us on how we looked or interacted. As we got older we realized that the questions were not ending and that there was something unique about us, and our parents realized it too. My mother decided that since so many people were interested in our hair, outfits, and style, why not make it public? On social media we focus on hair care and styles, as well as books written by black authors or about black stories."

This dynamic duo is a testament to the bonds of family, creative collaboration, and teamwork. Acehi says, "Always believe in yourself because you become who you say you are. You are amazing and beautiful. Don't let anyone tell you otherwise."

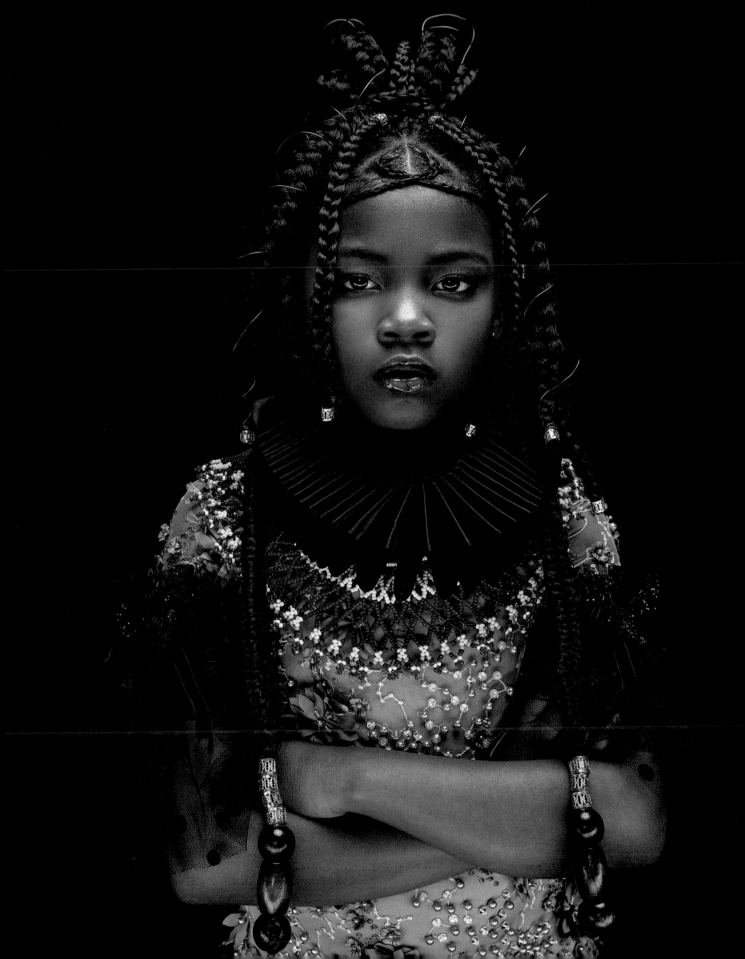

BRINGING THE GIFTS THAT MY ANCESTORS GAVE, I AM THE DREAM AND THE HOPE OF THE SLAVE.

—Maya Angelou

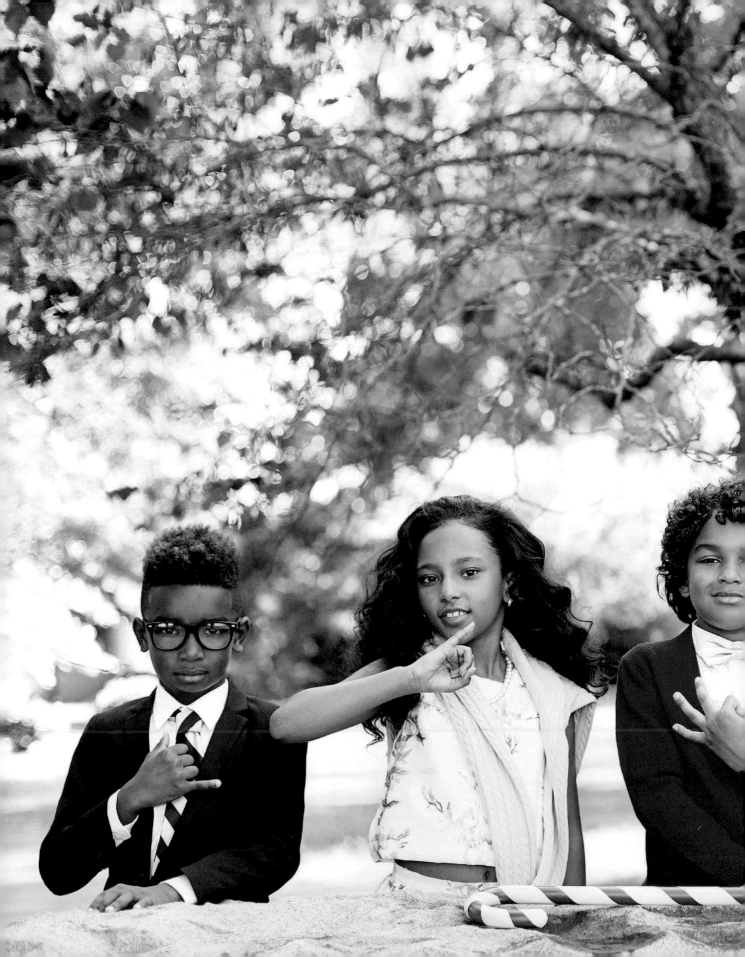

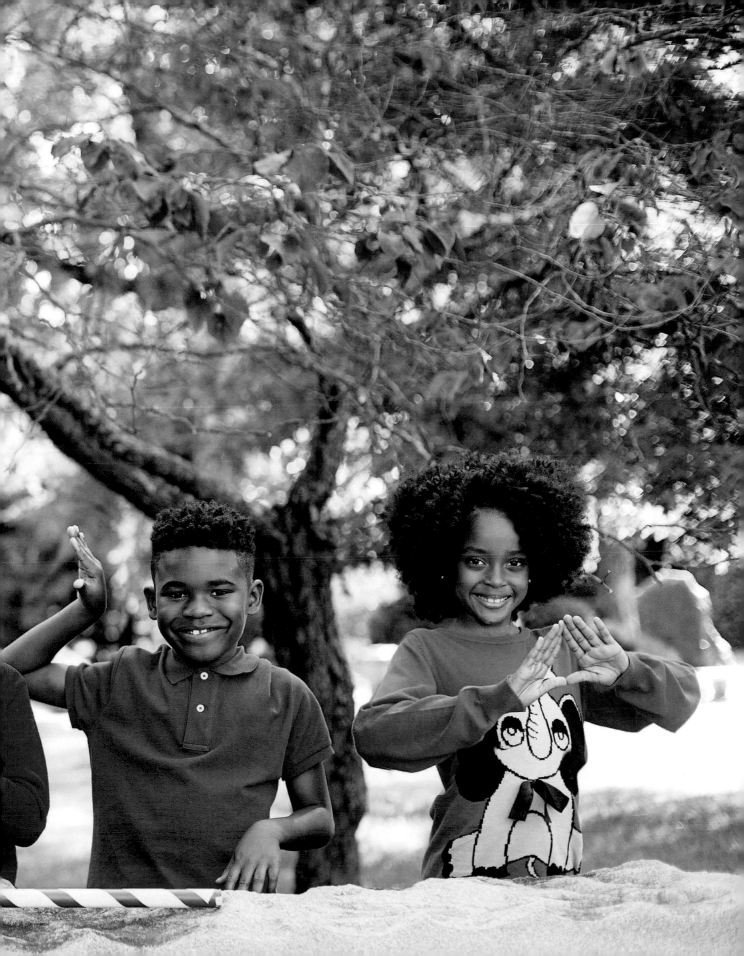

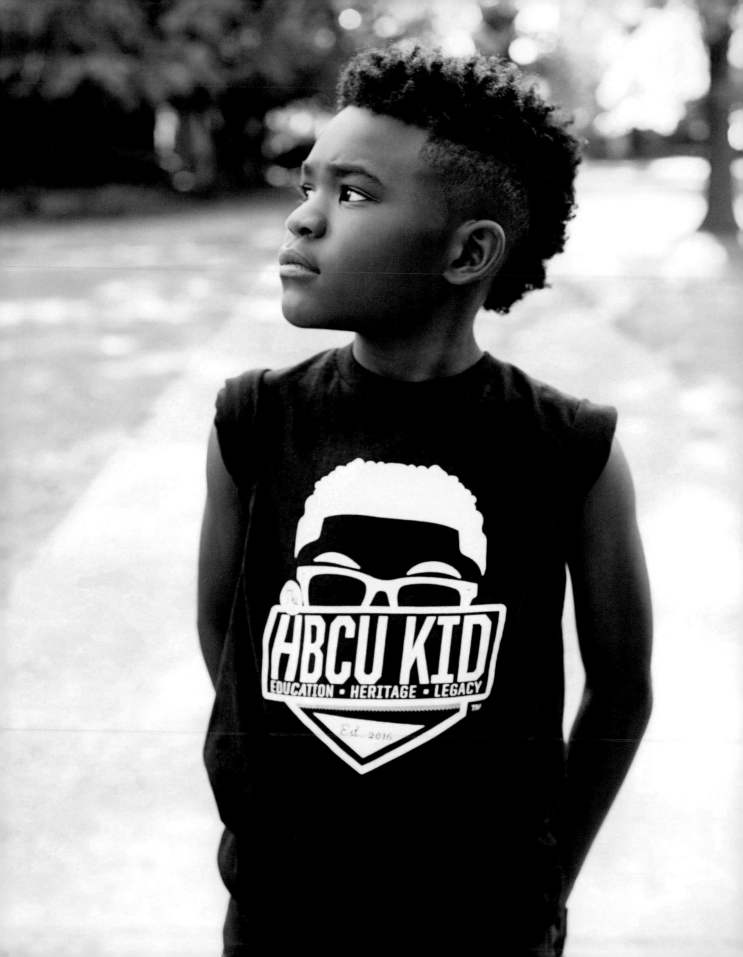

BRYSON

ARKANSAS

The HBCU Kid

At the tender age of eleven, Bryson Hardin, a kid advocate for Historically Black Colleges and Universities (HBCUs) has already attended twelve HBCU college tours. HBCUs have a deep-rooted heritage in his parents' lives since both attended HBCUs. Bryson's mother, Joy, was inspired to start a business called The HBCU Kid when she saw the positive effects that HBCUs could have on young people.

Bryson's parents also wanted to introduce him to the cultural ties behind Greek life. With Bryson's mom being a member of Delta Sigma Theta Sorority and his dad being a member of Omega Psi Phi Fraternity, his parents know firsthand the long-term success that both HBCUs and being members of Greek societies played in their lives. Bryson now wants to not only follow in his parents' footsteps by attending an HBCU, it's also his dream to follow in his dad's footsteps and one day become a member of his fraternity. Already an inspiration, Bryson wants to motivate other young people to be great, to be leaders, and to never give up on their dreams.

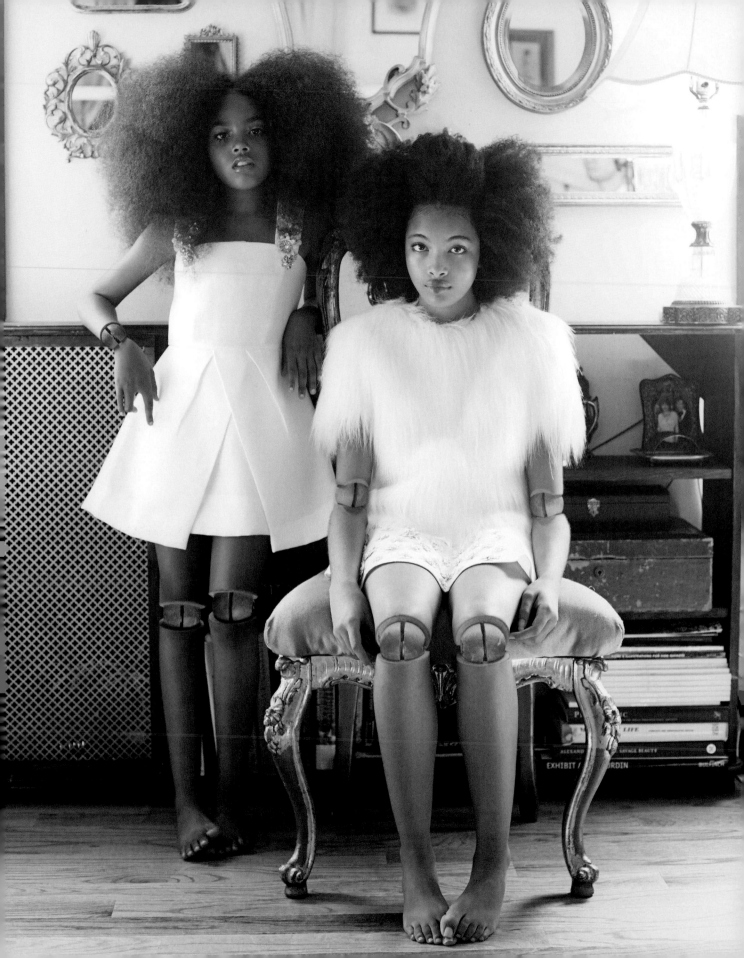

IF THEY DON'T GIVE YOU A SEAT AT THE TABLE, BRING A FOLDING CHAIR.

—Shirley Chisholm

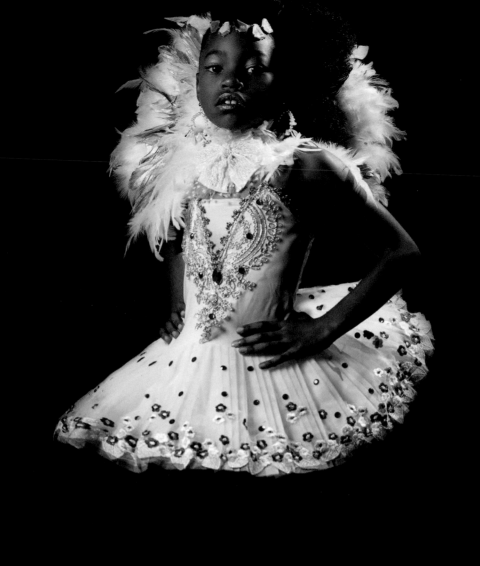

KA'IULANI

GEORGIA

The Caribbean Ballerina

Ka'iulani McIntosh-Ross is poised and accomplished beyond her years. She has danced *The Nutcracker* with Russia's Moscow Ballet and is a cast ballerina with the North Georgia School of Ballet in Georgia. Not only an incredible dancer, she is one of the top flexible rhythmic gymnasts in her level.

Ka'iulani's speaks fluent Spanish and English, which she attributes to her West Indian, Caribbean, African, American, and Latin American heritage. Ka'iulani hopes to become really good at ballet and start practicing in pointe shoes. She wants to dance in *Peter Pan*, *Anastasia* or *The Lion King*, and also to teach ballet. Ka'iulani feels as if she has wings when she is dancing. She has even had a dream where she has gold wings and she can give others gold wings by touching them. She says she wants to be able to do this for people, to give them wings.

To inspire other young girls, Ka'iulani says, "Keep trying and don't give up, especially when it feels hard."

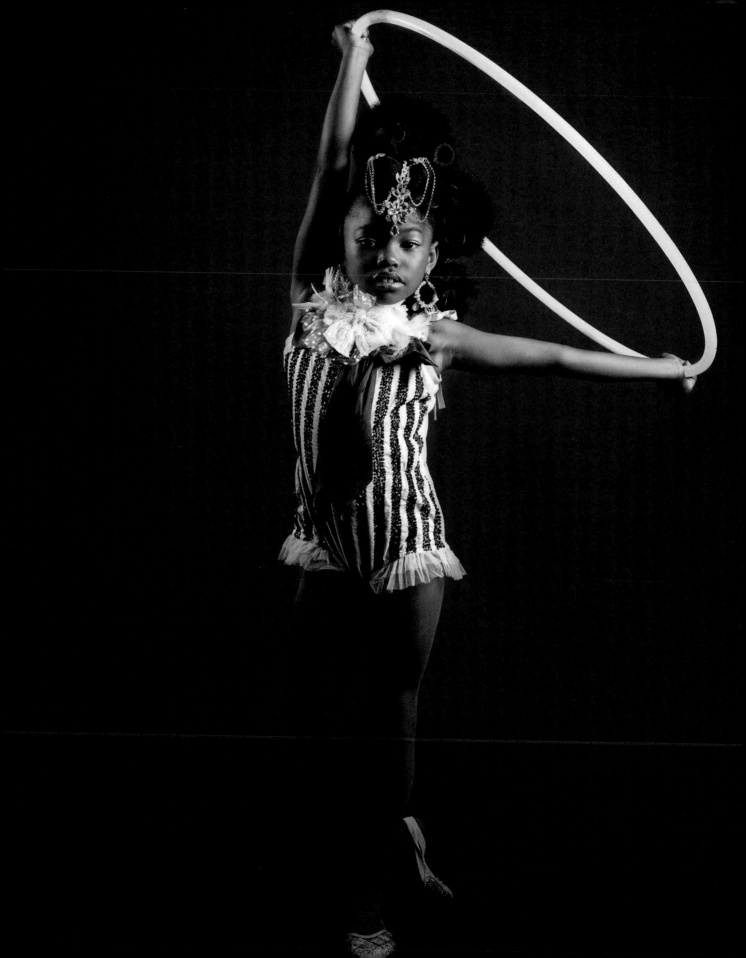

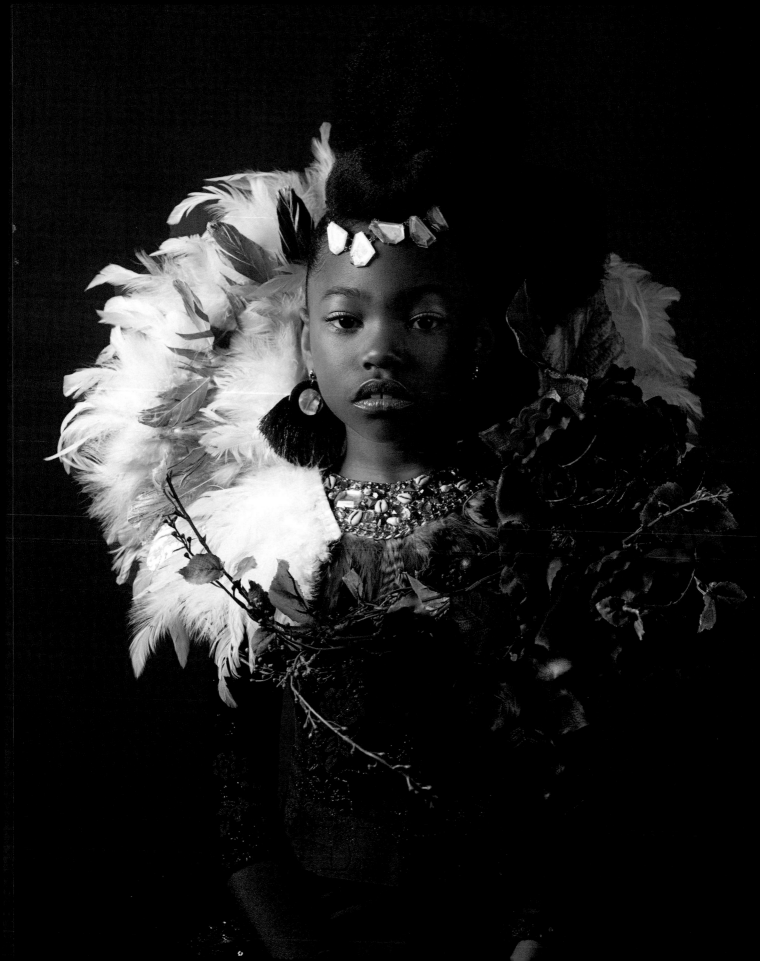

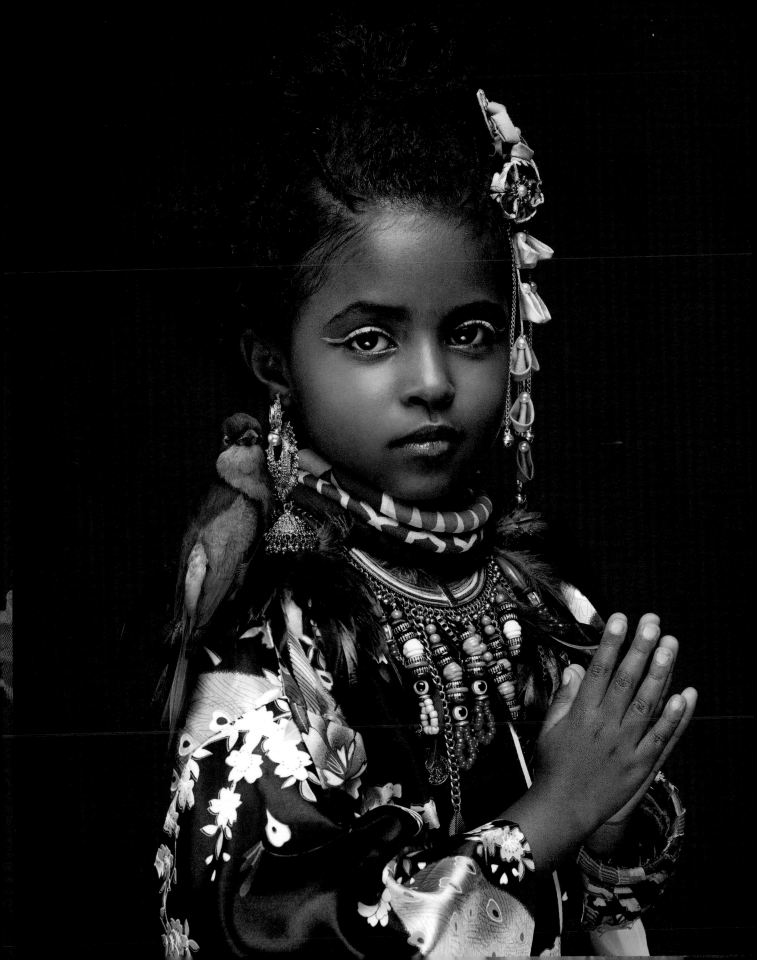

AMARI

Full of Life

Amari McCoy was born in Sululta, Ethiopia. Her first recorded weight at two weeks old, was only 4.4 pounds. Amari struggled with breathing issues and low white blood cell counts. Miraculously, after months of treatments, she fully recovered from all her medical issues. Now six years old, Amari is full of life and determined to do her part to make the world a better place. She can often be found on the school playground playing with the special-needs children or picking up trash in her neighborhood. Amari seems to radiate joy and makes everyone around her feel loved. She attends a Spanish Immersion school and is curious about other cultures. When she was five, she begged her parents to take her to the Chinese music and dance production of *Shen Yun* and to the King Tut Artifacts Exhibit.

Amari's signature trademarks are her kindness and her curls. To inspire other young people, Amari says, "Be a leader, not a follower. Be kind to others, work hard, and don't let anyone dull your sparkle!"

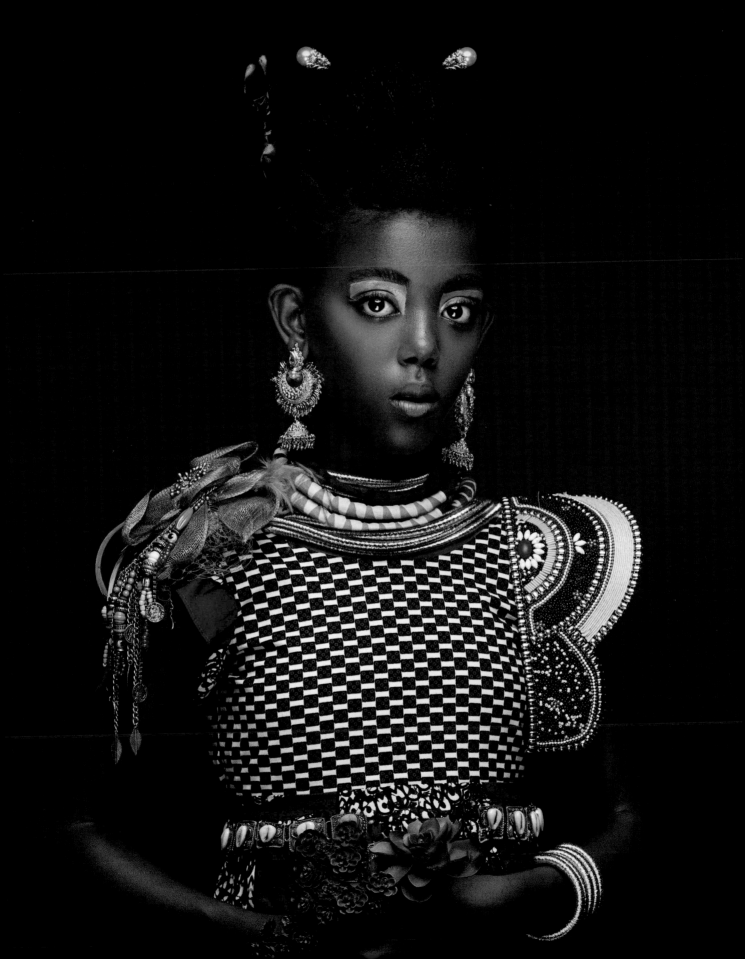

ZAELA

CALIFORNIA

A Testament to Resilience

Zaela McCoy was born in Addis Ababa, Ethiopia, and came to America at the age of ten months when she was adopted. Her Ethiopian name was Hermela. After arriving in the United States, the name Zaela was chosen in honor of Ethiopian Queen Zaela Ahyawa.

Outgoing and adventurous, Zaela is now eleven years old and a natural athlete who excels at whatever she puts her mind to. She is the ultimate social butterfly and also enjoys singing, dancing, and spending time with her many friends. Zaela loves to travel and experience other places and cultures. She returned to Ethiopia at the age of five to meet her sister, Amari, whose love for the Japanese culture also sparked Zaela's interest.

Zaela has overcome so much in her young life. But she is thankful for her loving family and being reunited with her sister. "I love my family for being unique, funny, and loving. And I'm proud to be from Ethiopia because there is so much history, and although some of the people there don't have a lot, they are still happy and full of pride." A testament to the power of resilience, Zaela would tell other young people to "always express your natural beauty and personality."

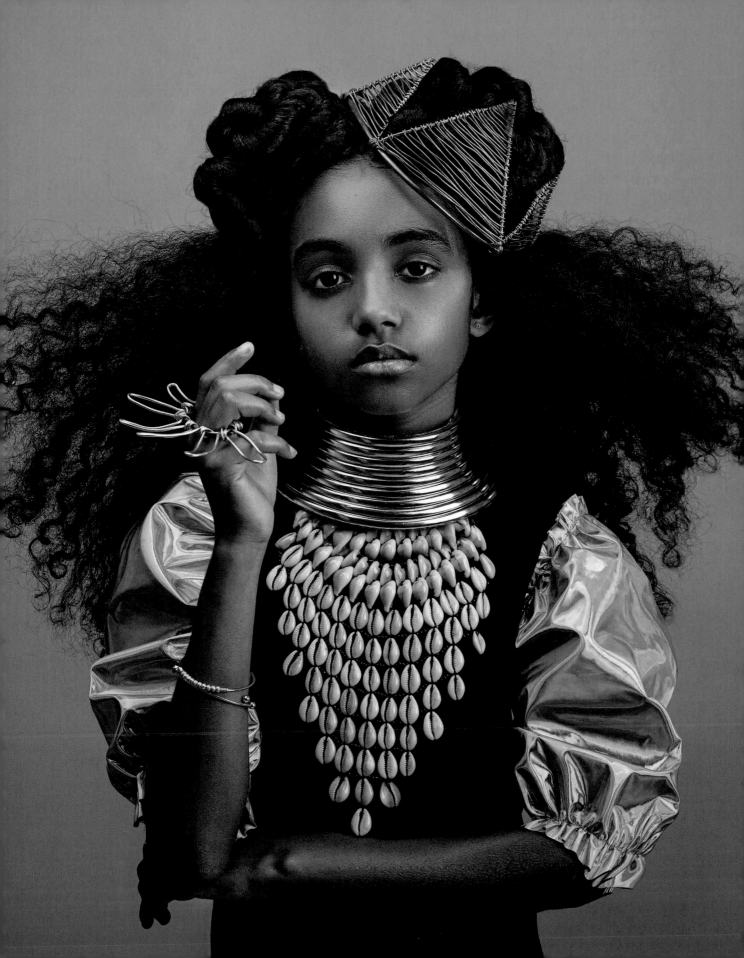

YOU CAN NEVER KNOW WHERE YOU ARE GOING UNLESS YOU KNOW WHERE YOU HAVE BEEN.

—Amelia Boynton Robinson

EVAN

Little Drummer Boy

At only seven years old, Evan Wright is a musician, actor, and model. Perhaps it is his boundless energy, enthusiasm, and commitment to learning and exploring his environment that has taken him so far beyond his years. Evan believes, "You can do whatever you put your mind to if you work hard and do your best."

As a baby, Evan absorbed all types of music—soul, jazz, classical, reggae, and salsa to name a few. As a toddler, he gravitated toward classic artists such as Earth, Wind & Fire and Maze featuring Frankie Beverly for nighttime lullabies. At thirteen months old, when he picked up straws and began drumming on a restaurant table, his parents knew they had a future musician in the family. Soon after, Evan professed his passion for music and declared he wanted to be a drummer. At the age of four, while attending a tribute concert for the legendary artist Prince, Evan announced that his name would one day be called on stage. Shortly after his fifth birthday, he began taking formal training with the Atlanta Drum Academy. There Evan was given the opportunity to cultivate his skills as a musician and share his love of drumming with the public. Having already spoken his future into existence, Evan went on to perform on *Little Big Shots* with Steve Harvey and during activities for Super Bowl LIII. And he is just getting started.

ZULAIKHA

SOUTH AFRICA

Protesting to Just "Be"

Born in South Africa, at age thirteen Zulaikha Patel became a symbol of the fight against Pretoria Girls High School's policy regarding black girls' hair and how it could be worn. She and her classmates held a demonstration that led to not only a change in school policy, but also an inquiry into allegations of racism at the school. Pretoria Girls' High School, in Pretoria, Republic of South Africa, was all white during apartheid, but since 1990, the school is open to all races. Their Code of Conduct does not specifically mention Afros, but it laid out rules for general appearance. It was implied that girls' hair needed to be straightened or tied back, not worn as Afros.

Zulaikha was among the students who led a demonstration against the school's hair policy. The teenagers were threatened with arrest as Zulaikha

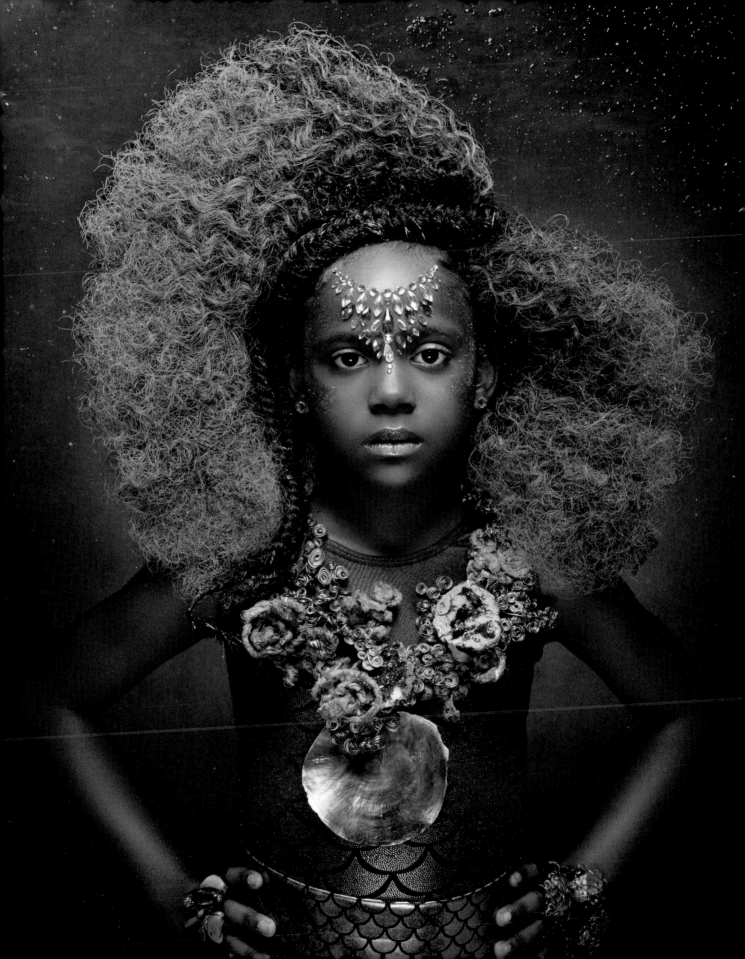

WHATEVER WE BELIEVE ABOUT OURSELVES AND OUR ABILITY COMES TRUE FOR US.

—Susan L. Taylor

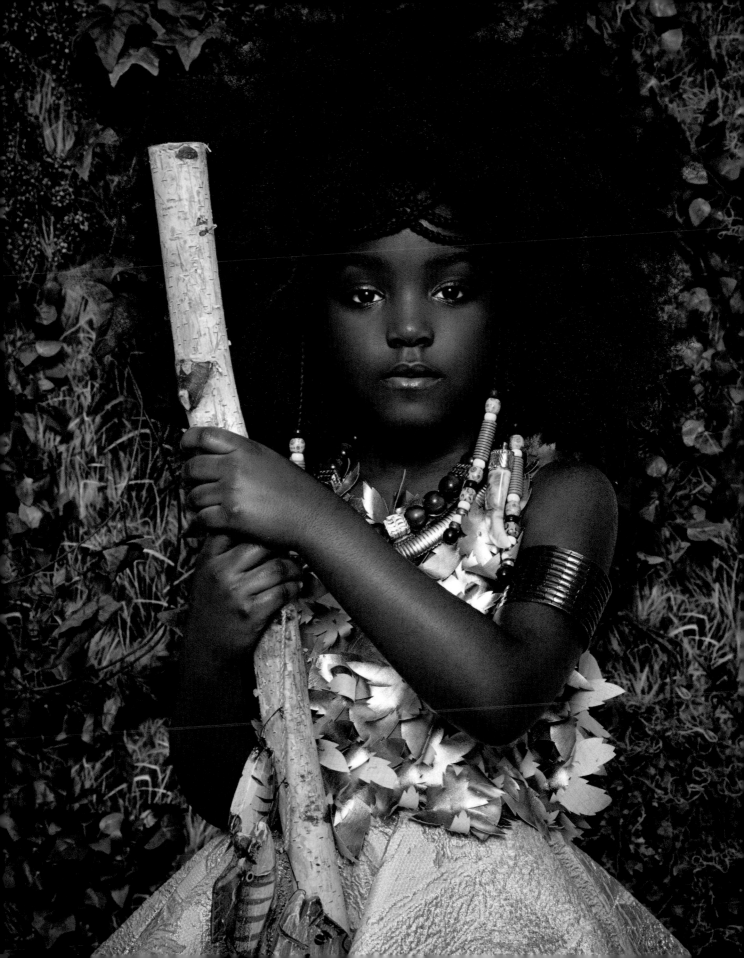

KORYN

LOUISIANA

Cajun Barbie

Koryn Moore inspires children of color to love their natural beauty early on in their lives because she embodies that message. Born in Vermilion Parish (the most Cajun place on earth), this remarkable seven-year-old is not your typical southern belle, as she has a whole lot of Cajun spice and sass as evidenced by her love of dancing to zydeco music, eating crawfish, attending festivals, wearing rubber boots with everything, and, of course, fried chicken!

The baby of the family, Koryn has always been confident in her school work, dancing ability, and all-around fun-loving personality, but did not always appreciate her thick head of hair, and often wanted to have straight hair like other girls. However, she has grown to love her natural hair and often asks her mom to make her Afro puffs even bigger. Koryn wants other little girls who may be different or stand out for any reason to not worry about what other kids think, and instead be inspired by what makes them different.

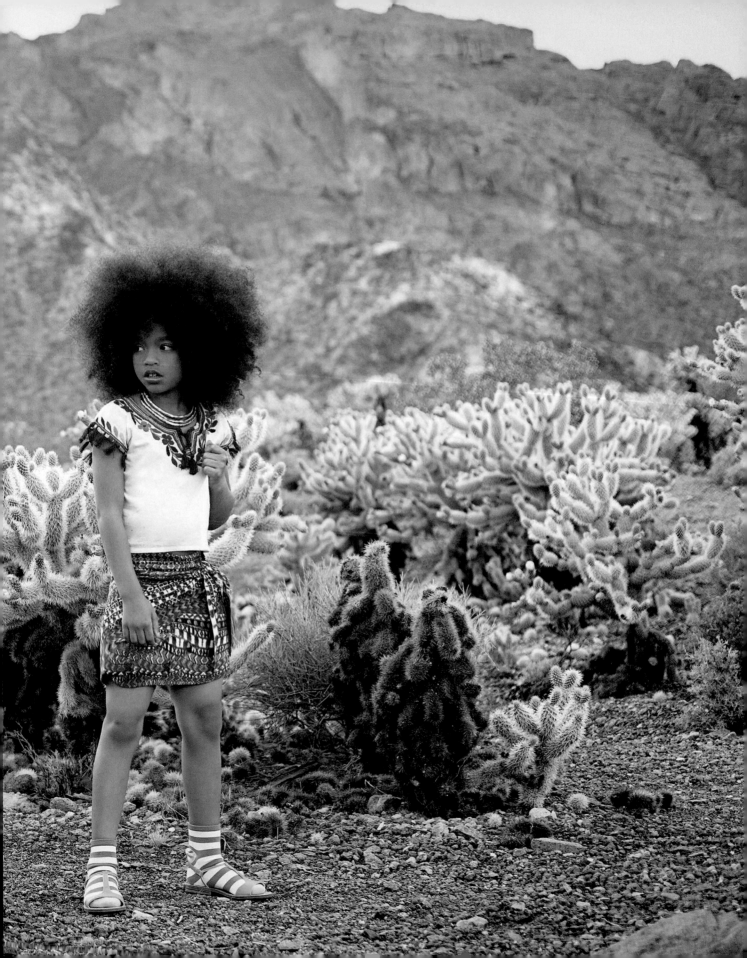

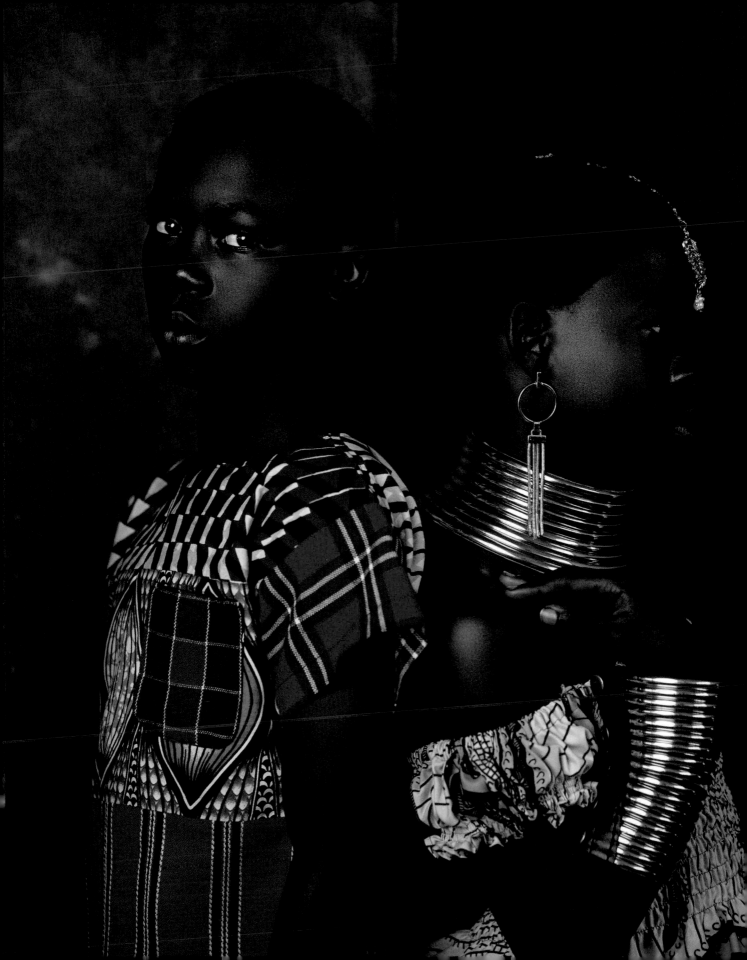

THE JAMESTOWN PROJECT

A community determined to overcome

When selecting the models, we wanted a variety of kids across the African diaspora from diverse backgrounds. As we traveled throughout Africa we made a conscious decision to show a different narrative than what was being told in the media. However, we felt that we would do ourselves a disservice by dismissing the large number of kids who did not come from affluent homes or neighborhoods. Their voices needed to be heard too. We spent time in the fisherman community of Jamestown, Ghana, where despite the circumstances of poverty, there is a vibrancy and will to succeed like no other place on earth.

During our visit, we were able to meet several kids in the town and get to know them and their life stories a little more. We wanted to not only capture their true essence, but also show their resilience and strength. Our hope is that they will one day look back on these photos, remember their journey, and see their inherent beauty and strength.

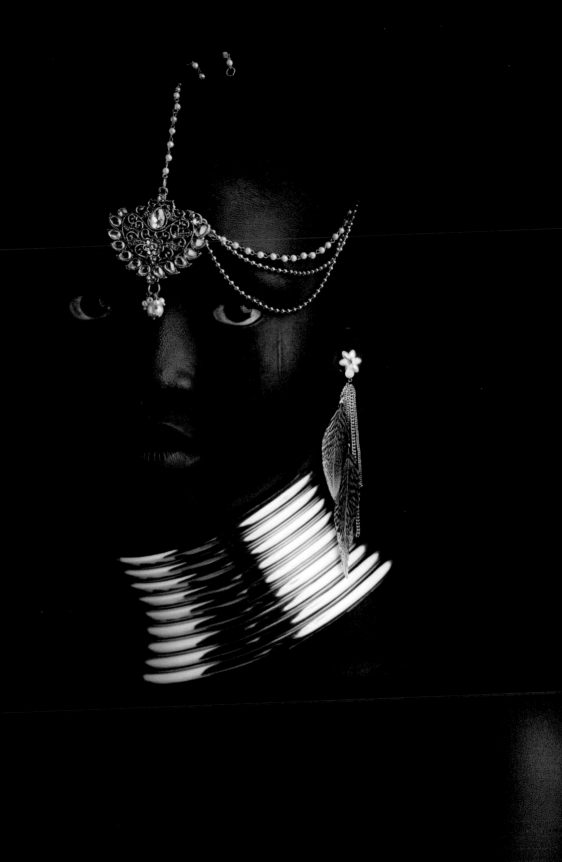

REBECCA

GHANA

Jamestown Princess

We first met Rebecca Mensah in 2016 in Jamestown, Ghana. This quiet, stunning girl captured our attention among the crowd of students we were visiting at her school. Since then, we've developed a bond with her and her family that can never be broken. Rebecca absolutely loves school. At age fourteen, she is one of the few kids in Jamestown who has the opportunity to attend classes because of her parents, value in her education. Rebecca lives with her family in a home where there are no lights, running water, or even a restroom. Her father is a fisherman and her mother cooks and sells food to provide a better opportunity for their children and to fund their education.

She dreams of one day being able to study abroad and attend a university so she can help support her family. When we think about her, we are inspired to push through any obstacles that may come our way and be forever grateful for the blessings and opportunities we have in this moment. Rebecca has had to overcome almost insurmountable odds, but her drive and will to succeed will take her far.

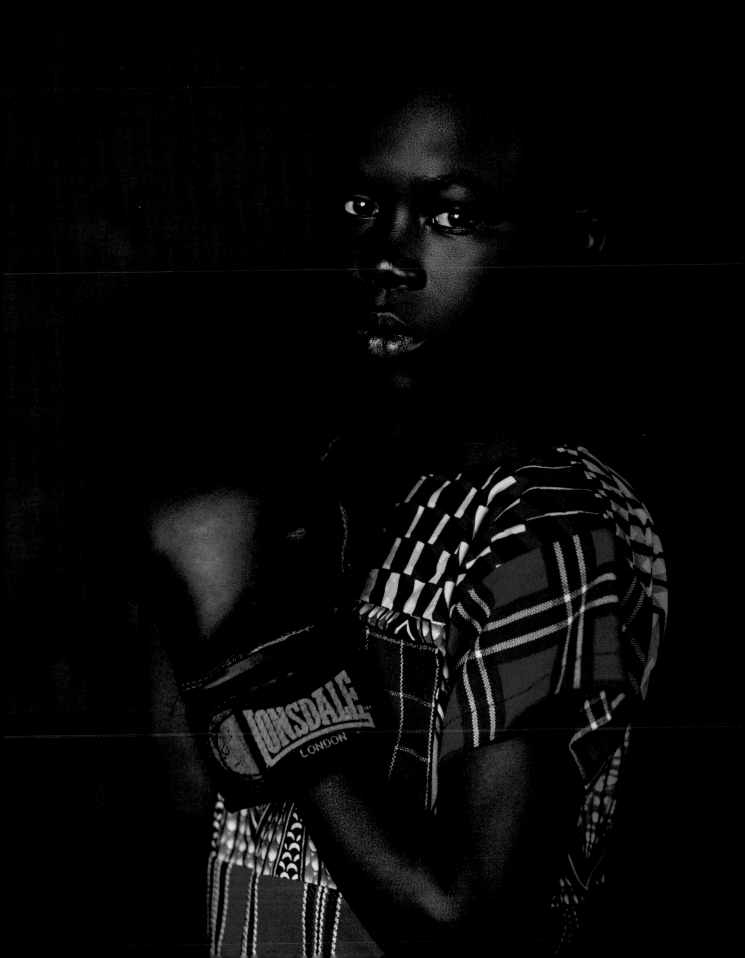

YAHUZA

GHANA

Boxing Dreams

Twelve-year-old Yahuza Abbas dreams of one day being a world boxing champion. Boxing is a popular sport for young men in Jamestown, who visit the ring every day to practice and prepare for matches. Boxing is built into the culture, and four out of five national champions have come out of Ghana. Boys often use boxing as a way to escape the harsh realities of their daily lives. They meet in the gym and train together, forging strong bonds that can last a lifetime.

"The Ga people like boxing very much," Yahuza says. "We are called the atswele, or fist people." Resolute and focused, a steely glint of determination in his eyes, Yahuza works hard to achieve his goals and will make a name for himself, either inside the ring or out

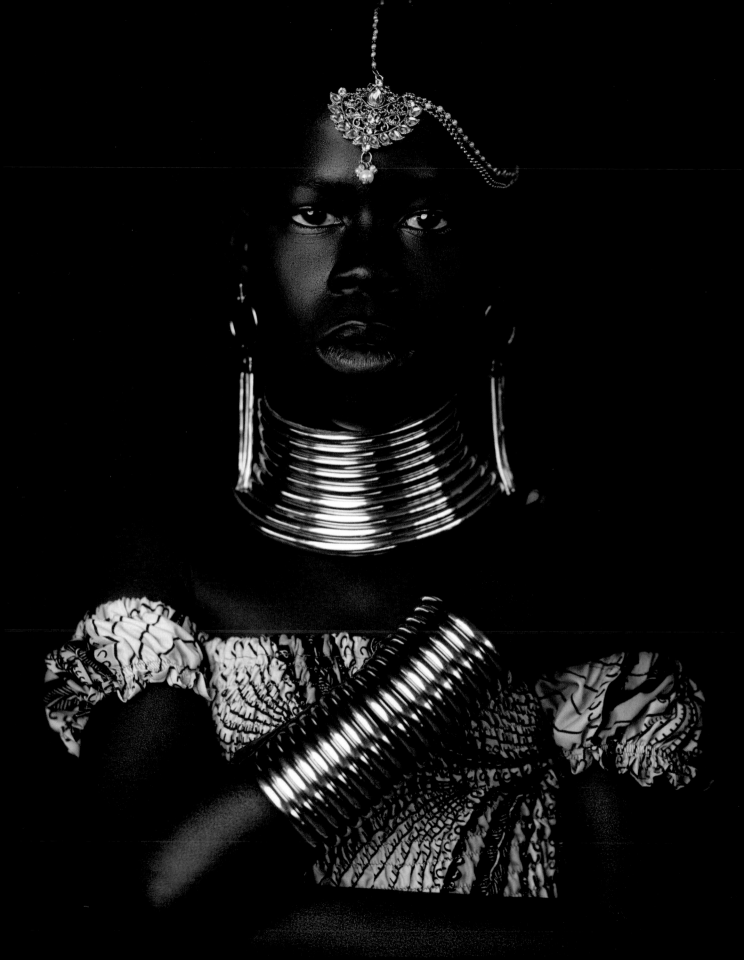

AHIMA

The Water Girl

Often in the community of Jamestown, Ghana, parents are unable to afford to send their children to school. The money they make has to go toward putting food on the table. Thirteen-year-old Ahima Tetteh lives with her disabled mother and siblings and helps to provide for the household by selling water in the busy markets in town. This is hard work for a young girl. Her deeply soulful eyes and quiet determination are a testament to her daily struggles, but Ahima is happy to be able to contribute.

She knows there are others with far less than she has. Athletic and a creative spirit, Ahima loves track and field and arts and crafts. This dedicated young woman hopes that one day she will be able to attend school so she can provide a better way of life for her family

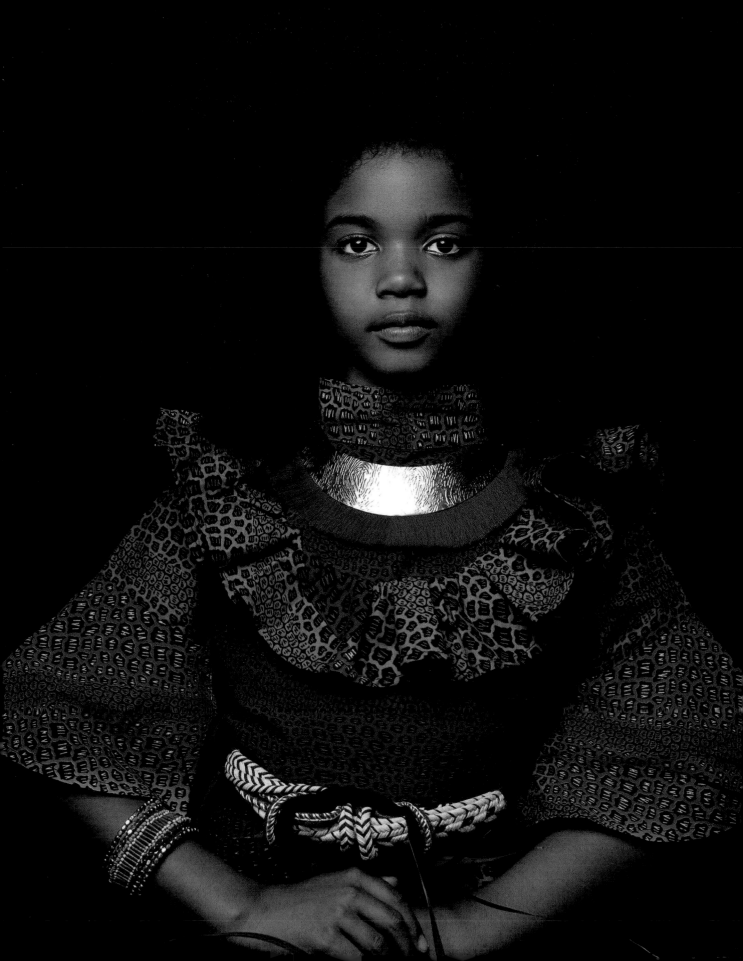

DEFINING MYSELF, AS OPPOSED TO BEING DEFINED BY OTHERS, IS ONE OF THE MOST DIFFICULT CHALLENGES I FACE.

—Carol Moseley-Braun

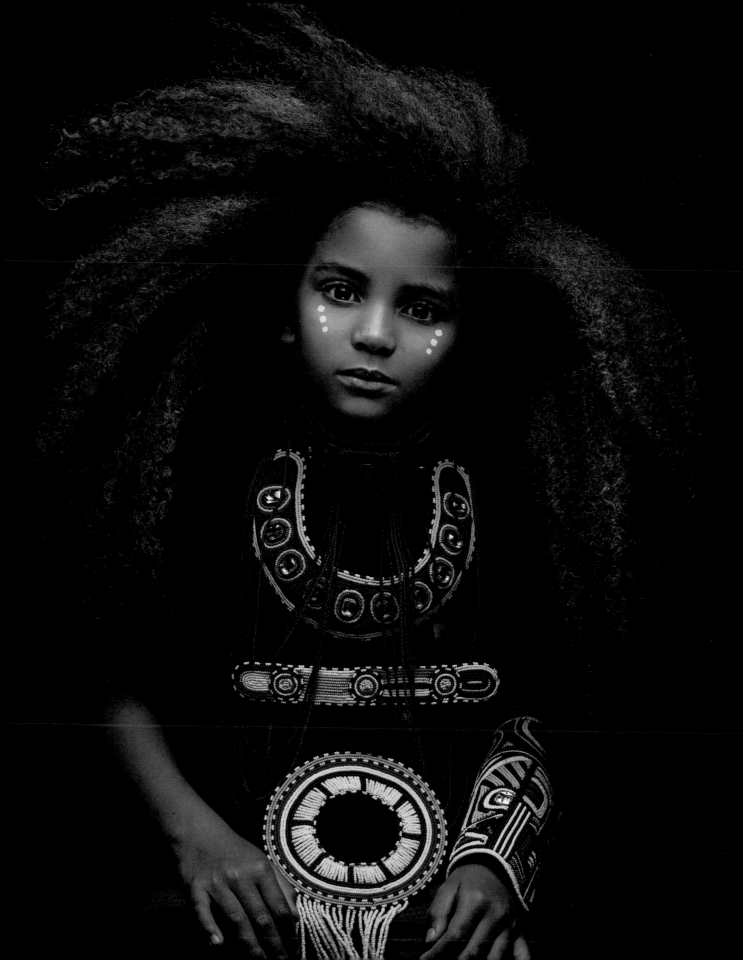

FAROUK
A Lion's Mane

Farouk James was born in London, England. His father is Ghanaian and his mother is British. Outgoing, fun-loving, and charismatic, he began his modeling career at just six months old. At two years old, his mother started posting his pictures to Instagram, and within a few months his following grew incredibly quickly, and like his amazing lion's mane of hair, it hasn't stopped growing since. Farouk now has an army of ferociously loyal social media fans who would hunt down anyone who even suggests he should cut it!

At just seven years old, Farouk has already graced catwalks across the globe and appeared in publications and on television promoting fashion, travel, and natural hair. Farouk has an incredibly kind heart and hopes to inspire other girls and boys to embrace their natural hair through his images and videos on social media.

Farouk's androgynous look immediately draws boys and girls to play with him. When the girls realize he's a boy it doesn't matter, as they have already become friends. Boys don't care how long his hair is, they just love that he's a lot of fun. Farouk calls this his superpower. He leaves an impactful impression, and teaches an important lesson: boys can have long hair too.

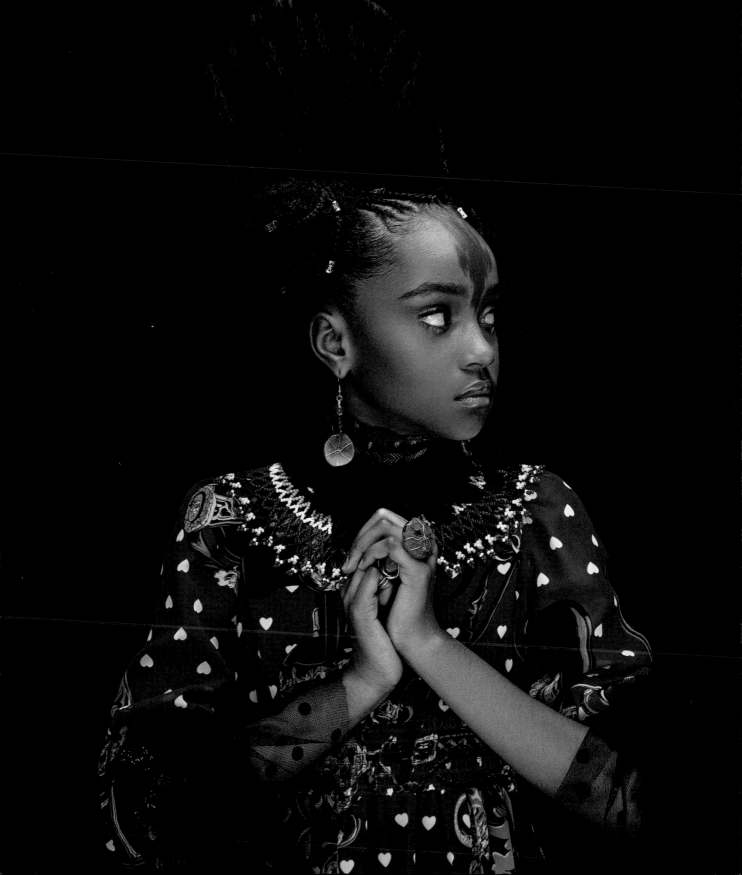

A PEOPLE WITHOUT THE KNOWLEDGE OF THEIR PAST HISTORY, ORIGIN, AND CULTURE IS LIKE A TREE WITHOUT ROOTS.

—*Marcus Garvey*

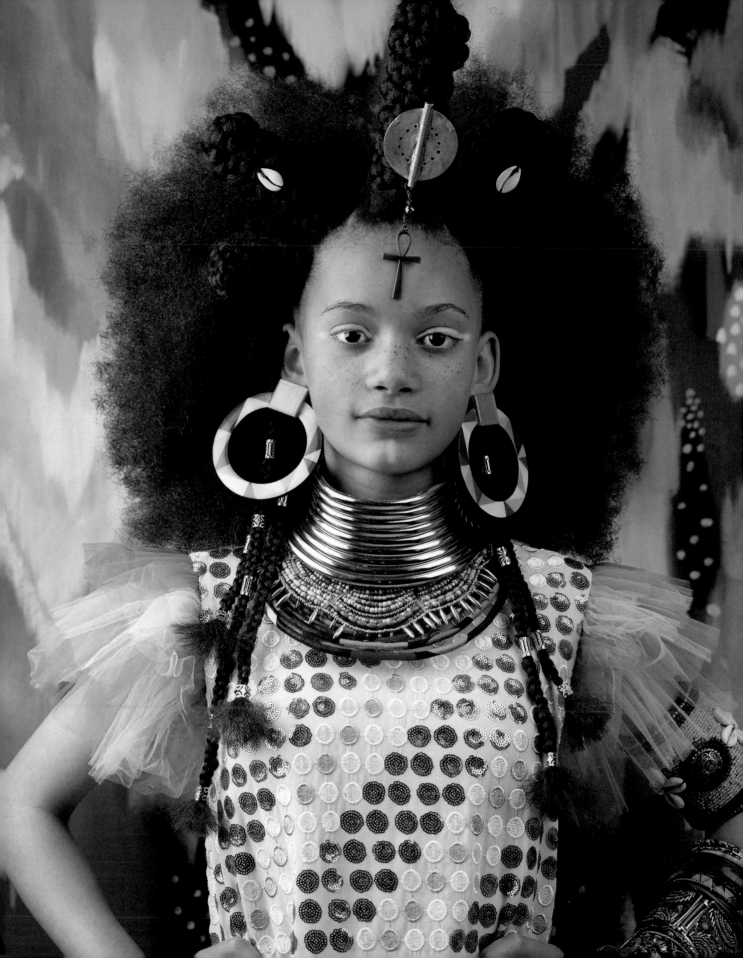

ÉMILIE

PARIS

A Heart of Gold

Wherever Émilie Afatsawo went with her family, whether in her native France or all over the world, people would stop and comment on her hair, often asking if it is her natural color. She would laugh because, at thirteen, she is too young to have dyed her hair! Émilie, who was born in Paris, is of mixed heritage—she is Togolese and French and her freckles and naturally reddish auburn hair are inherited from her grandfather's father.

Although a successful model, Émilie is still a typical teenager who is "keen on Harry Potter" and loves sports. She also enjoys modeling and being in front of the camera for photo shoots, because it helps to build her confidence.

Sweet and thoughtful, Émilie has a heart of gold and an excellent memory. She always remembers little things that everyone else has forgotten, which usually makes them smile.

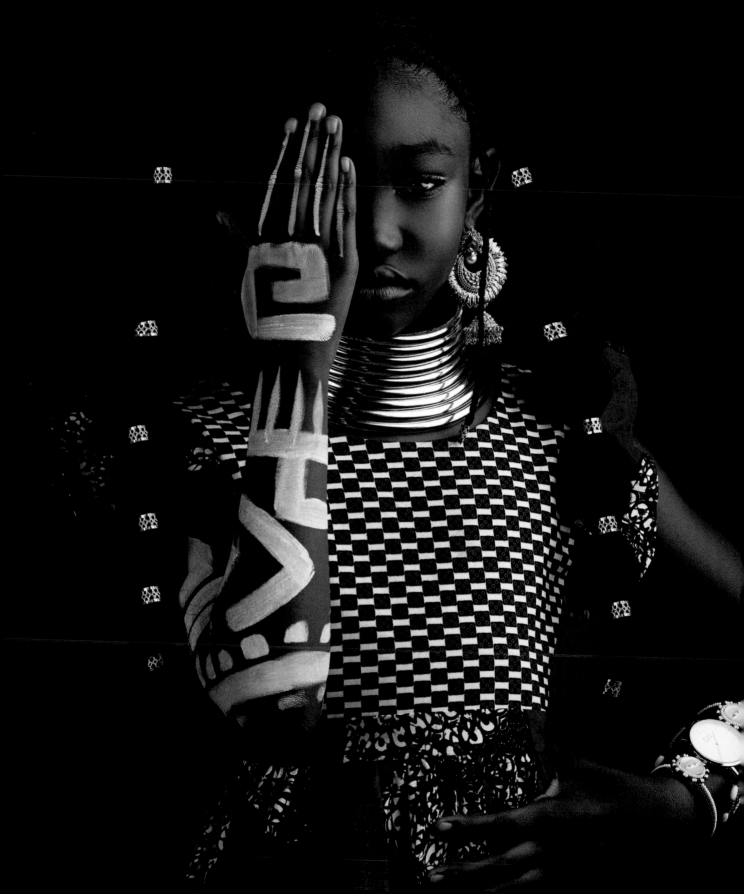

THE TIME IS ALWAYS RIGHT TO DO WHAT IS RIGHT.

—Martin Luther King, Jr.

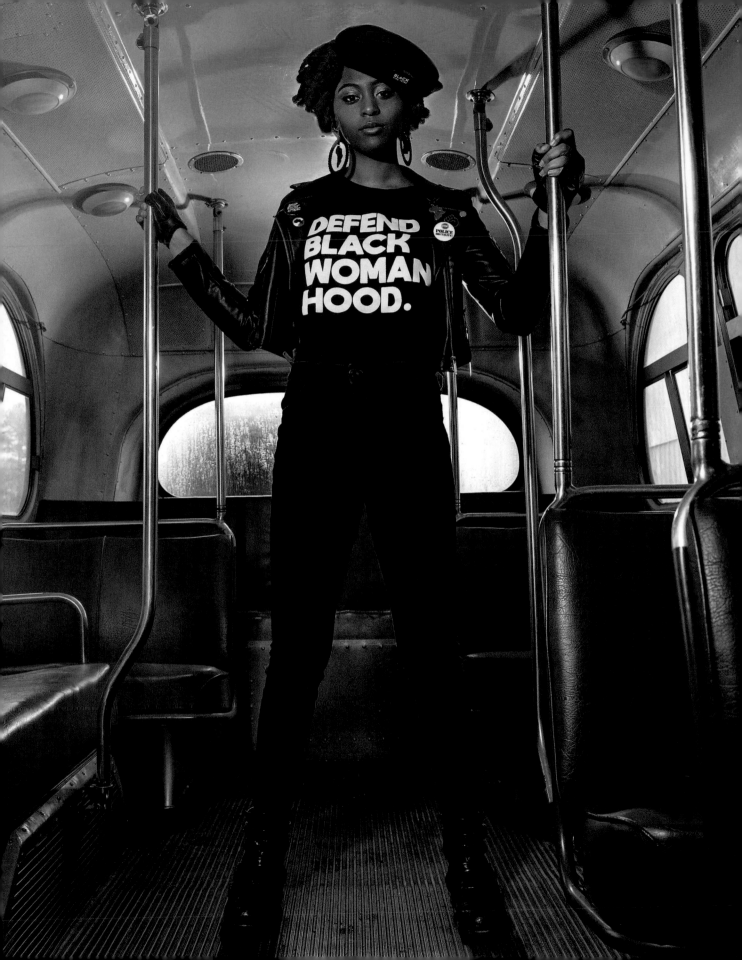

TRINITY

GEORGIA

The Freedom Fighter

Trinity Simone is the next generation of freedom fighters. This determined sixteen-year-old has a burning desire to make a positive impact on the world. She loves reading, writing, and everything word related. Based on this love of the written word, Trinity decided to launch The Youth Will Be All Write initiative, which donates journals to institutionalized and incarcerated youth in juvenile detention centers. She wanted to give them an outlet to express themselves in a positive way. Trinity knows that we are all humans and make mistakes, but "The power of pen and paper can heal, bring peace, and allow for change." She hopes to use her platform to shine a light, bring awareness, and give a voice to those who are voiceless during this chapter in their lives.

Trinity's goals derive from one dream: to further help connect, love, uplift, and build while walking the path her ancestors paved for her.

"If I can utilize my words to craft eloquent and articulate dialogue like the black literary revolutionaries I grew up admiring, all my dreams will be fulfilled and satisfied." Brave beyond her years, she's not afraid to stand up for what she believes in and is often on the frontline speaking out against social and racial injustice. Trinity is a revolutionary and our hope for the next generation of free thinkers and cultural innovators.

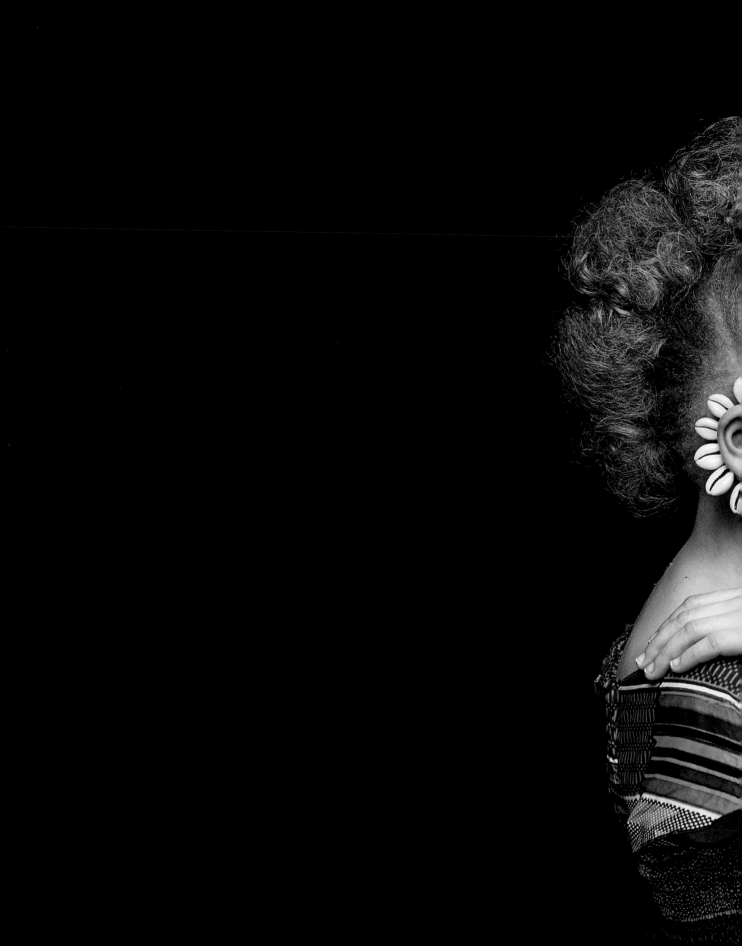

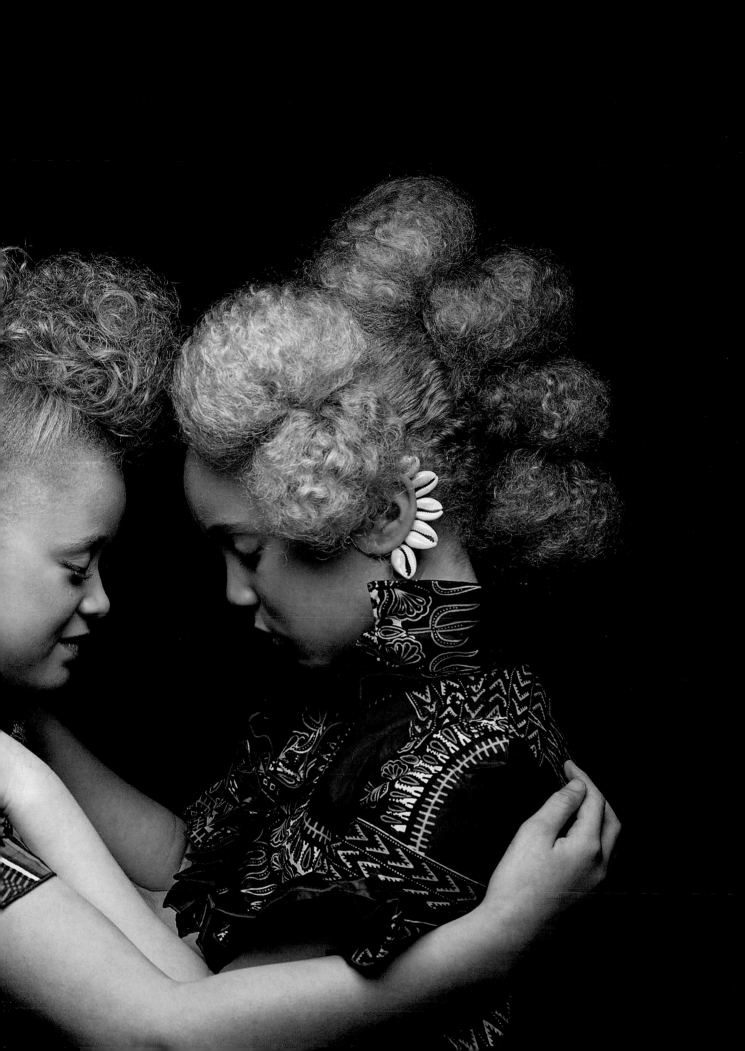

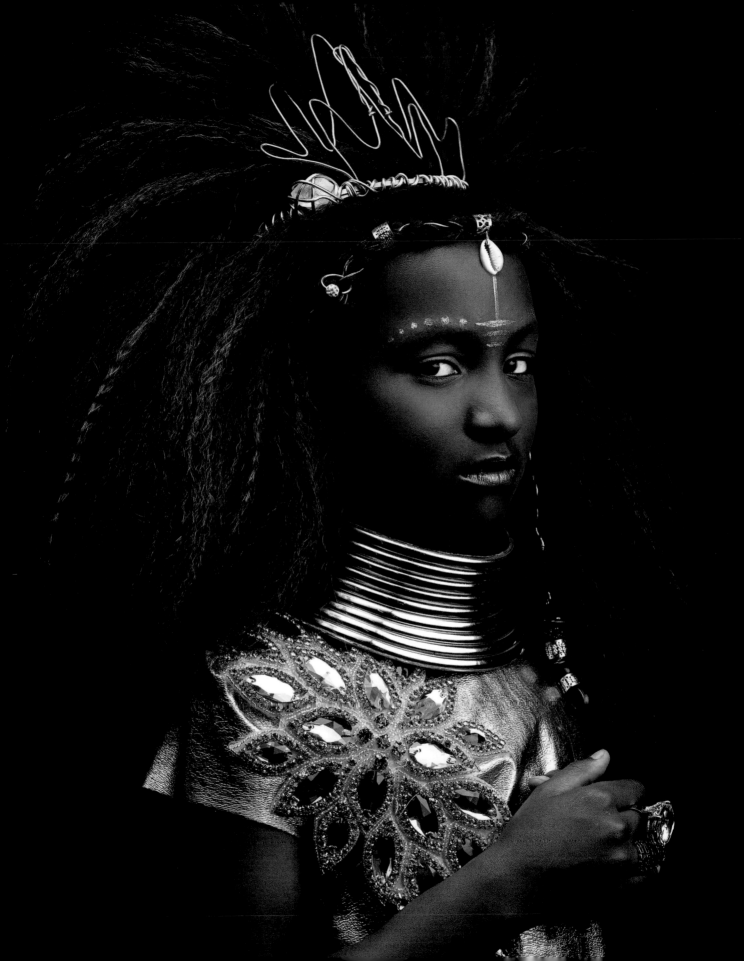

AND IF YOU FALL, STAND TALL AND COME BACK FOR MORE.

—Tupac Shakur

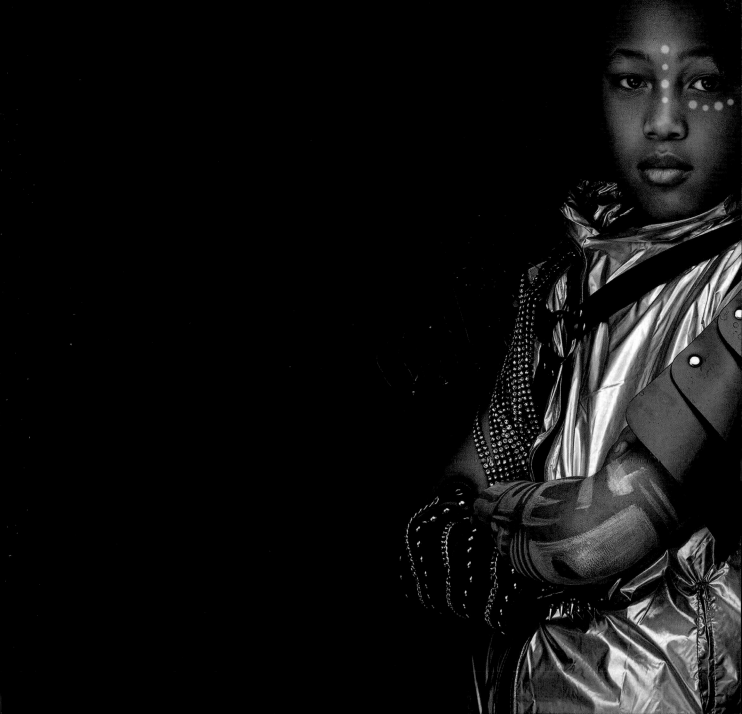

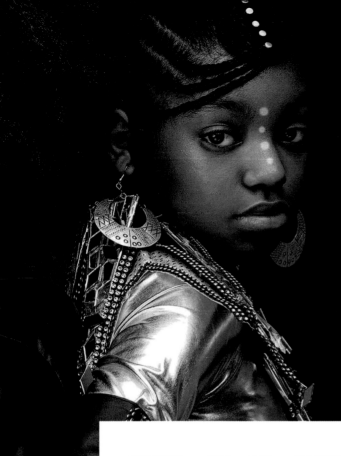

FUTURE

OUR UNBOUND GLORY

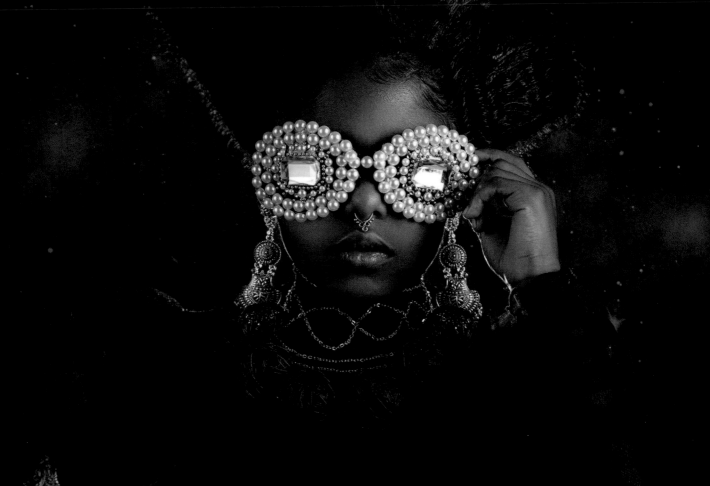

GLORY UNFURLED

A look into the future

What was is now again. Those who ruled return to their thrones. The forgotten are remembered, the fractured are restored. The future becomes the dream the past could not live. We are moving in step with our dreams; our dreams are in step with our lives and our vision. Everything becomes us; we become everything. The fever has broken, and we are awake to boundless possibility.

I dream of a world where our magnificent outer beauty is a reflection of our inner beauty. Where we embrace the full spectrum of our glorious differences, because it is this diversity that unites and unifies us. It has been a long, long journey of self-exploration and discovery to rediscover our natural beauty. We now recognize it around the world in our brothers and sisters of every shade and hue. Together we have finally realized our value and self-worth and embrace it—unapologetically.

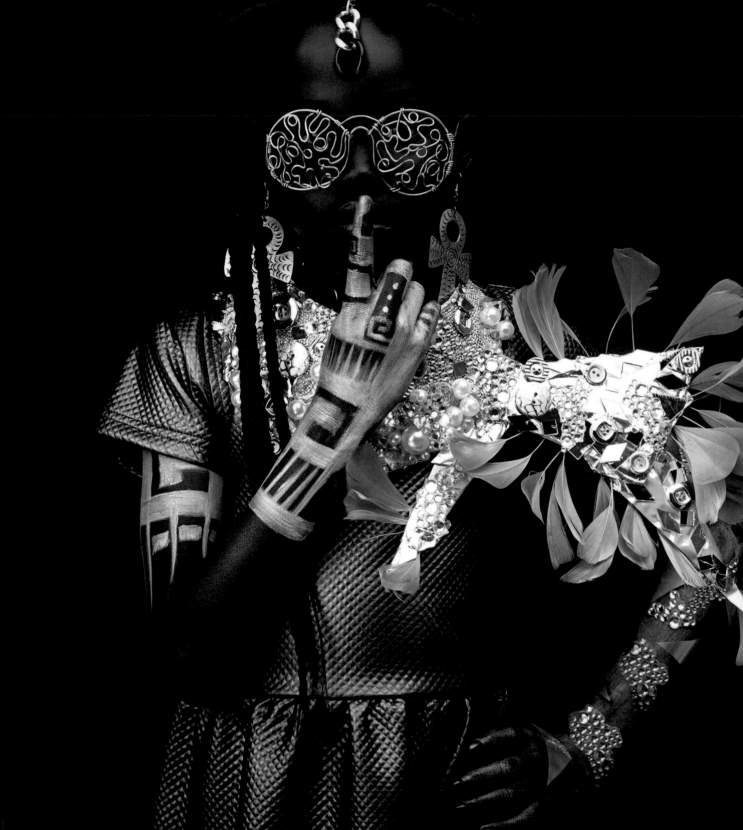

NEVAEH

Melanin Beauty

Although only eight years old, little Nevaeh Camara is brimming with confidence, which she attributes to her parents and grandparents. Her father is half Sierra Leone and half Liberian. Her mother is from Northern Sudan, a war-torn country where she, at the age of two, had to flee with her family to escape genocide. They eventually came to America as refugees and hope to give their children the opportunities they did not have.

Not always this self-assured, Nevaeh faced criticism about her gorgeous ebony complexion.

"The first time I noticed my skin color was different was when I was four and a classmate asked me why my skin was so dark. My mom explained that it is my heritage. Not long after that, I was again taunted by kids about my hair and skin color. My parents comforted me by explaining who I am, what I have to offer, and to love myself as God made me. I love who I am. My hair and my skin are beautiful. Others may not always embrace my uniqueness, but God has placed a village around me to confirm my worth."

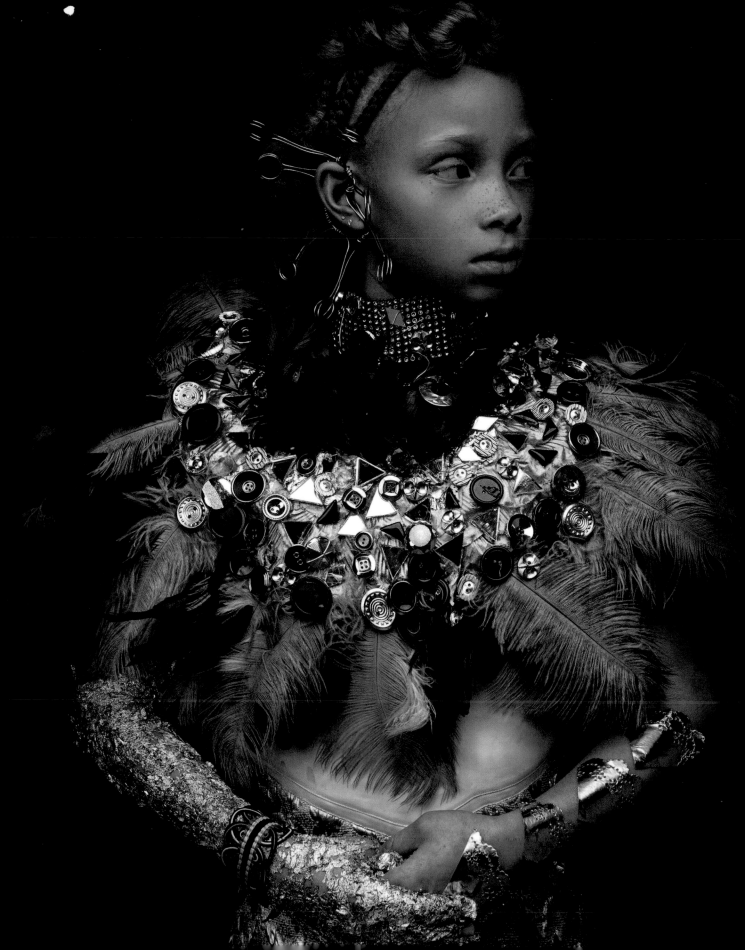

LEGEND

The Inspiration

Being a red-haired model with freckles in an industry known for its redundancy can sometimes be challenging. When Legend Pearl Phillips decided to enter the kids' fashion industry at six, she had no idea her unique and ethereal beauty would enable her to work as a model. Many people think that being a child model is easy, but they do not see the drive, determination, and hustle it takes to do well. Legend's mother has been in the industry for almost twenty years. She knew it was important to make sure that Legend stays humble and to constantly make sure it is something she wants to do. Her drive and determination are inspirational. Even with all of her success she loves to serve others—whether it means helping the homeless or assisting the elderly in her community.

In addition to having a successful career as a model or actress, ten-year-old Legend dreams of graduating from Howard University. She is proud of her resilience, her self-confidence, and also of the strong foundation of love that her family provides and their constant support of one another. She loves her culture for its strength, wisdom, strong heritage, and constant growth. Legend would tell other young girls to not try to blend in because what makes you unique is your gift to the world.

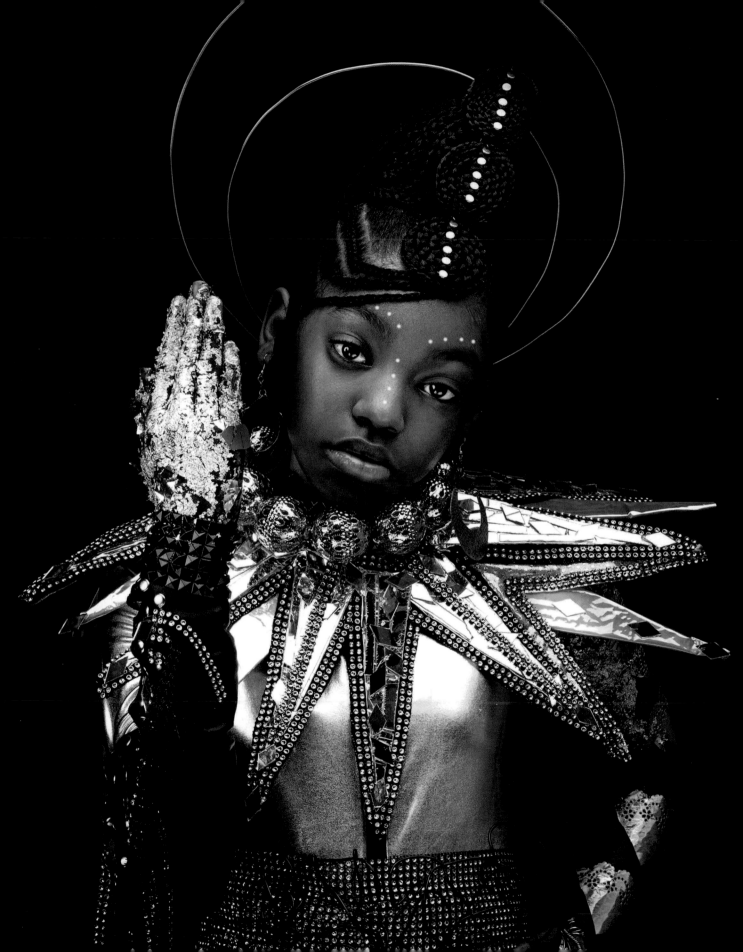

JADA

The Sky Is the Limit

Growing up, Jada Billy was very shy, but she always loved being in front of the camera. The twelve-year-old began to overcome her shyness when her mom enrolled her in ballet. She was a natural and eventually started joining dance shows in school where she showcased hip hop and tango dancing. Jada struggled with her thick curly hair and had a hard time sitting still to get her hair styled. Her aunt suggested she try going natural. At first Jada was embarrassed about wearing her natural hair because other kids made mean comments about it. Dancing has boosted her confidence tremendously; activities that she would previously have shied away from, she is now excited to try, like stilt-walking!

Jada wants young people to be proud of who they are, to love themselves, and to be the best they can be, despite society's standards of beauty. She also dreams of attending Harvard University.

"Education is so important to me. I want young girls my age to know you can be anything you want to be. The sky is the limit and I am aiming high."

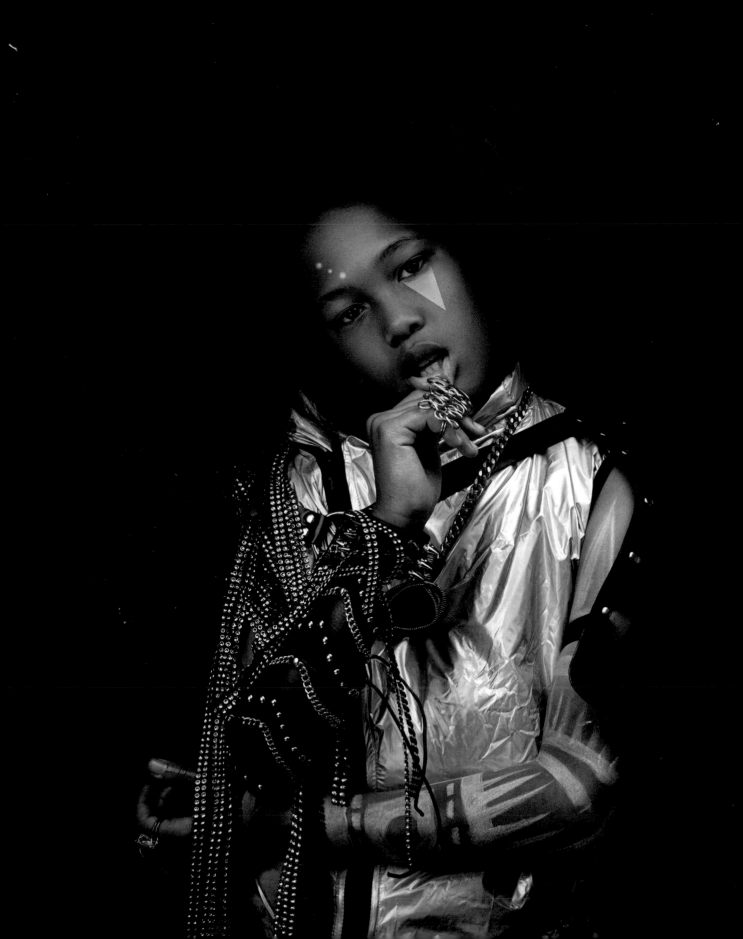

JAYDEN

NEW YORK

The Trendsetter

At twelve years old, Brooklyn native Jayden Alexander Pyram is a spontaneous, fearless kid who is friendly with everyone he meets. He loves skateboarding, soccer, music, video games, and reading mysteries. Jayden is interested in marine life and global warming and aspires to one day become a marine biologist or climate scientist. Since he was about two or three years old he would attend special art exhibits, music, and fashion events with his dad, eventually making special appearances in fashion blogs and music videos. When he was five years old, his aunt submitted him for a kids' magazine cover contest and he won.

Jayden signed with a modeling agency at seven years old, and he is currently one of the top child models in New York. Jet-setting Jayden has also participated in London Fashion Week in the UK. He is self-possessed and confident, and he loves to rock his huge Afro, which, along with his assured sense of self, always makes him a standout.

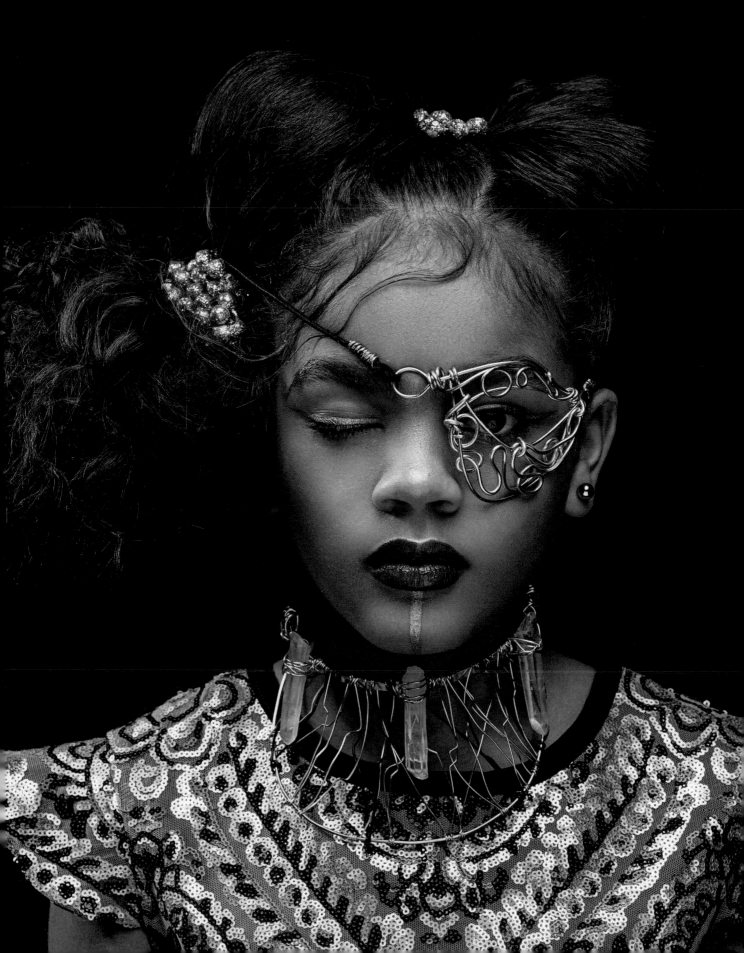

HISTORY HAS SHOWN US THAT COURAGE CAN BE CONTAGIOUS AND HOPE CAN TAKE ON A LIFE OF ITS OWN.

—Michelle Obama

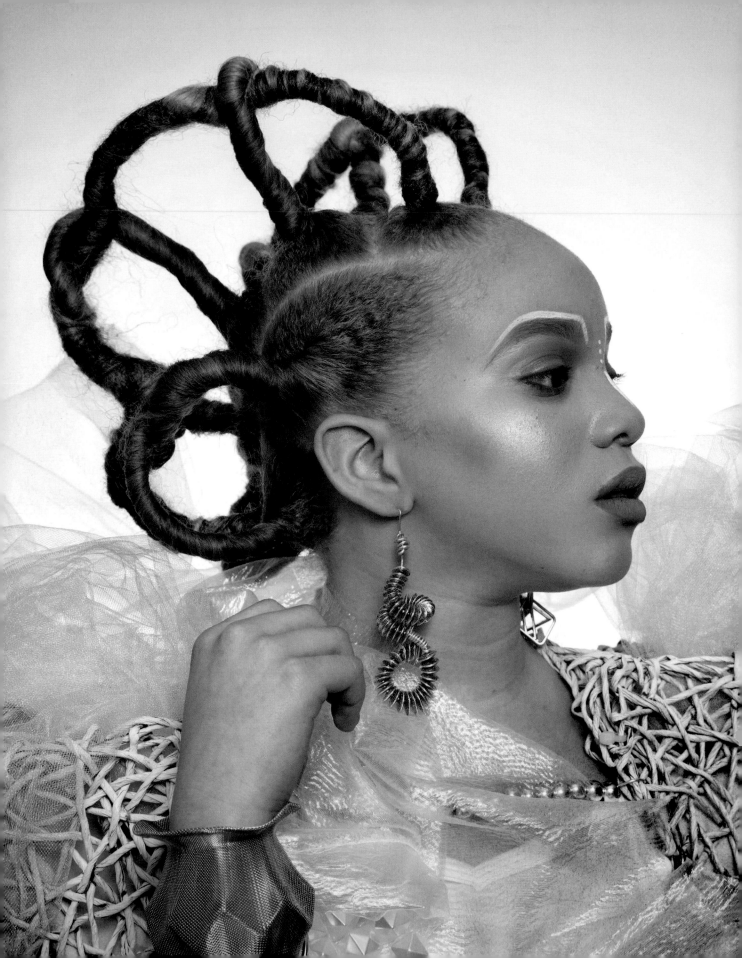

AVA

Uniquely Designed

Ava Clarke—uniquely designed by God—is a fair skinned, African-American, naturally blond girl with blue-green eyes. She inspires people through her upbeat personality and her incredible resilience. At three months old, Ava was diagnosed with oculocutaneous albinism. Doctors reported Ava was blind because her eyes did not respond to light or darkness. Though legally blind, Ava does not set limits on her abilities.

Now, at eleven years old, Ava has grown to love the way she looks. "I used to try on wigs to see how I would look with different-colored hair. I've also used Photoshop to change my eye color. When I saw myself with different hair and eye colors, it made me appreciate the way God created me. I am proud to be an inspiration to anyone who looks different or might have a hard time accepting things about themselves."

Ava's charm and arresting looks have caught the attention of photographers and celebrities. Ava is most proud of an invitation from Beyoncé to appear in her film *Lemonade* and join her on the red carpet at the MTV Video Music Awards.

"When I was younger, modeling was all about having fun and dressing up for the cameras. I now know that my photos are more important than that, because they show albinism in a positive way and help to build awareness and self-confidence."

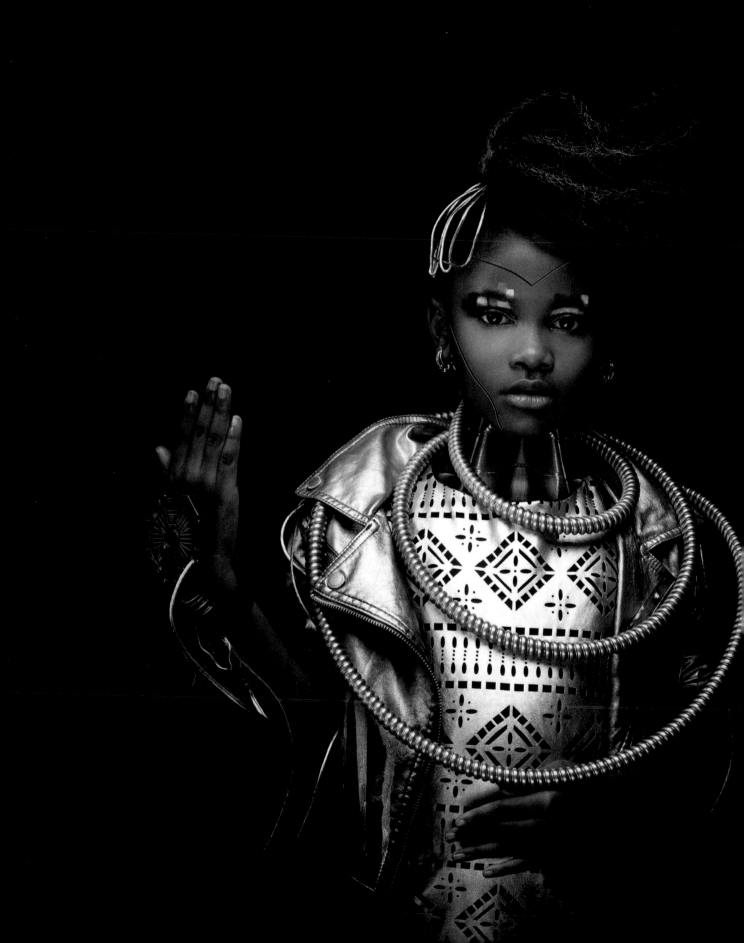

AMOY
GEORGIA
The Neuroscientist

There were several defining moments when it became apparent that eight-year-old Amoy Antunet was interested in science. Moments like when she would put on her mother's stethoscope and pretend to listen to her pulse. Amoy's passion for science truly began at the age of three, when she became fascinated with her father's microscope. He brought it home to study for biology classes he was taking as a college student. Her father eventually bought her a microscope and science textbooks that she, an early reader, would read each morning. Not long after, Amoy could discuss the brain and cranial nerves' form and function. The third grader from suburban Atlanta has become known as a neuroscience expert. She dissects mind-boggling topics, including cell division, the heart, pH testing, the brain, neurophysiology, and a multitude of other scientific subjects.

"I love science because it's always changing. As technology changes the world innovates. So we know more about things today than we did yesterday."

Loving science has taken Amoy far beyond the classroom. She was recently a featured speaker at the Roadmap Scholars NEURAL Conference, where she spoke about Alzheimer's, and was given the award for being an outstanding scientist. She is the youngest person ever to present at a neural convention.

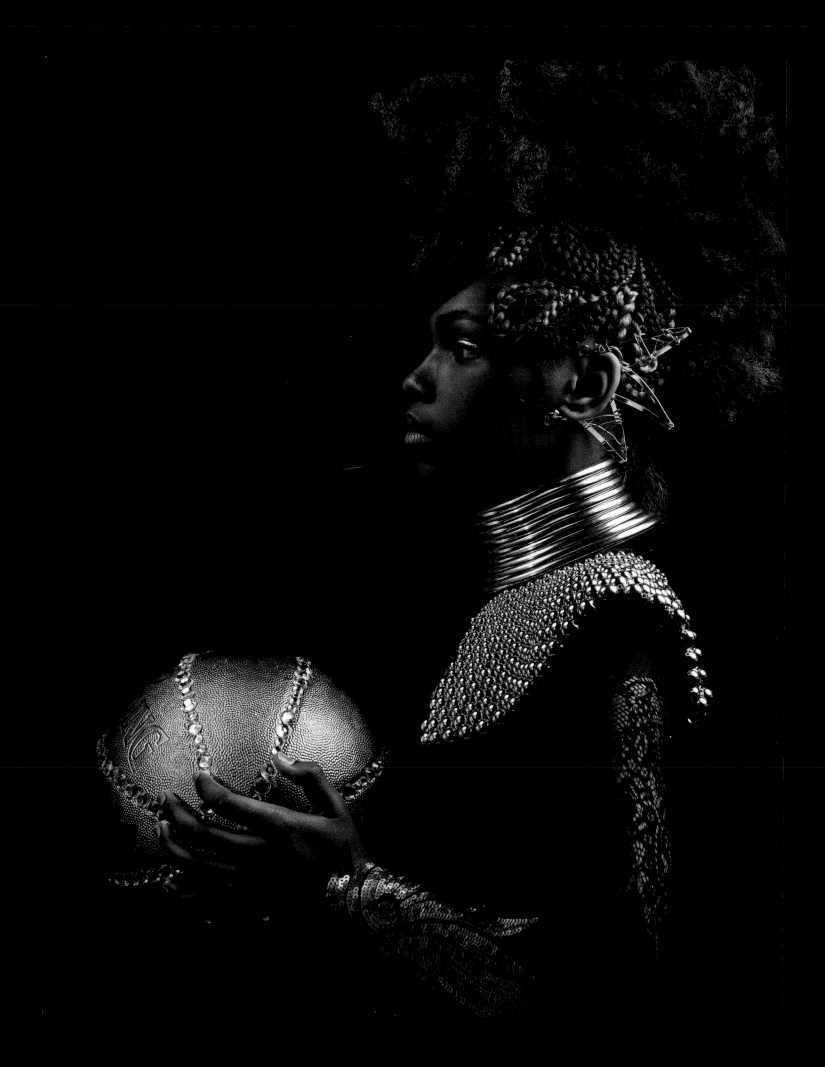

DON'T BE A HARD ROCK WHEN YOU REALLY ARE A GEM.

—Lauryn Hill

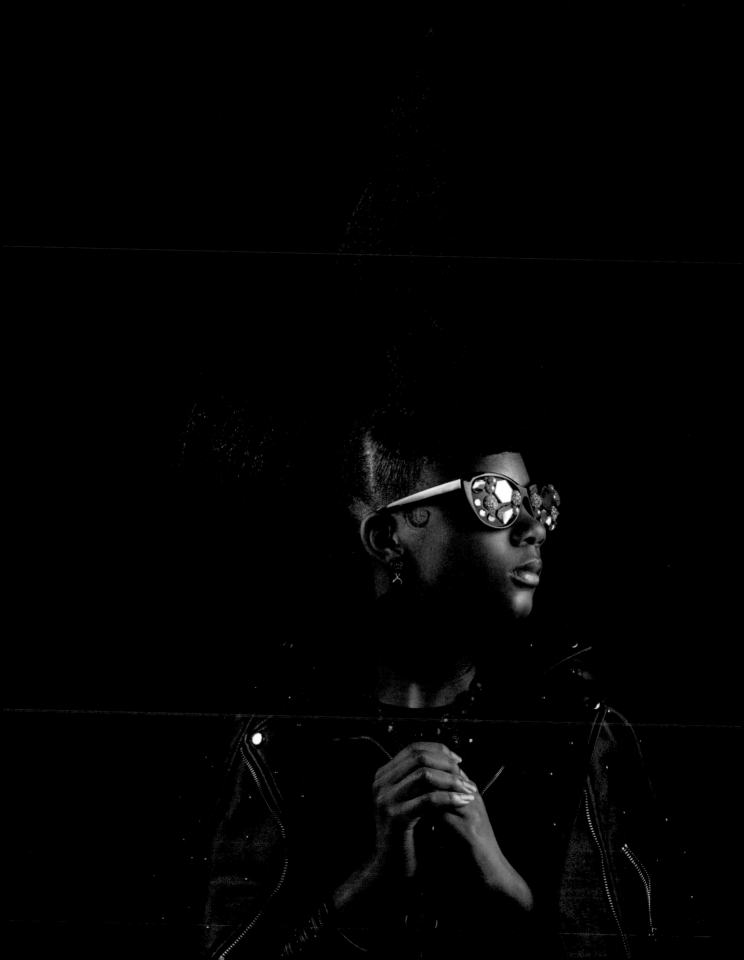

PHOENIX

GEORGIA

Rise and Start Anew

Ten years before she was born, her father had already picked out her name, Phoenix. She was named after the mythological bird, only one in existence at a time. After a long life and its purpose served, the phoenix creates a pyre and is set ablaze by the rising sun. From those ashes, a new phoenix rises. He had no idea how prophetic that name was.

Like her mythical namesake, Phoenix Lyles has also had to rise and start anew. A divorce is not only tough on the husband and wife, it is tough on the child as well. The stability Phoenix once knew evaporated. She struggled to create strong friendships and started to lack confidence. Focusing on helping others and learning to love herself, including her thick head of natural hair, is making her feel confident again. The kids at school don't tease her because of her hair; instead, they tell her they want to wear their hair like hers.

Now eleven years old, Phoenix is a precocious young lady with a relentless desire to learn new things. Phoenix is a STEAM (Science, Technology, Engineering, Arts, Mathematics) girl. She developed a love for travel early and has a goal to visit all fifty states.

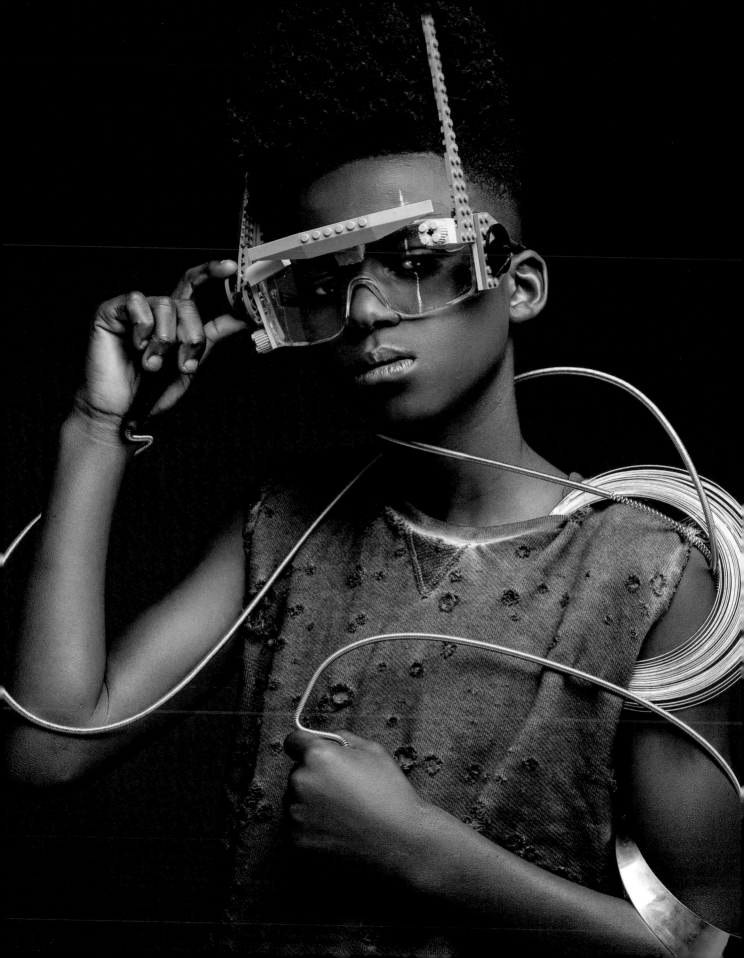

CHANGE WILL NOT COME IF WE WAIT FOR SOME OTHER PERSON OR SOME OTHER TIME.

— *Barack Obama*

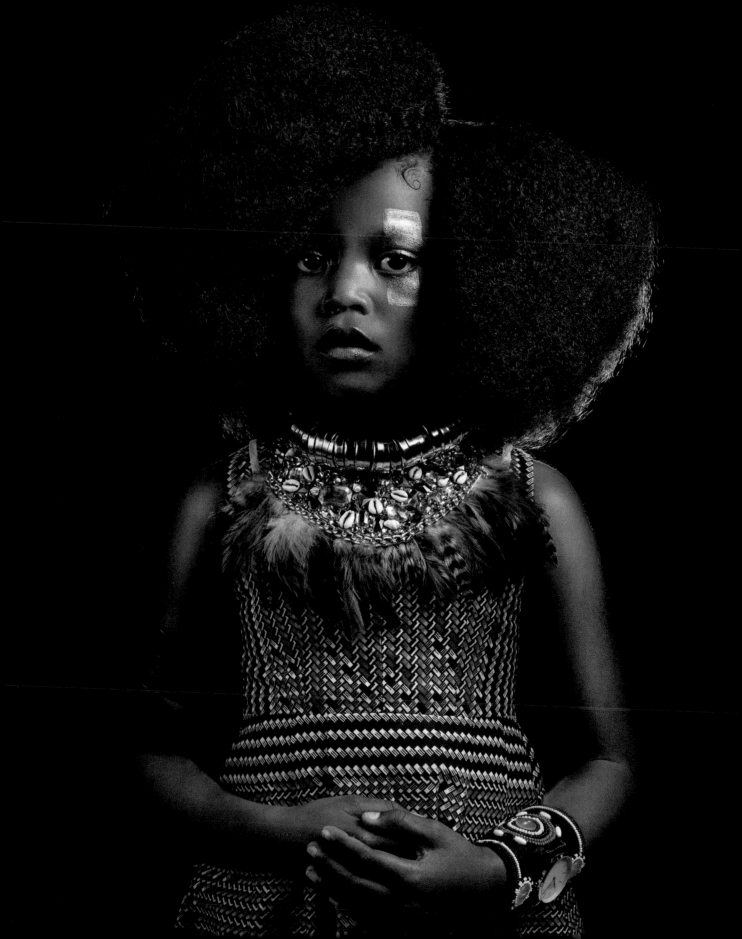

WILLA BREEZ

NORTH CAROLINA

The Free Spirit

Willa Breez Barr is a radiant, free-spirited seven-year-old who loves learning and playing. Naturally creative, Willa loves to draw, paint, and knit. She's also very proud of her garden, where she's grown watermelons, squash, and carrots for her family and neighbors. Willa B's first name is in honor of her paternal grandfather, Willy C. Willa Breez comes from one of her mother's favorite things, the sound of the breeze blowing through the weeping willow trees. Willa plays the piano, soccer, basketball, and is part of the local children's theater. Her free spirit and creativity inspires everyone around her.

Willa's thick head of naturally copper curls gets her lots of attention when she is out. Her family is teaching her how to return the admiration with gratitude and to also point out to others their own beauty. She is at the age where she's identifying with other brown girls through their shared characteristics, like their skin color or features. She also wonders why her hair isn't straight like some of her non-black friends. Seeing herself on these pages is a major affirmation of Willa's natural charm, elegance, poise, and greatness. We know she will pay it forward as she makes her mark in the world.

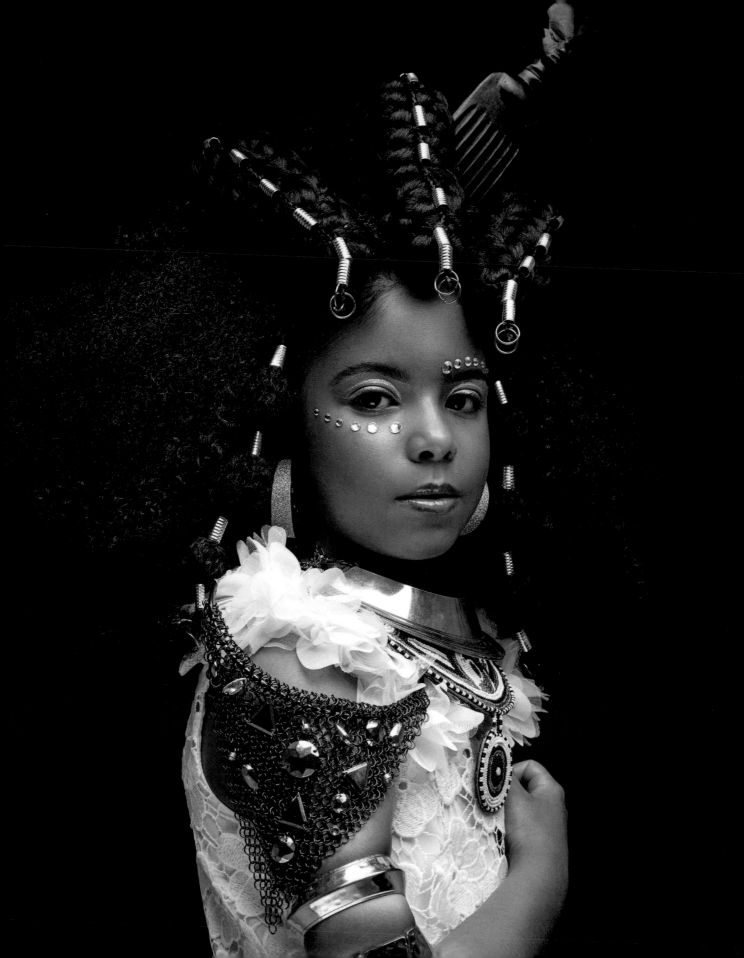

AMAIYA

The Quiet Storm

Amaiya Charles is a wildly creative eight-year-old girl who was born in London. Her mother is Caucasian and her father is black Caribbean. Amaiya enjoys learning about the islands of Saint Lucia and Grenada, where her grandparents are from. She wishes to one day visit the Pitons in St. Lucia to explore her heritage, and also run along the beautiful sandy beaches.

An amazing artist, Amaiya loves to draw. She believes her superpower is the ability to make her drawings come to life, and hopes to one day create her own comic book. She enjoys expressing herself and showcasing her creative personality through her curly hair. She experiments with different styles and colors to showcase her mood and has found a great sense of confidence through the beauty and versatility of her natural hair.

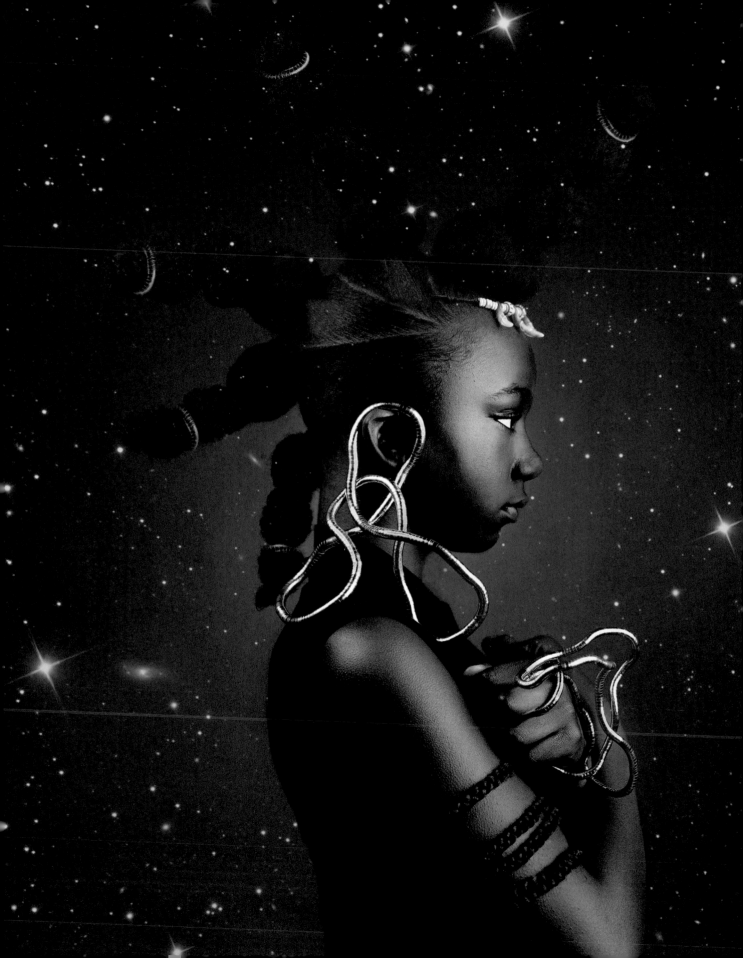

ONLY IN THE DARKNESS CAN YOU SEE THE STARS.

—Martin Luther King Jr.

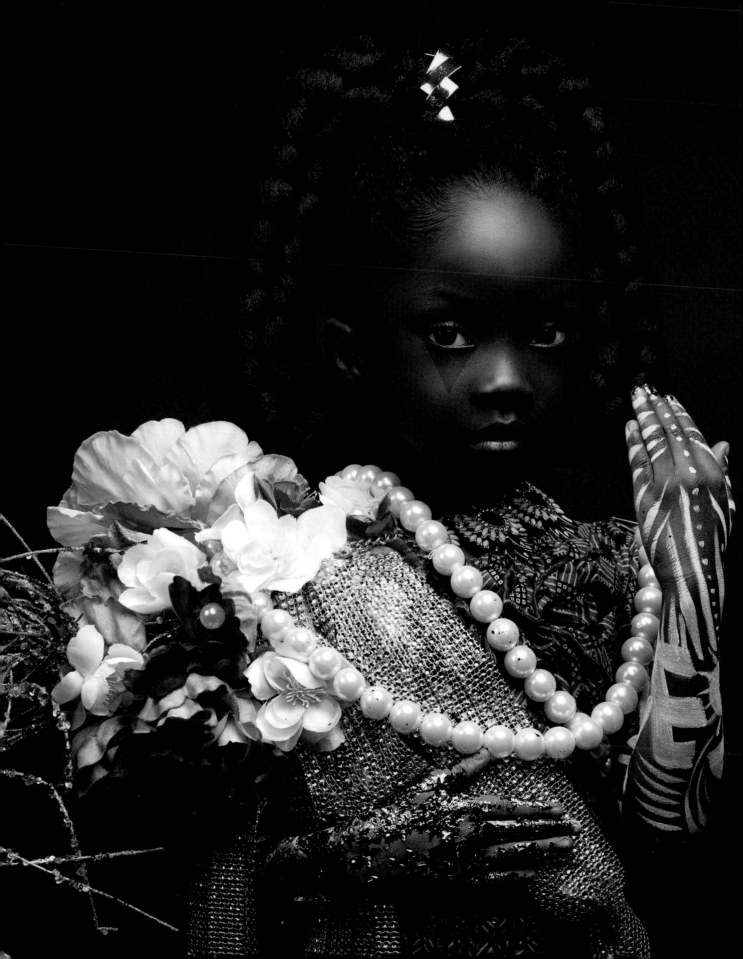

MYLAH

The Toddler Model

In Ghanaian culture, one of the most powerful things you can give a child is their name. It can project a child's future while at the same time connect them to their roots. Mylah Shyvonne Maame Yaa Agyiwah Gyimah's name traces her back to her family's roots in Ghana, West Africa. Her name, Mylah, means "merciful" and Yaa means she was born on a Thursday, just like all of her grandmothers and great-grandmothers. Mylah began her modeling career as a means of building her self-esteem and understanding the different colors and textures of beauty in the world, from the lightest vanilla to the deepest ebony, and every shade in between.

Mylah's family describes their Ghanaian-American heritage as "Ghanaian culture and tradition with a blend of African-American culture. Or what Mylah calls 'the love and support of all things African and all things and people brown and black.'"

As Mylah continues to acknowledge her inner and outer beauty she will grow as a confident little girl who knows she has something to contribute to the world. She is only five, but one thing is for sure, whomever she becomes or whatever she decides to do, she will inspire people and contribute to the visions of our diverse and expansive beauty, for years to come.

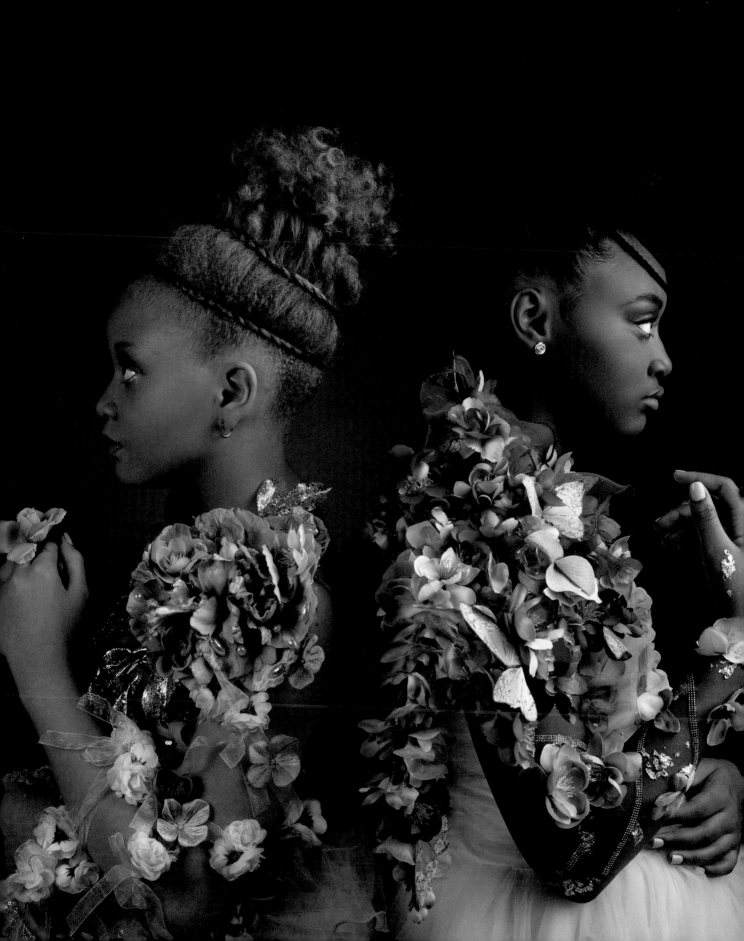

AVA AND LOGAN

SOUTH CAROLINA

Unique Sisters

Sisters Logan and Ava Fullington are simultaneously the worst of enemies and the best of friends. Logan both envies and admires Ava's unique features, while Ava at times, longs to look like "everybody else" in her family. Ava was born with blond hair and blue eyes to two brown-skinned, black-haired parents. Ava's one-of-a-kind features are a result of albinism, which came as a shock because the genes are recessive, with no known family history. At an early age, both girls are knowledgeable and inquisitive about ancestry and genetics, and it has sparked their interest in science and biology. They have learned, as a result of their distinctive looks, the importance of self-acceptance.

Ava, a quirky, precocious eight-year-old, is building a platform that instills self-acceptance. She is encouraging young girls and even adults, to embrace and overcome their differences, starting with the color of their skin. Older sister Logan, a reserved, yet take-charge eleven-year-old, is more of an introvert and is already dreaming of going off to college. Like all siblings, there are days when they are envious of each other's looks, but thankfully there are more days when they are proud of each other's distinct features. They consider each other the most beautiful girl in the world, which both protects and truly uplifts the other, while celebrating their own special, individualized look.

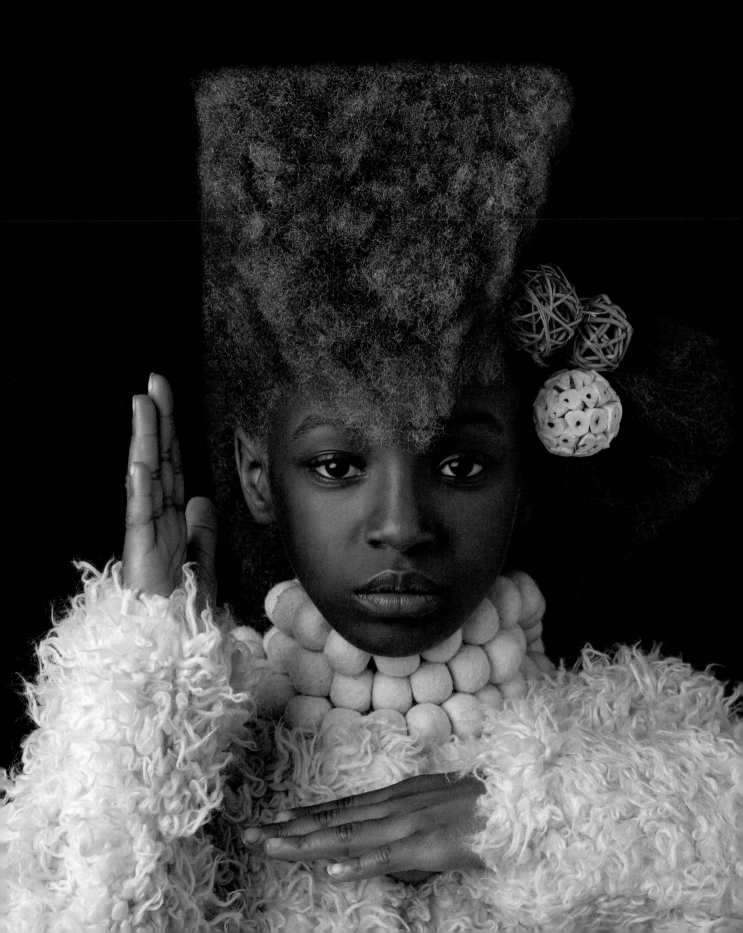

I'LL FIND A WAY OR MAKE ONE.

—Unknown

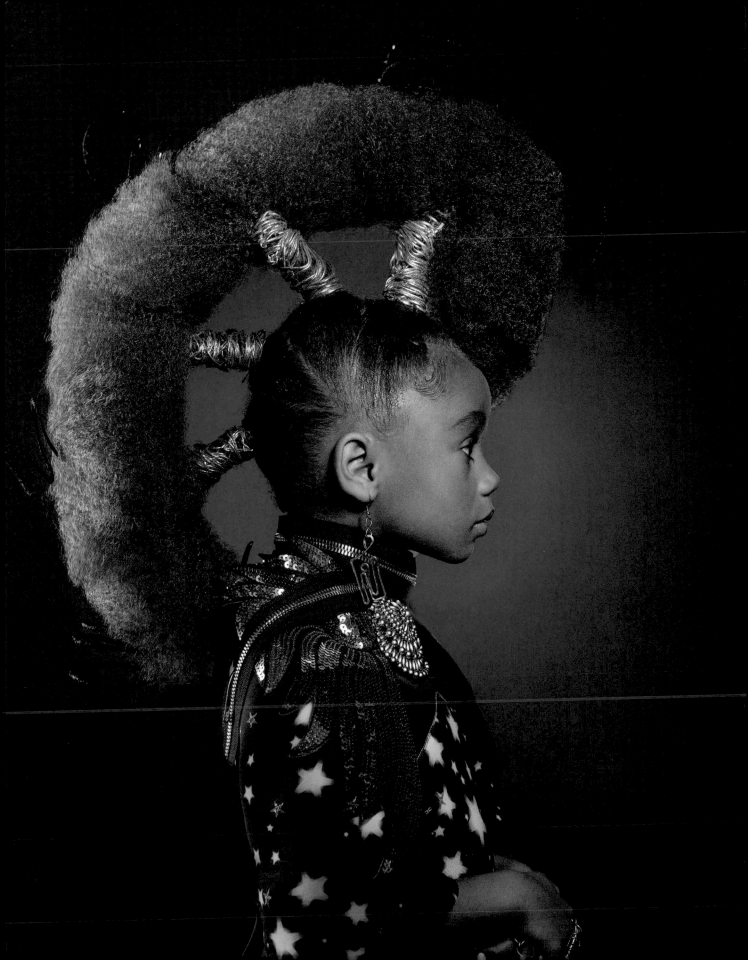

DON'T SET SAIL ON SOMEONE ELSE'S STAR.

—African proverb

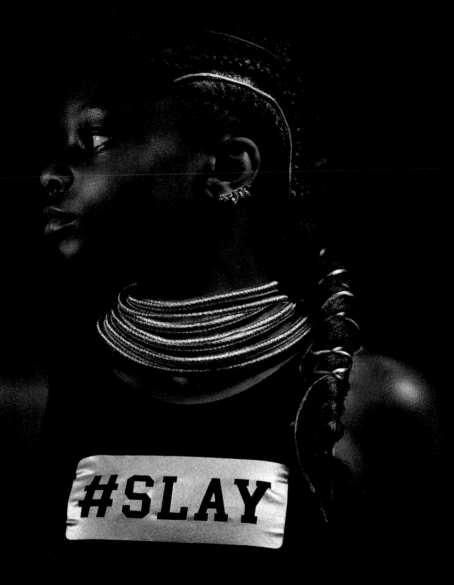

KENNEDI

The B'Girl

When I think about the future and what we are creating, I would be remiss if I didn't think of my own nieces and nephews who motivate us to keep pushing so that the next generation will have it a little easier than we did. My niece, Kennedi Hill, is a straight-A student and a state basketball champion who dreams of one day owning her own business. Only thirteen years old, she already possesses a calm and quiet strength. When I look at her I see a lot of myself—she's determined to succeed no matter what life may bring. Kennedi does not try to be special; she simply is, just by being herself.

"My aunt Kahran is my inspiration. When I see what she's achieved and how she can inspire people with her photos, it makes me want to inspire others. What I've learned from her is to always believe in yourself even if no one else does, and to be encouraged to do great things. Like she has. I love seeing other girls who look like me in my aunt and uncle's images. In their pictures I look and feel strong and beautiful, like a queen. It makes me happy and proud to know that they are in my family."

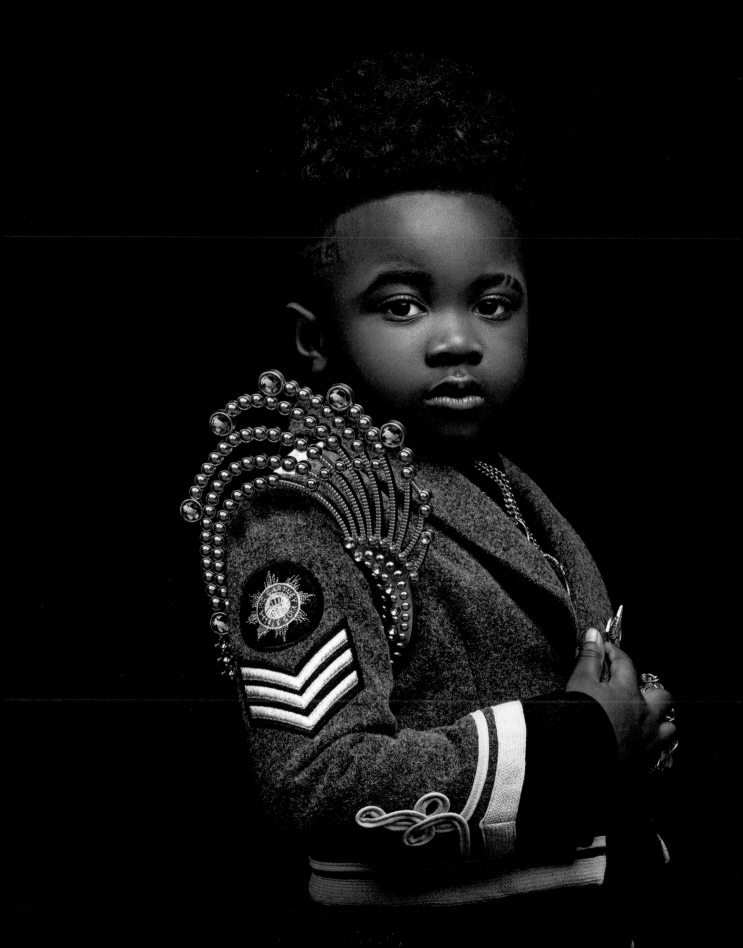

IF YOU HAVE NO CONFIDENCE IN SELF, YOU ARE TWICE DEFEATED IN THE RACE OF LIFE.

—*Marcus Garvey*

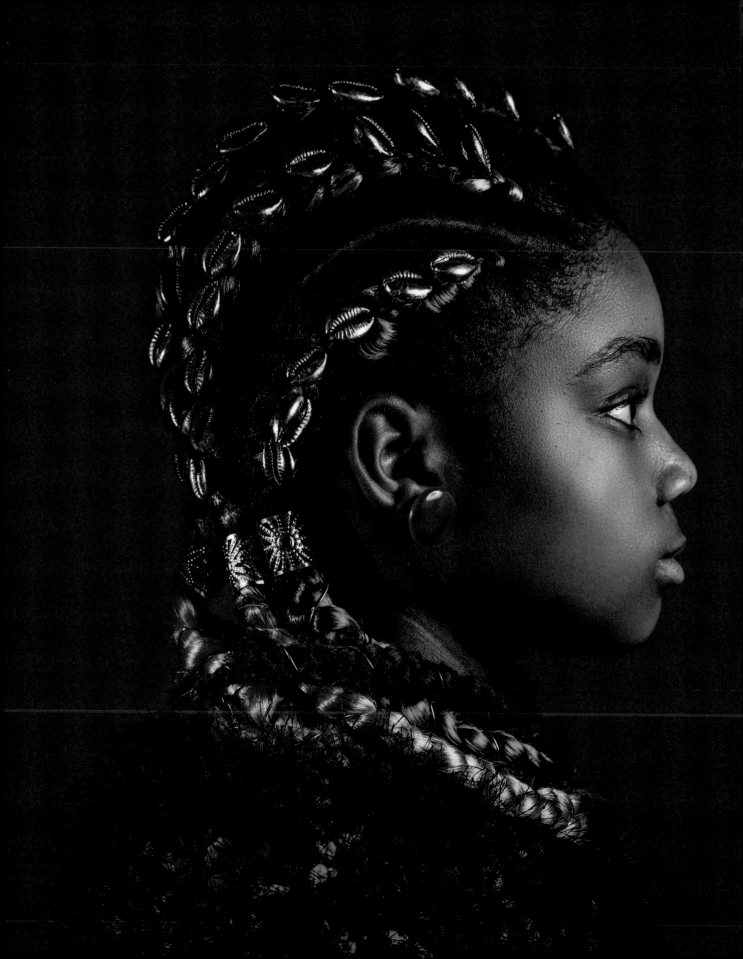

KYLA

The Braider

Women of African descent have a rich and varied history in the creative ways they wear and adorn their hair. A specific look could indicate the clan you belonged to, your marital status or your age. Throughout time, hair braiding has been at the root of African culture across the diaspora. At a young age, my niece Kyla Duckett, had a strong interest in braiding and started practicing on dolls (and even her sister Kennedi) to sharpen her skills. Now, at fifteen years old, she enjoys using her phenomenal skills on family and friends and wants to one day have her own salon so she can make women look and feel beautiful.

"I would like to be a hairstylist and also do interior design. My dream is to merge my two passions together into an amazing salon to create a unique experience for my clients. I created the braid style I wore in my photo. This isn't anything I would have imagined years ago, but I now know that anything is possible."

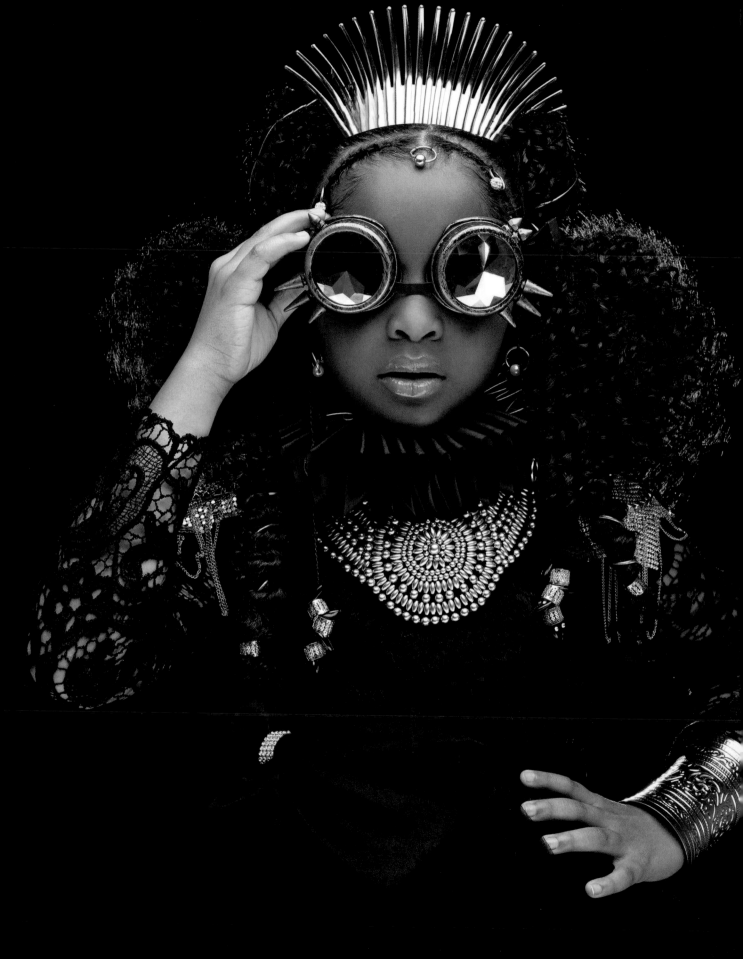

WE ARE THE ONES WE'VE BEEN WAITING FOR. WE ARE THE CHANGE THAT WE SEEK.

—Barack Obama

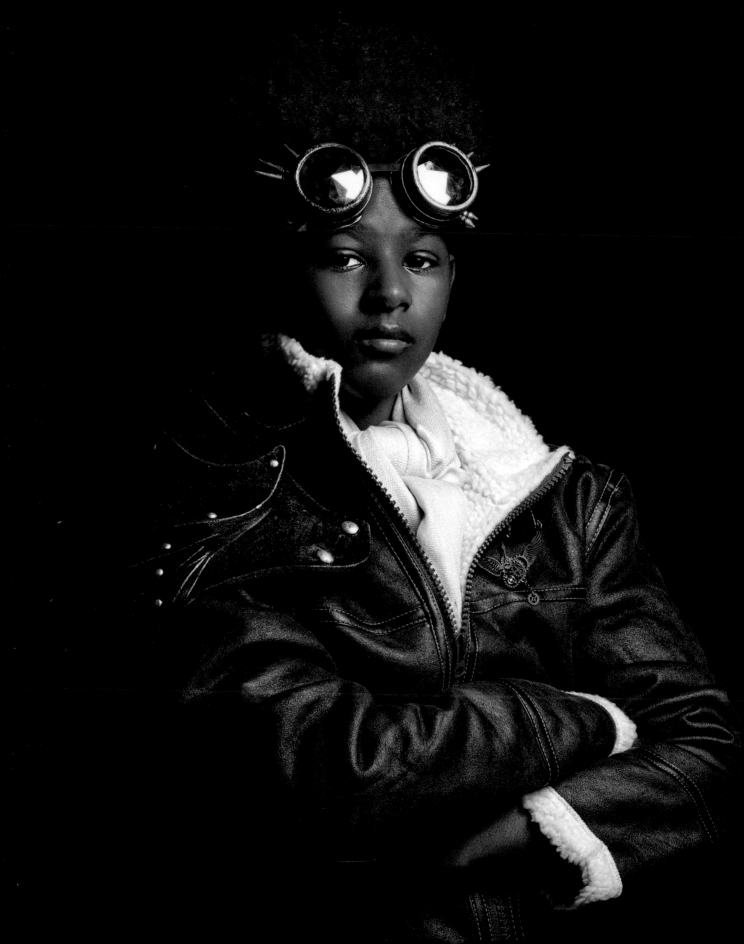

AA'ZION

Finding My Wings

At the age of twelve, Aa'Zion Dawkins was introduced to the idea of becoming a pilot because of his interest in engineering. However, his love for flying didn't start off as love. He was afraid of heights. Once he took his first flight, his passion to become a pilot took off. When he started there were only two other boys in his class who looked like him. Since then, he has made it his mission to introduce as many young black kids as he can to the possibilities of becoming a pilot.

"I never knew of any pilots growing up, especially ones that look like me, so becoming a pilot wasn't a reality for me. After my first experience flying, I fell in love with it. From that moment on it was my duty to show other kids and even adults that look like me or come from the background I come from that anything is possible. I'm no longer afraid to try new things. I'm brave and that's what I am most proud of. I'm also proud to be an African American because we are superheroes. Once we tap into our magic and understand our full capabilities, we are unstoppable."

At only thirteen years old, Aa'Zion was accepted as the youngest member of the iMeet NASA program at Georgia Tech. "I want to inspire other kids to find your magic and master it. We all have unique gifts and abilities designed especially for us. You are more than what your eyes can see. Life is limitless."

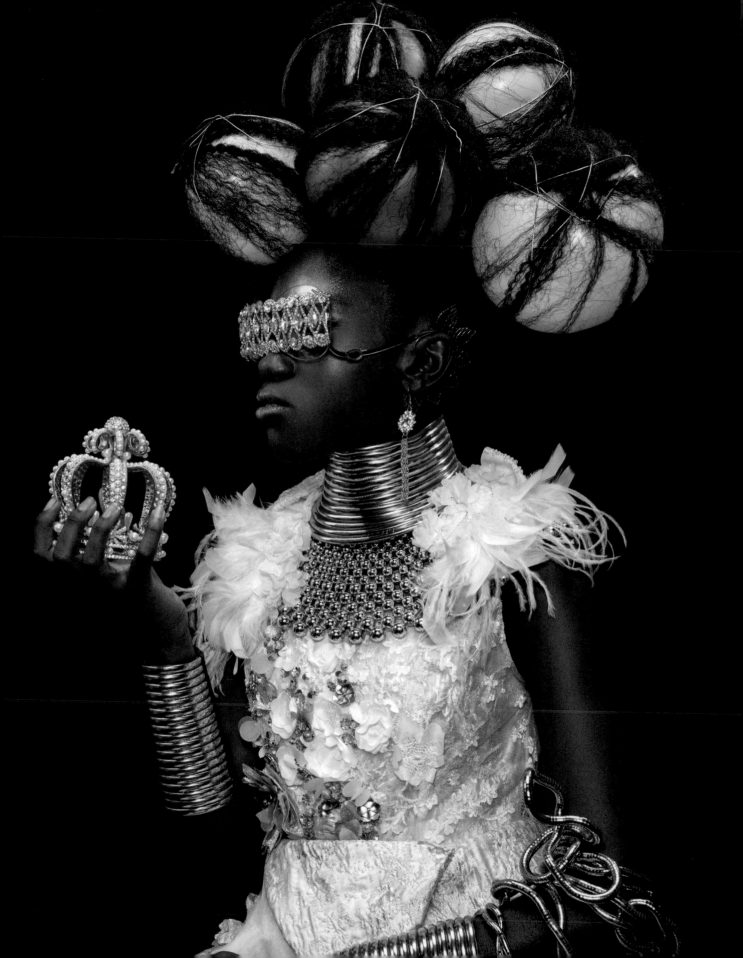

THE FUTURE BELONGS TO THOSE WHO PREPARE FOR IT TODAY.

—Malcolm X

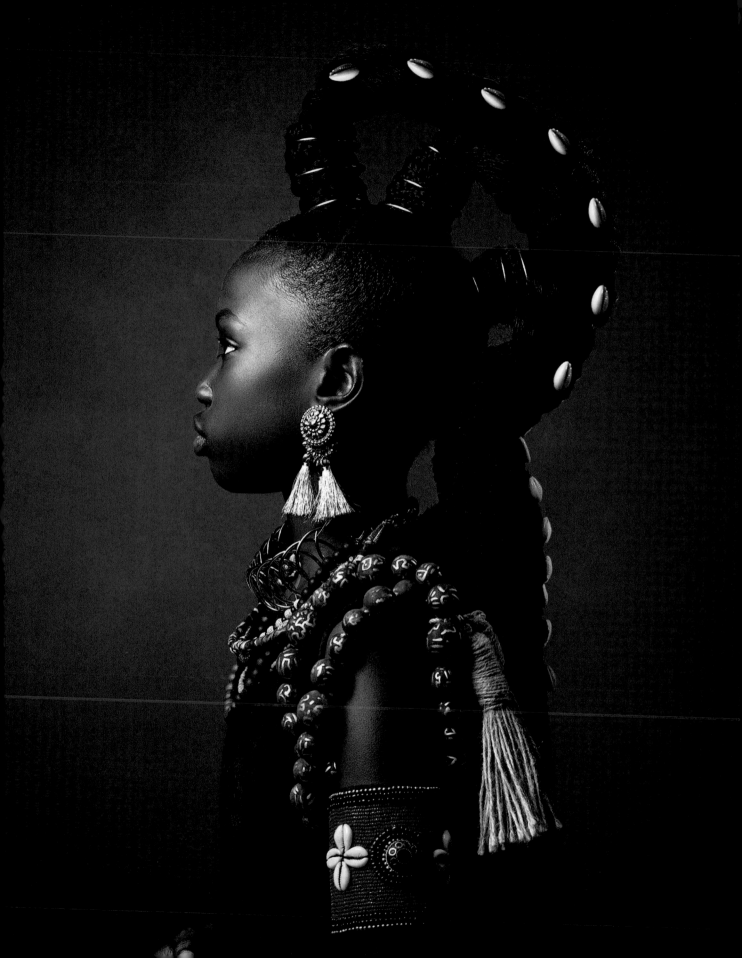

JENNESHA

Haitian Spirit

Jennesha Adore Pierresaint is a determined ten-year-old who loves music and singing and is learning to play the piano. Her father immigrated from Port-Au-Prince, Haiti, to the United States at the age of twelve and her multiracial mother was born in Miami, Florida. Jennesha's parents were homeless when she was born. Though still teenagers, they were determined to make a home for her any way they could. Their determination taught her that "your circumstances don't define you." Jennesha, who was named after both of her parents, has gorgeous dark skin and a full Afro, which she considers her superpowers because they make her stand out. This tenacious beauty hopes to be the voice of kids who are "born under unique circumstances."

Jennesha dreams of becoming an international singer and performing onstage in front of hundreds of people. Her family has taught her that dreams are attainable no matter what adversity you may have faced in the past; your future is yours to determine.

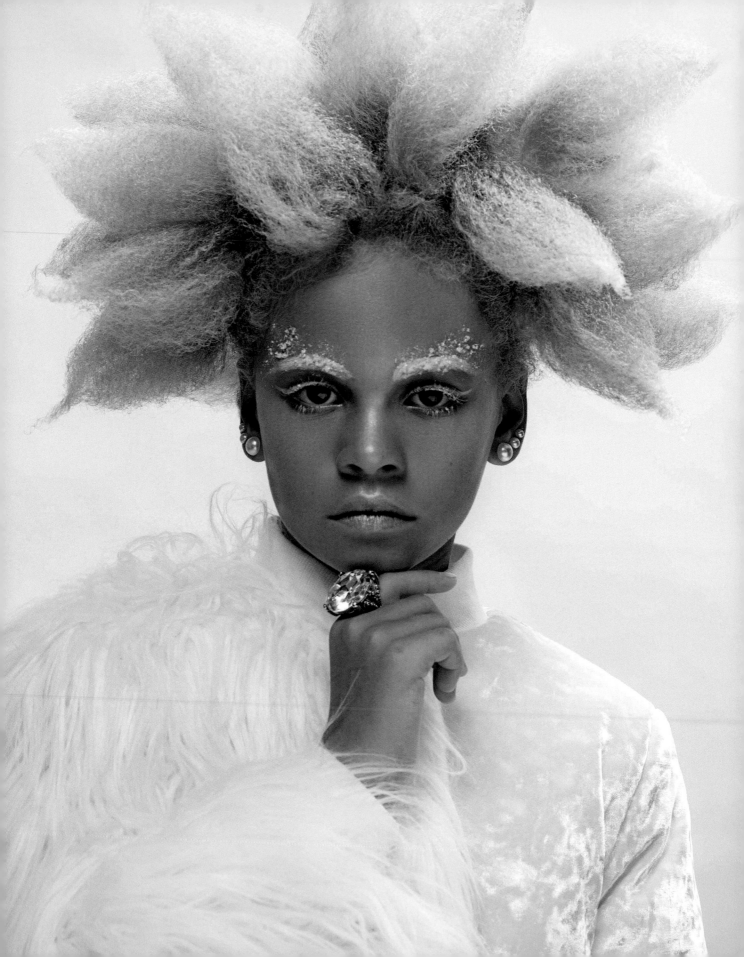

IF THERE IS NO STRUGGLE, THERE IS NO PROGRESS.

—*Frederick Douglass*

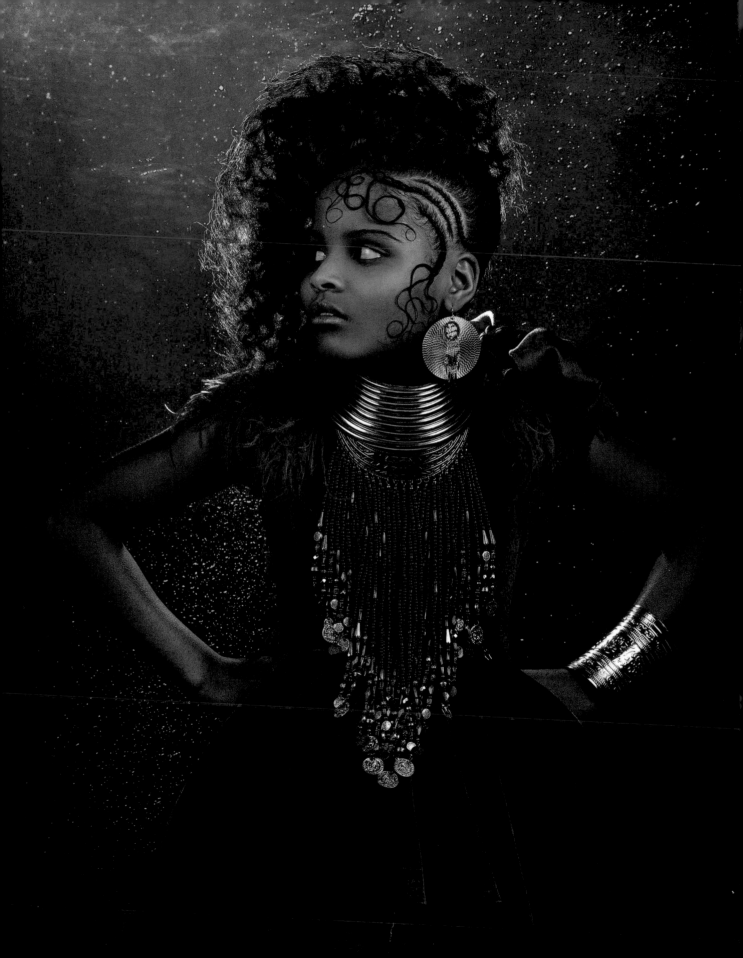

MARI

MICHIGAN

Little Miss Flint

Eleven-year-old Mari Copeny has not let her age prevent her from
making a significant impact on the dialogue around environmental
racism. At eight years old, Mari wrote a letter to President Barack Obama
challenging him to visit Flint, Michigan, to see the water crisis firsthand.
The letter confronted the entire country with the reality faced by victims
of state negligence.

Her activism has led her to meet Presidents Barack Obama, Bill Clinton,
and a host of other politicians including Hillary Clinton and Bernie
Sanders. The world has come to know Mari as Little Miss Flint through
her activism of bringing awareness to the ongoing Flint water crisis.Her
youthful honesty prevents political leaders from being able to ignore the
consequences of neglectful leadership. Mari has raised over $70,000 for
her Flint Kids projects, including backpacks stuffed with school supplies,
Christmas toys, Easter baskets, movie screenings, and bottled water. She
also regularly donates to the local children's center. Her work continues
to make an impact on the kids in Flint. She has raised over half a million
dollars to combat the Flint crisis and now has her own water filter to help
communities across the country dealing with toxic water.

Mari believes her superpower is being able to make adults listen and pay
attention to her. She wants other young people to know that they are
never too young, or too old, or too big or too small, or too loud or too
quiet to change the world.

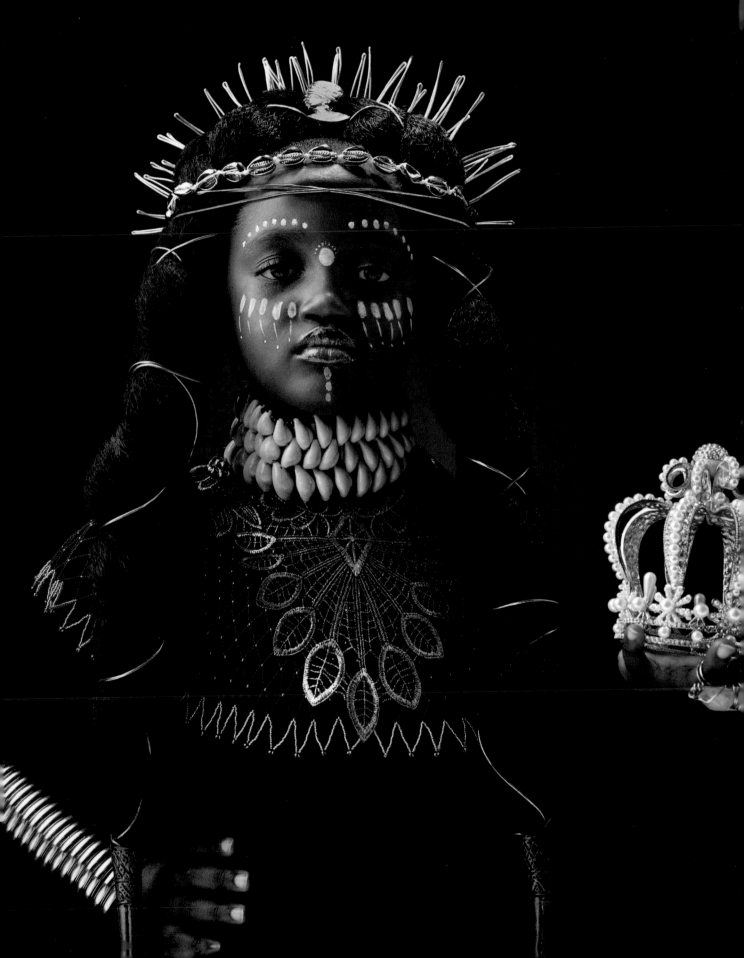

ANAYA

VIRGINIA
VIRGINIA

A Bright and Shining Star

Little Anaya Samms has been through more in her six years than many of us will experience in a lifetime. Three years ago she lost her mother, who was only twenty-three, to domestic violence. "My daddy played a trick on my mom. He pretended to be a nice guy. He took my mommy and I miss her so much."

Brave and resilient Anaya still sees the humanity in others. Inquisitive and always ready to give a helping hand, she is interested in science and animals and wants to be a veterinarian or a "people doctor." She has a real stethoscope that she uses to practice on her family, including the dog.

Anaya is blessed with a loving grandmother and has hope and optimism for the future. She is a bright shining light, which she shares with everyone she meets. She reminds us that no matter what we may have overcome, we will not be defined or diminished by it. Instead we will continue to rise and to shine brightly like a star.

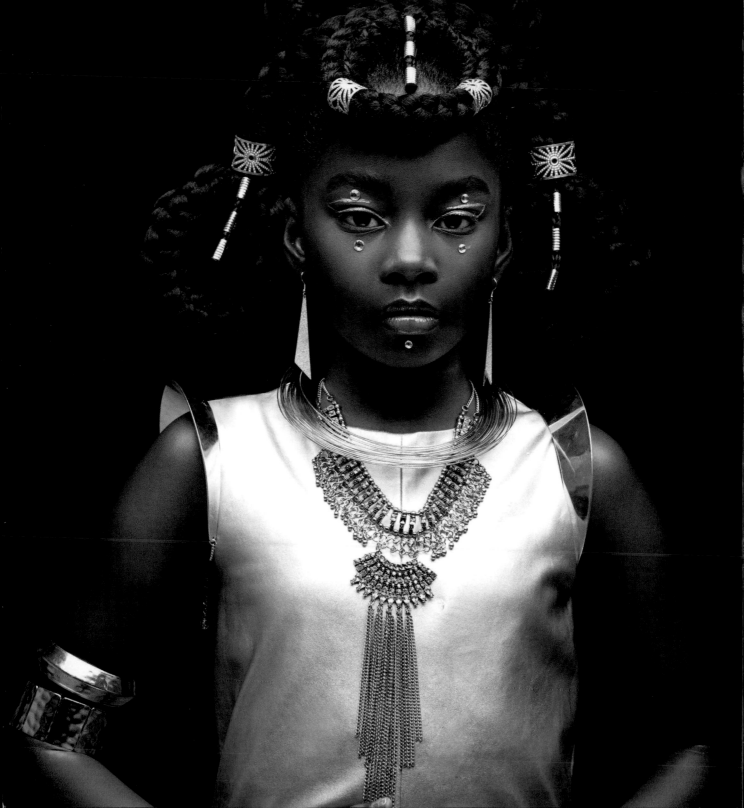

REMIND YOURSELF, NOBODY'S BUILT LIKE YOU. YOU DESIGN YOURSELF.

—JAY-Z

Behind the Scenes

One of the things that makes us most proud is being able to see a child's transformation (from the inside out) happen right before our eyes. It is the biggest reward we get to experience on a daily basis.

Seeing the looks on their faces when they see themselves in a way they never thought was possible makes all of the effort more than worth it.

Check out some of our favorite behind-the-scenes moments from our shoots captured around the world.

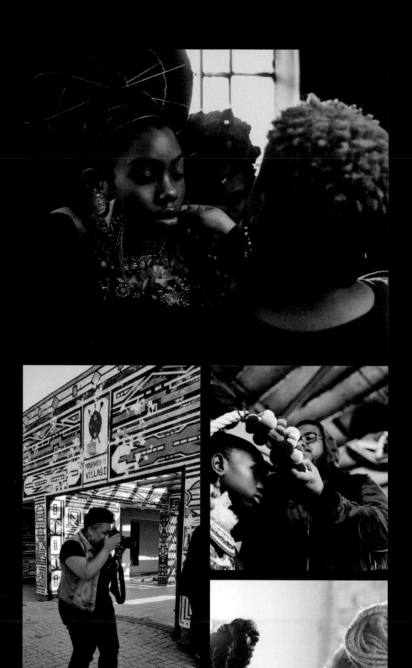

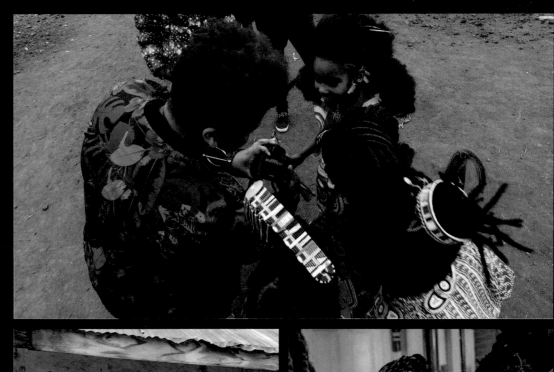

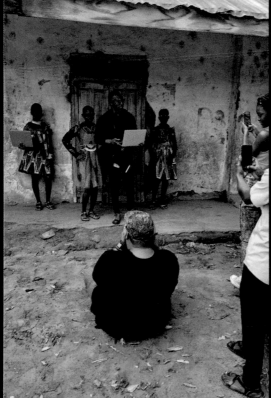

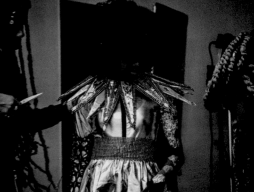

ACKNOWLEDGMENTS

This book would not have been possible had it not been for the amazing team of stylists, designers, models, and vendors who helped make our visions come true. We were blown away by your creativity and grateful for your support.

Hair/Makeup Stylists

LaChanda Gatson
Shanna Thomasson
Lisa Farrall
Jennifer Lord
Ricky Kish
Angela Plummer
Twists & Locs Salon
Keya DeLarge
Mirage Magic
Aleroh Beauty
Zara Green
Ebony Malika
Tee Albertini
Princess Ndlovu
Denyelle Duckett
Seni Wendemu
Ericka Cherrie
Dyroll Dydy
Dionne Smith
Sherita Blango
Tadatoshi Horikoshi
Sabine Bernard

Designers/Wardrobe

Alexandria Olivia
Sara Bunn
Kevo Abbra
Kiki Clothing
Kiki Tillman
Bayabs
Charabia Paris
Pattern & Shape
Isossy Children
Alivia Simone
Luthi Creatives
Suoak
Kua Kids
Yetunde Clothing

Vendors

Ekocreashunz
Rebelheart Designs
Uniquely Wired
Orijin Culture
Luthi Creatives
Zulu Beads Ada
Aakofii
Black Vibe Tribe
Planet Enjeanious

Vendors (cont.)

Sued Watches
Jua Accessories
Major Expression
TruFace by Grace
Moyobybibi
Burkinabae
RashidaGurl

Behind-the-Scenes Photos

Cris Sanchez
Andrew Clifton
Thomas
AJ Robinson

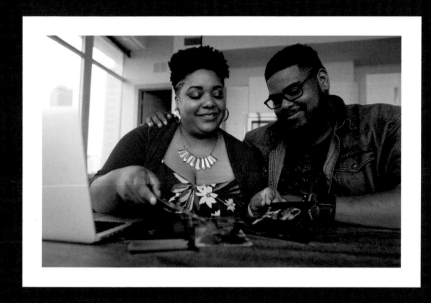

World-renowned child photographers REGIS and
KAHRAN BETHENCOURT are a husband-and-wife team
and the imaginative forces behind CreativeSoul
Photography. They gained global recognition with their
AfroArt series. The collection, which showcases the beauty
and versatility of Afro hair, was conceived as a way to
empower kids of color around the world. The images
went viral after early supporters Will Smith, Jada Pinkett
Smith, Taraji P. Henson, Alicia Keys, and Common,
among others, praised the series on social media. Their
holistic approach to capturing one-of-a-kind moments
has allowed their work to be featured on BBC News, CNN,
CBS News and BET, and in *Teen Vogue*, *Glamour Brazil*,
and other publications.